THE CINCINNATI WING

THE CINCINNATI WING

The Story of Art in the Queen City

EDITED BY JULIE ARONSON

with contributions by Anita J. Ellis and Jennifer Howe

CINCINNATI ART MUSEUM

Ohio University Press • Athens

The Cincinnati Wing: The Story of Art in the Queen City is made possible through a generous gift from Thomas and Mary Lynn Cooney and supported in part by awards from the National Endowment for the Humanities and the National Endowment for the Arts. Any views, findings, conclusions, or recommendations expressed in this publication do not necessarily reflect those of the National Endowment for the Humanities.

The Cincinnati Art Museum gratefully acknowledges the generous operating support provided by the Fine Arts Fund, the Ohio Arts Council, the Institute of Museum and Library Services, and the City of Cincinnati.

Ohio University Press, Athens, Ohio 45701
© 2003 by Ohio University Press

Ohio University Press books are printed on acid-free paper ⊗ ™

11 10 09 08 07 06 05 04 03 5 4 3 2 1

The epigraph for chapter 1, from a letter of William A. Adams to Thomas Cole (1842), is reprinted from the Thomas Cole Papers, courtesy of the New York State Library, Manuscripts and Special Collections.

Frontispiece: Detail
Benn Pitman (1822–1910), designer, Adelaide Nourse Pitman
(1859–1893), carver, and Elizabeth Nourse (1859–1938), painter
Bedstead, 1882–83
Mahogany and painted panels
110 x 59 ¼ x 85 in. (279.4 x 150.5 x 215.9 cm)
Gift of Mary Jane Hamilton in memory of her mother, Mary Luella Hamilton,
made possible through Rita S. Hudepohl, guardian, 1994.61

Library of Congress Cataloging-in-Publication Data
The Cincinnati Wing : the story of art in the Queen City / edited by Julie Aronson ; with contributions by Anita J. Ellis and Jennifer Howe.
 p. cm.
 Includes bibliographical references and index.
 ISBN 0-8214-1487-9 (cl. : alk. paper) — ISBN 0-8214-1488-7 (pbk. : alk. paper)
 1. Art, American—Ohio—Cincinnati—19th century—Catalogs. 2. Art, American—Ohio—Cincinnati—20th century—Catalogs. 3. Art—Ohio—Cincinnati—Catalogs. 4. Cincinnati Art Museum. Cincinnati Wing—Catalogs. I. Aronson, Julie. II. Ellis, Anita J. III. Howe, Jennifer.

N6535.C55 C54 2003
709'.77178'07477178—dc21

2002074957

Contents

Foreword

Although showcasing the Cincinnati Art Museum's extensive holdings of works by Cincinnati artists would be reason enough to publish this volume, its broader purpose is to mark the opening of eighteen thousand square feet of newly renovated galleries that honor the rich artistic legacy of this great city. These handsome spaces display over four hundred objects that chronicle an impressive record of individual achievement and confirm the significant role that Cincinnati played— especially during the late nineteenth and early twentieth centuries—in the history of American art.

From Cincinnati's beginnings as a small settlement on the western frontier of the young American republic, to the present when it serves as a vital urban center for a region with a population of more than two million, the visual arts have enjoyed a prominent place in the cultural life of the city. They remain central to its identity today and continue to inspire visitors and residents alike. For if the past is prologue to the future, and if we look back on Cincinnati's history and note with pride that the arts have always been among its most important attributes, then we should continue to honor and support the arts because they point the way to a bright future for our city.

It is fitting that the Cincinnati Art Museum undertake such a project, for this institution was founded at a time when civic optimism was at a high point and the establishment of an art museum was seen as both an ornament to the city and an educational resource for the benefit of the entire community. The Cincinnati Art Museum is delighted as well that the completion of the Cincinnati Wing coincides with the celebration of Ohio's bicentennial, for this city holds a distinguished place in the history of the state, and its cultural contributions are without equal.

Developed over a span of nearly five years, the Cincinnati Wing is the product of

the creative contributions of our staff and Board of Trustees, who have been assisted by many volunteers and friends of the museum. Without their dedication and hard work, the realization of this project would not have been possible. All deserve sincere thanks, and some, special mention. First and foremost, I would like to express my gratitude to Director of Curatorial Affairs Anita Ellis, who initially proposed that we highlight this important part of our collection. Her advocacy for the arts of Cincinnati and her intellectual leadership brought to every phase of work on this project have been indispensable. Second, I would like to express my deep appreciation to Deputy Director Stephen Bonadies for his time and energy overseeing virtually every phase of the development of the Cincinnati Wing, from design and construction, to the installation of the galleries and the creation of educational programs. His assistance has been invaluable. Last, I must also acknowledge with gratitude a member of our Board of Trustees, Dr. Kenneth Kreines. A devoted collector with a great passion for the arts of Cincinnati, Dr. Kreines has played a pivotal role in the development of this project. In addition to making a leadership gift that provided the initial impetus for the Cincinnati Wing, he chaired the committee that provided oversight and guidance as we progressed through the development of the design, the selection of the works of art, and the details of the interpretive plan. Enthusiastic, determined, resourceful, and, above all, patient, Dr. Kreines has been an ideal partner and a pleasure to work with.

Throughout the long process of researching and selecting the objects presented in these galleries, Ellis worked in close partnership with two colleagues in her division: Curator of American Painting and Sculpture Julie Aronson and Associate Curator of Decorative Arts Jennifer Howe; and with Curatorial Assistants Amy Miller, Heather Braunlin, and Brittany Hudak. I greatly appreciate their many contributions, along with those of Head Librarian Môna Chapin and Archives Volunteer William Clark. Thanks are due as well to members of other divisions in the museum who provided both leadership and critical support. Curator of Education Ted Lind, former Acting Curator of Education Lorna-Kay Peal, and Assistant Curators of Education Amber Stafford and Marion Rauch collaborated with the curatorial staff to develop a broad range of interpretive programs that will provide new insights into this city and its artistic heritage. Director of Marketing and Communications Jackie Reau and her staff devoted a great deal of time and energy to promoting this project as an important event in the history of

this institution and producing publications to mark the opening. Members of our Museum Services Division—most notably Fred Wallace, chief conservator, Katherine Haigh, registrar, and their staffs—made many contributions to the care, documentation, and installation of the works of art, many of which have never before been displayed. Director of Development Jill Barry and her colleagues, Christa Flueck and Marianne Quellhorst, brought energy and determination to raising funds for the Cincinnati Wing. Thanks are also due to Director of Finance and Operations Debbie Bowman and her staff for the skill and good humor they brought to the complex challenges of managing such a large capital project.

The process of design and construction is critical to the success of any undertaking of this size and complexity. For this reason the museum was fortunate to secure the services of KZF Design. I would like to thank Don Cornett and his staff, and especially Jim Cheng, whose design for the Cincinnati Wing provided an elegant solution to the problem of integrating a new set of galleries into a space not easily adapted to this purpose. Working in close partnership with their counterparts at KZF, Chief Designer Michael Brechner and several members of his staff—most notably Amy Barrie, Bethany Keller, and David Dillon—are largely responsible for the handsome installations.

Several people made noteworthy contributions to the production of this beautiful book. Managing Editor Kathryn Russell expertly coordinated all aspects of the publication and enhanced the eloquence of its prose. The one hundred and fifty color plates are a tribute to Scott Hisey, photographic services/rights and reproductions coordinator, who skillfully managed the photography. The book represents a fruitful collaboration with Ohio University Press, under the able directorship of David Sanders.

The Cincinnati Art Museum is deeply grateful for the help received from many friends and colleagues who offered guidance, shared their insights on various aspects of the arts in Cincinnati and the history of this city, and helped in many other ways. Special mention should be made of the following: Jean Clendening, who volunteered in our Decorative Arts Department; consulting ethnologist Susan Meyn, who enhanced our understanding of the paintings of the American West and works of Native American art; and Ruby Rogers, director of the library and community history at the Cincinnati Historical Society, a good friend of the museum who has generously aided with research, interpretation, and loans of works of art.

Finally, the museum would like to express thanks to two groups of people without whose assistance the Cincinnati Wing could not have been realized. First, many generous contributors provided support for the construction of these new galleries, and for the educational programs designed to bring Cincinnati's rich artistic heritage into vital connection with the present. Second, it gives us great pleasure to acknowledge and express appreciation to all who have given the works of art presented in the Cincinnati Wing. These donors are motivated by a sense of civic pride and by a desire to share what they love with others. The Cincinnati Wing now provides us with the means of fulfilling that noble purpose.

Timothy Rub
Director

Introduction

The purpose of this book is to give the reader a sense of the rich beauty and profound story of art offered in the Cincinnati Wing at the Cincinnati Art Museum. Illustrated are one hundred and fifty selections out of the approximately eight hundred extraordinary works of painting, sculpture, and decorative arts that are in the museum's Cincinnati collections. Artists trained in the city created most of the work; however, about one percent was created by other artists for and about Cincinnatians, such as various portraits of its citizens, and August von Kreling's model for the Tyler Davidson Fountain in Fountain Square (pl. 1).

Reflecting the layout of the Wing, the illustrations are arranged in nine sections in roughly chronological order, with a brief text before each section offering remarks on the city's extraordinary cultural history. Since art represents more than just an aesthetic expression, the story is placed in the context of five themes that weave through each section offering a greater understanding of the art. The theme of the changing frontier demonstrates how Cincinnatians thought of themselves collectively as the city evolved from a frontier outpost, to Queen of the West, to Gateway to the West, to one of many portals leading westward. The rise of industrialization addresses the cultural paradigm shift that resulted in the establishment of public schools and numerous educational resources (libraries and museums), an unprecedented accumulation of wealth, an equally unprecedented utilization of land resources, and nostalgia for earlier times that were seen as simpler and less demanding. Another theme is the sustaining of the arts by patronage, beginning with generous gifts from individuals such as Nicholas Longworth, and continuing with support from schools (such as the Art Academy of Cincinnati), museums (especially the Cincinnati Art Museum), and industry. The personal identity of the artists, which reflected ethnic backgrounds, religious beliefs, and/or gender-specific issues, also enriched the artistic culture. The theme of art education demonstrates how regional

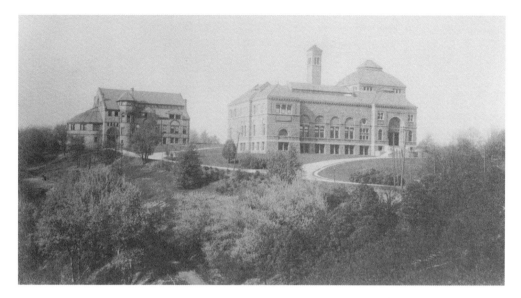

Fig. 1. Cincinnati Art Museum and the Art Academy of Cincinnati, ca. 1887. *Cincinnati Art Museum Archives*

artists at first sought their education elsewhere, then looked to Cincinnati—ultimately to the Art Academy of Cincinnati, which opened as the McMicken School of Design in 1869—making the Queen City a regional center for art and art education. Indeed, the Queen City became one of the major American art centers of the nineteenth century.

While the themes enlighten the story, it is the art itself that makes the story come alive. The objects created since the city's founding in 1788 are not simply parochial in nature but are of national and international importance. They demonstrate the pivotal role that the city has played in the history of American art, and offer clues to the workings and lifestyles of people as expressed in creative activity. With the Cincinnati Wing and ancillary publications and programs, Cincinnati and the tri-state region applaud a very important, very rich artistic history and enjoy a pride of place that will resonate throughout the nation.

Anita J. Ellis
Director of Curatorial Affairs,
and Curator of Decorative Arts

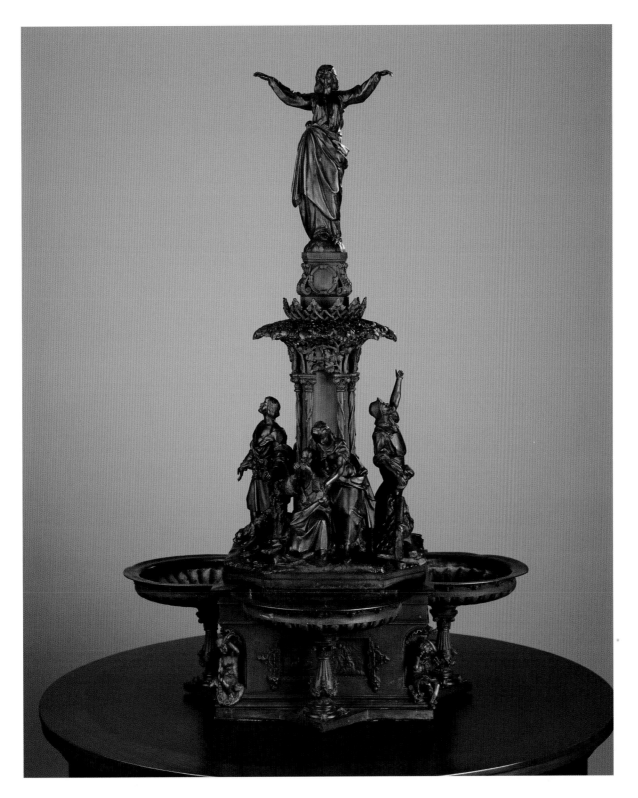

Plate 1

August von Kreling (1819–1876)

Model for the Tyler Davidson Fountain, ca. 1868

Bronze

41 ¼ x 29 ¹⁵/₁₆ x 29 ¹/₁₆ in. (104.8 x 76 x 73.8 cm)

Bequest of Eugene Booth, 1952.198

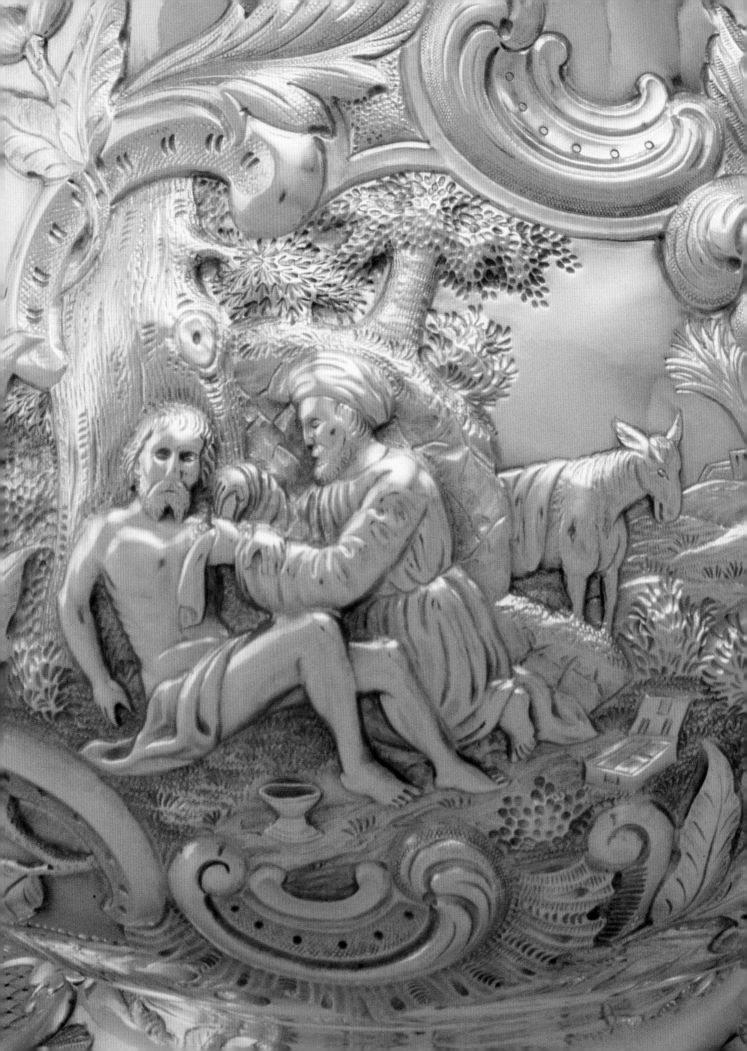

1

The Rise of an Art Center

Cincinnati, 1788–1865

Wealth has engendered a taste for the arts [in Cincinnati], and the inhabitants seem to be peeping out of the transition state, and entering upon one of taste and refinement.

—William A. Adams to Thomas Cole, 1842

Cincinnati had its origins in Fort Washington, a military outpost established in 1788 on the western frontier to protect settlers from the Native American inhabitants. It remained a straggling collection of log cabins and frame houses along the riverbank until 1795, when the Treaty of Greenville resolved problems with the Indians and secured tranquility for the region. By 1800 the population was 750; by 1810 it was 2,320; by 1820 it was just short of 10,000. During this period, immigrants came from New Jersey, then New England and Virginia. These newcomers brought their good taste, their work ethic, and above all, their ambition. Patronage for the arts resulting from wealth and industry began almost immediately. For example, a tall-case clock in the Federal style, with clockworks by Samuel Best (pl. 2), was made about 1810–15, thus demonstrating a taste for high style and a need for accurate time-keeping very early in Cincinnati history. The Best family was the first family of silver-smiths in the city. Objects that family members created, such as spoons, beakers, bowls, and even spectacles, point to an early sophistication in luxury goods. High-style furniture, portraits, silver objects, and precision timepieces reflect both the patterns of patronage and the development of a new urban culture that were creating a demand for such items.

During the second quarter of the century, Cincinnati's collective identity developed from a frontier outpost to the "Queen of the West," as Henry Wadsworth Longfellow later dubbed the city. It was the most sophisticated municipality in the rugged frontier. Industry grew quickly. As early as 1805 furniture producers could boast of fifteen join-ers and cabinetmakers. Timber was plentiful and of excellent quality. Hardwoods such as oak, hickory, cherry, walnut, and pecan, and most softwoods (with the exception of pine) grew in abundance. As the population grew, so did the need for furniture. Cabinet pieces, such as the aforementioned clock, the James Reed chest of drawers (pl. 5), and the William Hawkins bookcase (pl. 7), exemplify the desires and sophistication of the time. In 1841, when the population was more than 47,000 and buildings numbered more than 7,000, there were forty-eight furniture factories, eight bedstead factories, eleven

Fig. 2. Ehrgott & Forbriger lithographers, *Cincinnati. From Charles Cist,* Sketches and Statistics of Cincinnati in 1859 *(Cincinnati: n.p., 1859), frontispiece.*

chair makers, and one desk maker, in all employing 533 people producing a product value of $696,800 for the year, more than $11.5 million in today's market. In 1845 the application of steam power to furniture making spurred unprecedented growth in the industry. In 1836 Robert Mitchell established a furniture factory with Robert Moore, and then in 1846, with Frederick Rammelsburg. The firm of Mitchell & Rammelsburg became one of the largest in the country. At its height it employed almost one thousand people, stocked every description of furniture, and specialized in the finer, more artistic grades such as the secretary-bookcase (pl. 22). At midcentury Cincinnati was exporting many kinds of goods far beyond its boundaries. By the Civil War Cincinnati was manufacturing half of all furniture sold in the South. By 1870 no city of equal size in the United States produced more furniture.

By midcentury the population exceeded 115,000, producing increased wealth and taste for luxury goods. The taste for silver plate, seen early in Cincinnati, continued to grow. The quality of the silver was superb and numerous styles abounded. For example, simplicity can be seen in William McGrew's tea and coffee service (pl. 24); whereas the

complexities of the Rococo Revival can be seen in E. & D. Kinsey's "Good Samaritan" pitcher (pl. 9) with a Bible lesson embossed on its side. The rise of industrialization was driving consumption, and the product that distinguished prosperity was silver. It was used and displayed openly on sideboards in homes as a mark of success. By the Civil War Cincinnati was the chief supplier of silver products in the Midwest.

Motivated by the desire to compete commercially with eastern cities, the citizens of early Cincinnati believed that the development of the fine arts was imperative to provide a civilizing influence and moral backbone for society. The first works of art were primarily commemorative: portraits of famous men such as Lafayette (pl. 6), sculpted by Frederick Eckstein during the Frenchman's 1825 visit; and portraits of city residents such as educator Thomas Matthews (pl. 4), painted by Aaron Haughton Corwine. Because Cincinnati initially provided little training for artists, a group of men who recognized the need for first-rate education in order for the fine arts to take root in the city subsidized Corwine's study in Philadelphia. As the city grew, it offered a number of ephemeral academies, and a growing colony of artists provided apprenticeships. Thus, the young Hiram Powers, America's most celebrated sculptor of the mid-nineteenth century, enjoyed his first instruction in Eckstein's studio.

By the 1830s, painters and sculptors from a broad region were flocking to Cincinnati to train and take advantage of the burgeoning market. During this decade and the one that followed, nationalism and prosperity brought about widespread changes in American painting. Pictures of everyday life in America and of the American landscape rose in popularity, and Cincinnati artists took a prominent role in the development of these art forms. American identity was wedded to the concept of the wilderness as the new Eden, and to associations of the land with national progress and destiny. This philosophy elevated the stature of the West, and placed Cincinnati in the advantageous position of offering urban amenities in proximity to all the wild beauty the artist could desire. The city became known as the home of the so-called Western School of Landscape Painting, and its finest representatives included Worthington Whittredge (pl. 20), William Louis Sonntag (pl. 21), and Robert S. Duncanson (pl. 11).

Although some artists complained of a lack of support for the fine arts in the Queen City, many in fact thrived under the patronage of its affluent citizens. The most

Fig. 3. Robert S. Duncanson, *Portrait of Nicholas Longworth*, 1858, oil on canvas, 84 x 60¼ in. (213.4 x 153 cm). © *University of Cincinnati Fine Arts Collection*

7

celebrated benefactor was Nicholas Longworth (pl. 10), an eccentric lawyer who, through real estate investment, became one of the wealthiest men in the United States. Retiring from law, he indulged his enthusiasm for horticulture and established a vineyard to great success. He supported artists most often by funding their travel to the East Coast and Europe, which they required to compete nationally. Among his greatest beneficiaries were Powers, who made *Eve Disconsolate* (pl. 13) as a tribute to him, and Duncanson, who painted murals in his home. Longworth's patronage was remarkably blind to race and gender. His encouragement and support enabled African American Duncanson and Lilly Martin Spencer (pl. 14) to rise to preeminence in their fields. Another patron of note was Reuben Springer (pl. 18). Like Longworth, Springer was a self-made man whose wealth was tied to the industrial growth of Cincinnati. His money came from wholesale merchandizing and the transporting of goods by river from Cincinnati to the South. Among the artists Springer favored was Whittredge, whose study in Germany he supported by paying in advance for *The Mill* (pl. 20). Springer assisted the Archdiocese of Cincinnati in its own efforts at patronage with the commission of two marble angels by Italian sculptor Odoardo Fantacchiotti (pls. 16, 17) for the Cathedral of Saint Peter in Chains. Springer supported not only the visual arts, but music as well. In 1878, at the inaugural performance at Music Hall, he was awarded a vase and dedication medallion made by Tiffany & Co. (pl. 19) for his role in the promotion and financing of the new concert hall.

The growth of the middle class in the mid-nineteenth century created a new breed of patron that expanded support for art in Cincinnati. To capitalize on the robust new market, the Western Art Union was founded in 1847. The Art Union promoted art and artists by distributing engravings after their works to a far-flung membership and then selling the originals by lottery. Powers, Duncanson, Sonntag, Spencer, and James Henry Beard (pl. 8) were among the local artists whose works were popularized by the Union. Although financial misdeeds spelled the demise of the Art Union in 1851, the market it fostered was manifest in the establishment of commercial art galleries in downtown Cincinnati, including Wiswell's in 1851 and Baldwin's in 1854.

The growing enthusiasm for painting and sculpture, as well as the decorative arts, encouraged the pursuit of artistic careers. In 1853 Sarah Worthington King Peter

founded the Ladies Academy of Fine Arts to enhance the city's cultural life and provide women with art education from female instructors. Peter's academy staged annual exhibitions and housed a gallery of copies after Old Master paintings. She believed that education in good design was a key to Cincinnati's eminence in manufacturing, and sought to advance women's participation in the city's economic fortunes. Peter's academy and the Western Art Union are but two of the most important among the organizations that proliferated in Cincinnati during the dynamic period when the city experienced its greatest growth. With the onset of the Civil War, cultural activities virtually came to a standstill, and this era drew to a close.

AJE/JA

following page

Plate 2

Samuel Best (1776–1859)

Tall-Case Clock, 1810–15

Mahogany, cherry, inlays of burled maple and flame grained
mahogany, poplar, white pine, glass, and brass
104⅝ x 19¾ x 11⅛ in. (265 x 50.2 x 28.2 cm)
Museum Purchase, 1966.1175

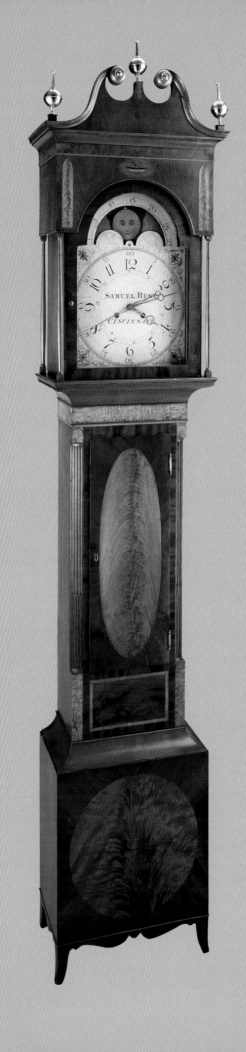

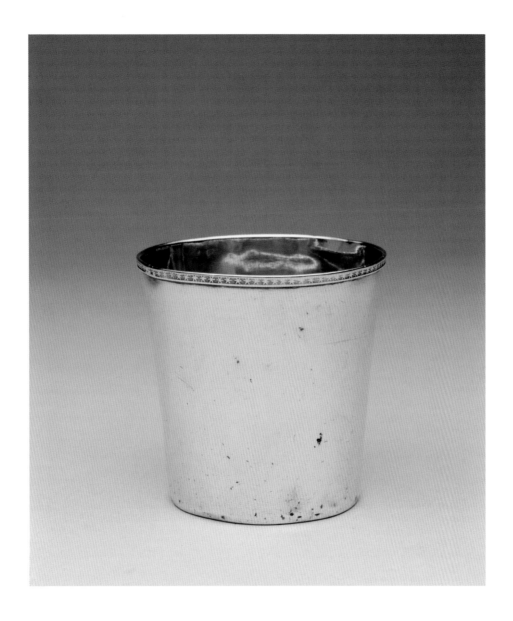

Plate 3

R. Best & Company (1815–1817), manufacturer

Beaker, 1815–17

Silver

H. 3 ⅛ in., diam. 3 in. (h. 7.9 cm, diam. 7.6 cm)

Museum Purchase: Gift of Harry G. Friedman, by exchange, 2001.2

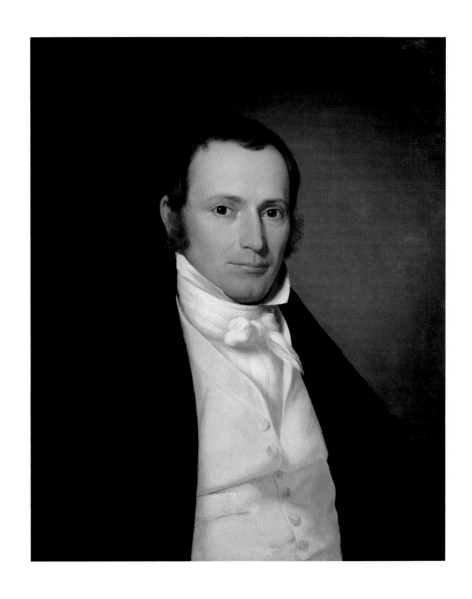

Plate 4

Aaron Haughton Corwine (1802–1830)

Portrait of Thomas Johnson Matthews, ca. 1820–23

Oil on canvas

27 3/16 x 22 11/16 in. (69 x 57.6 cm)

Bequest of Elizabeth Matthews, 1965.268

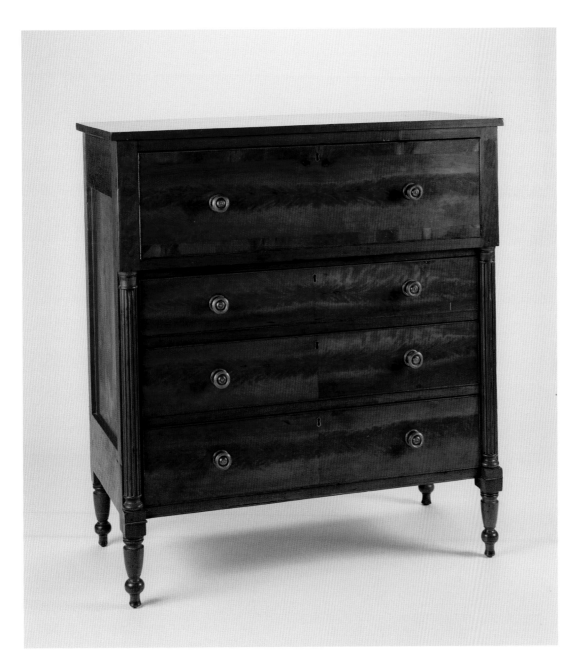

Plate 5

James Reed (dates unknown)

Chest of Drawers, 1822

Cherry, veneers of mahogany and crotch mahogany, pine, and brass

46 x 42 ½ x 22 in. (116.8 x 108 x 55.9 cm)

Museum Purchase: Charles Matthew Williams Fund, 2000.163 a–e

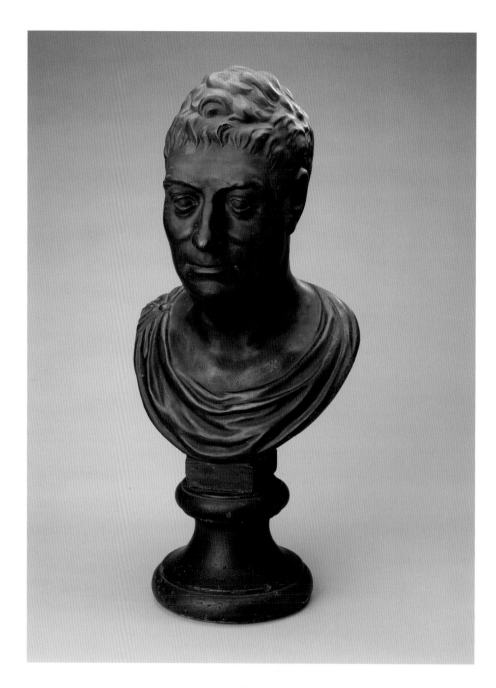

Plate 6
Frederick Eckstein (ca. 1774–1852)
Marquis de Lafayette, 1825
Plaster
22 ⅝ x 13 ³⁄₁₆ x 9 ¹³⁄₁₆ in. (57.4 x 33.5 x 24.9 cm)
The Edwin and Virginia Irwin Memorial, 1957.150

14

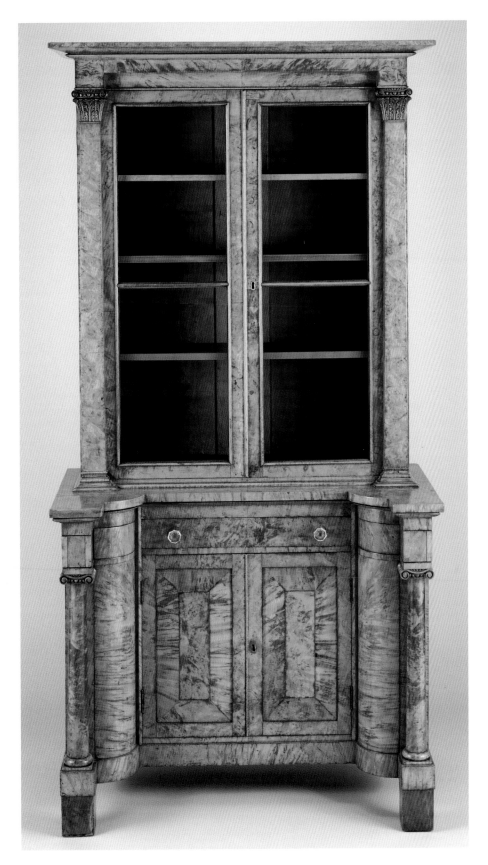

Plate 7

William Hawkins (1807–1839)

Bookcase, 1830s

Tiger maple veneer, cherry, poplar, and glass

75 x 38 x 21 in. (190.5 x 96.5 x 53.3 cm)

Bequest of Rose Marion Verhage, 1968.460

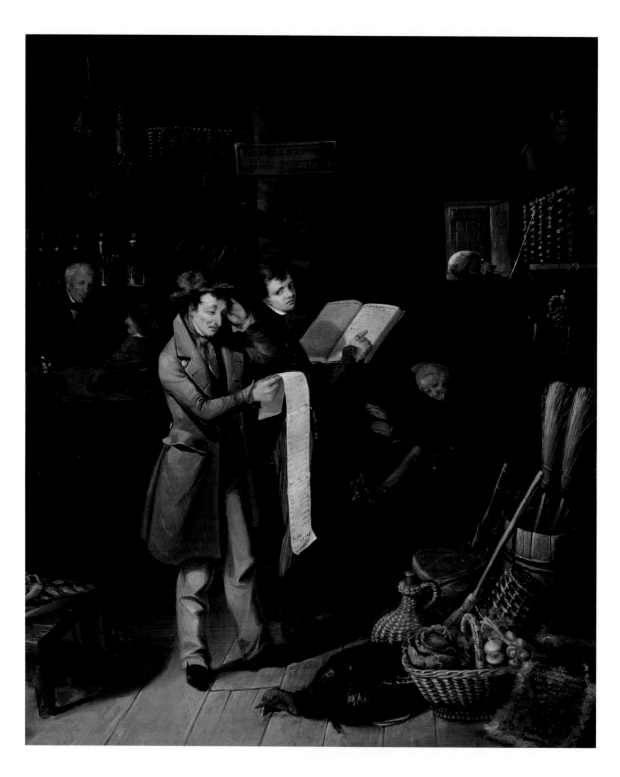

Plate 8

James Henry Beard (1811–1893)

The Long Bill, 1840

Oil on canvas

30 ⅜ x 24 ⅞ in. (77.2 x 63.2 cm)

Gift of Mrs. T. E. Houston, 1924.186

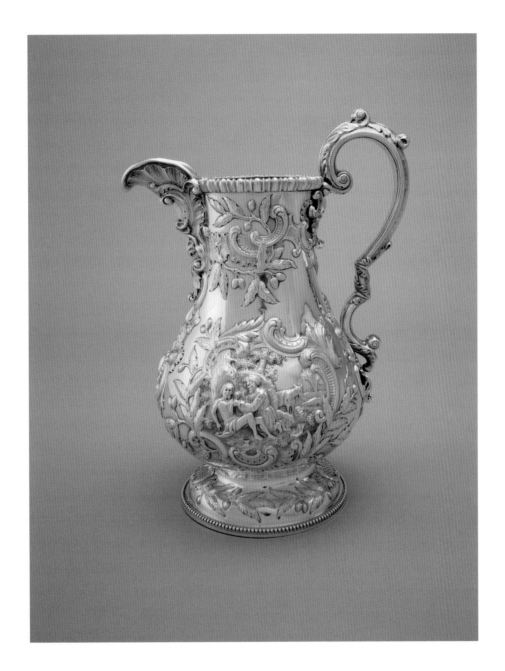

Plate 9

E. & D. Kinsey (1844–1861)

"Good Samaritan" Pitcher, 1844–61

Silver

11 ¹³⁄₁₆ x 9 x 6 ¼ in. (30 x 23 x 16 cm)

Museum Purchase: Decorative Arts Deaccession Funds, 2000.158

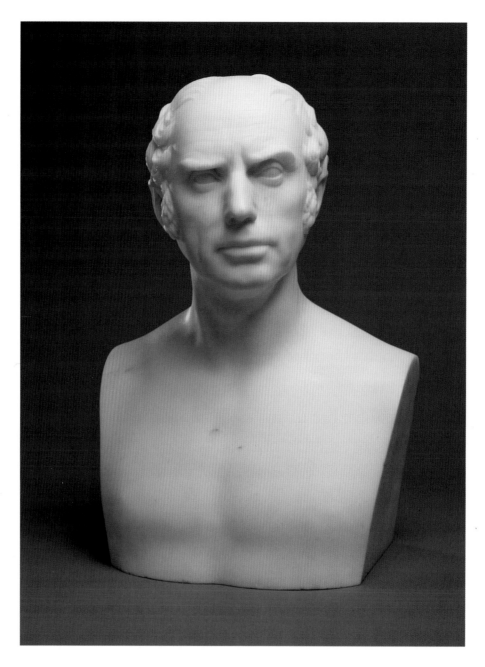

Plate 10
Hiram Powers (1805–1873)
Portrait of Nicholas Longworth, designed 1837, carved 1850
Marble
19 11/16 x 13 1/2 x 8 9/16 in. (50 x 34.3 x 21.7 cm)
Gift of Alice Roosevelt Longworth and Paulina Longworth Sturm, 1954.112

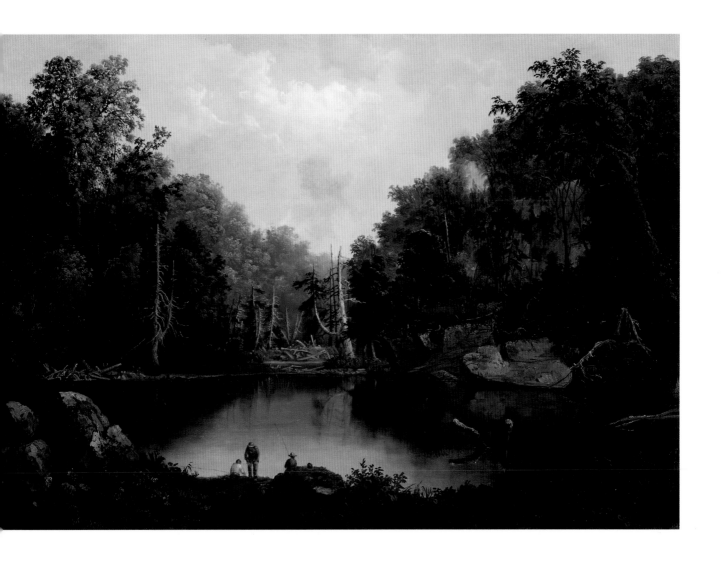

Plate 11

Robert S. Duncanson (1821–1872)

Blue Hole, Little Miami River, 1851

Oil on canvas

28 ½ x 41 ½ in. (72.4 x 105.4 cm)

Gift of Norbert Heermann and Arthur Helbig, 1926.18

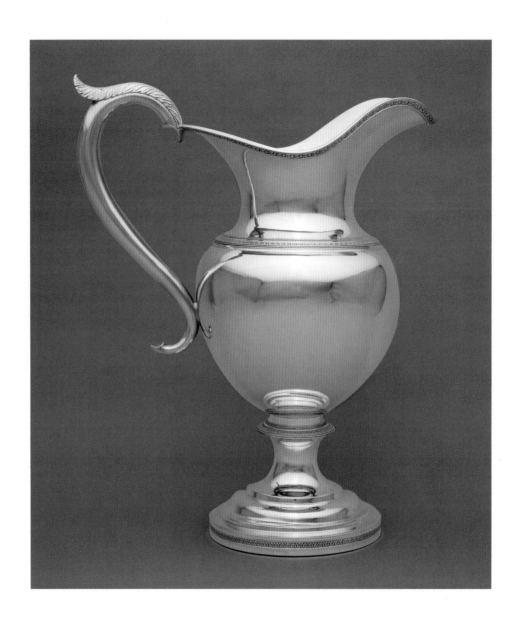

Plate 12
Edward Kinsey (1810–1865)
Pitcher, mid-19th century
Silver
13 ¾ x 11 ¼ x 6 ¼ in. (34.9 x 28.6 x 15.9 cm)
Museum Purchase, 1907.194

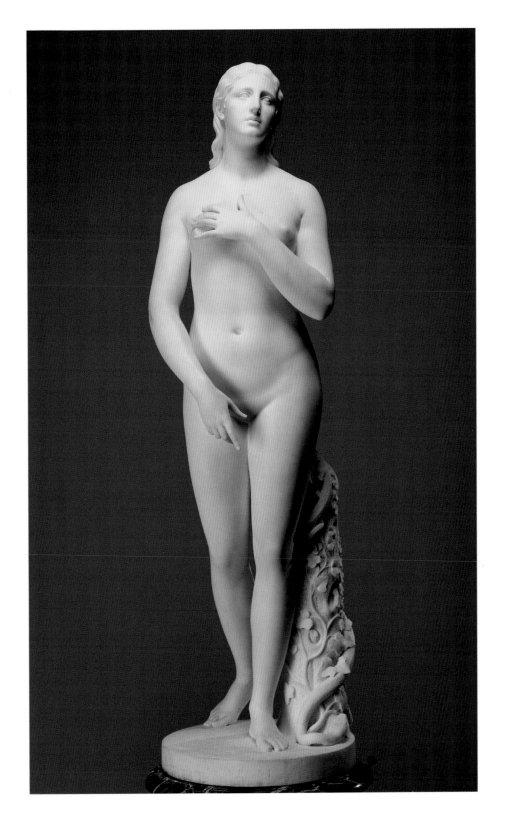

Plate 13

Hiram Powers (1805–1873)

Eve Disconsolate, designed 1859–61, carved 1873–74

Marble

H. 76 3/16 in., diam. of base 22 1/6 in. (h. 193.5, diam. 56 cm)

Gift of Nicholas Longworth, 1888.86

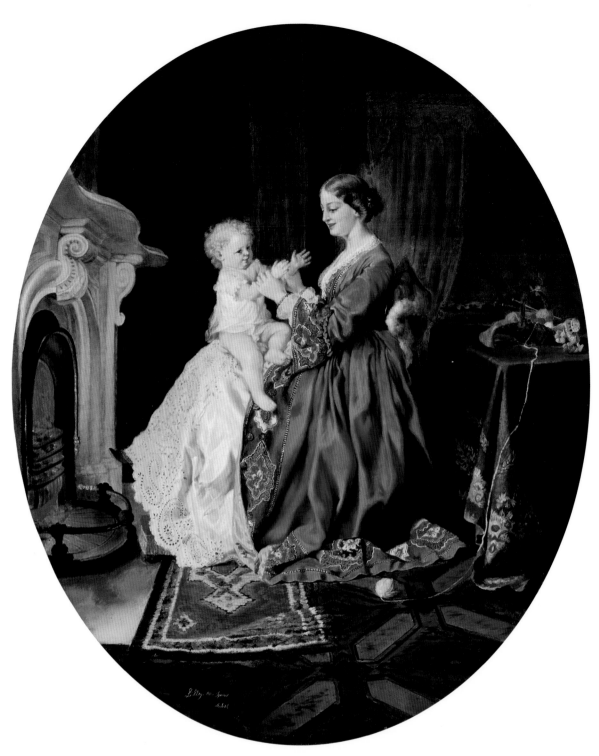

Plate 14

Lilly Martin Spencer (1822–1902)

Patty-cake, ca. 1855–58

Oil on canvas

24 x 20 in. (61 x 50.8 cm)

Museum Purchase: Bequest of
Mr. and Mrs. Walter J. Wichgar, 1999.214

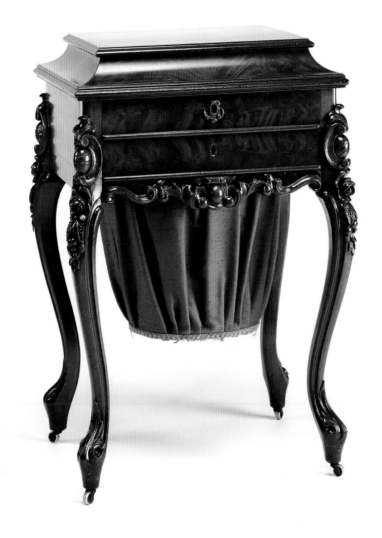

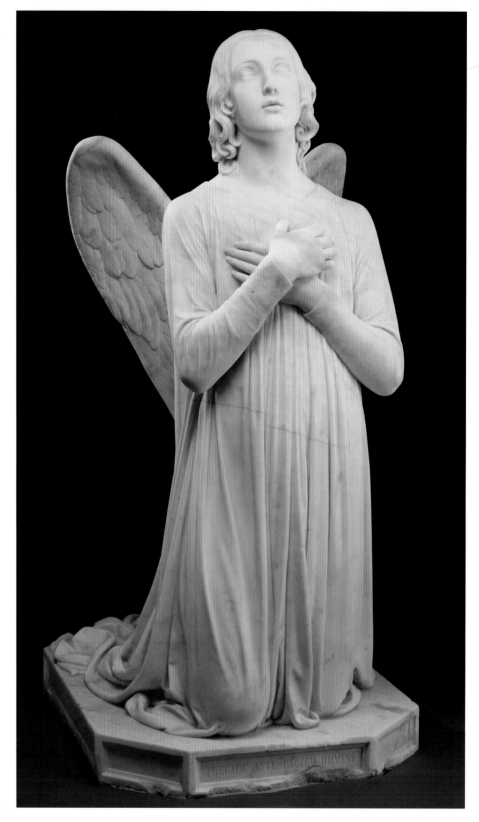

Plate 16

Odoardo Fantacchiotti (1809–1877)

Praying Angel, 1848

Marble (Carrara)

54 ½ x 26 x 35 in. (138.4 x 66 x 88.9 cm)

*Gift of the Archbishop of Cincinnati, from the Churches of St. Peter in Chains Cathedral
and St. Theresa of Avila Catholic Church, Price Hill, 1998.59*

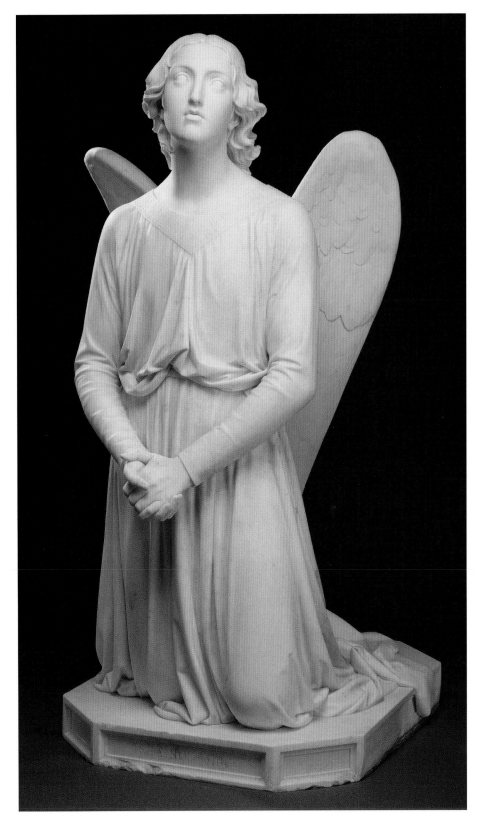

Plate 17

Odoardo Fantacchiotti (1809–1877)

Adoring Angel, 1849

Marble (Carrara)

54 x 25 x 35 in. (137.2 x 63.5 x 88.9 cm)

Gift of the Archbishop of Cincinnati, from the Churches of St. Peter in Chains Cathedral
and St. Theresa of Avila Catholic Church, Price Hill, 1998.60

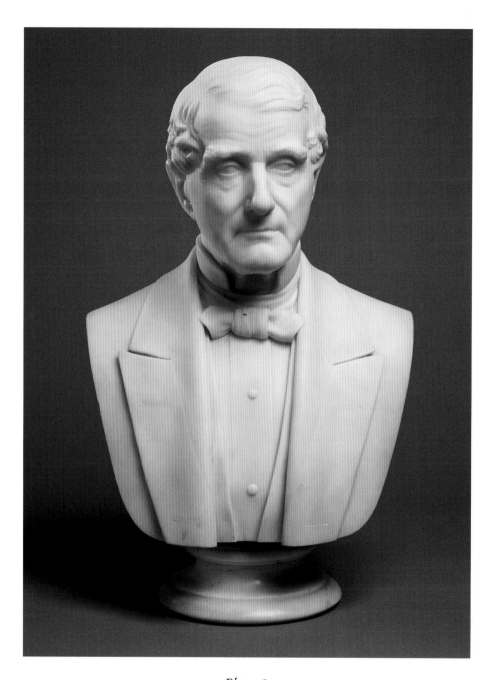

Plate 18
Preston Powers (1843–1927)
Portrait of Reuben Springer, 1880
Marble
25 x 16½ x 13⅜ in. (63.5 x 41.9 x 34 cm)
Gift of the Artist, 1983.306

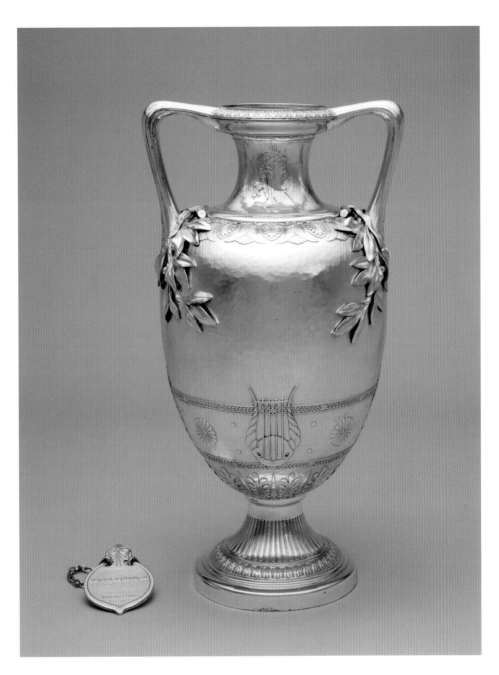

Plate 19

Tiffany & Co. (1853–)

Vase and Dedication Medallion, 1877

Silver

17 ¼ x 9 ½ x 8 ½ in. (43.8 x 24.1 x 21.6 cm)

Bequest of Reuben R. Springer, 1884.483

Plate 20
Thomas Worthington Whittredge (1820–1910)
The Mill, 1852
Oil on canvas
34⅜ x 51⁷⁄₁₆ in. (87.3 x 130.7 cm)
Bequest of Reuben R. Springer, 1884.354

Plate 22

Mitchell & Rammelsberg Furniture Company (1847–1881)

Secretary-Bookcase, 1860s

Mahogany, poplar, brass, and glass

101 x 47 x 25 in. (256.5 x 119.4 x 63.5 cm)

Museum Purchase: On to the Second Century Endowment, 2001.14

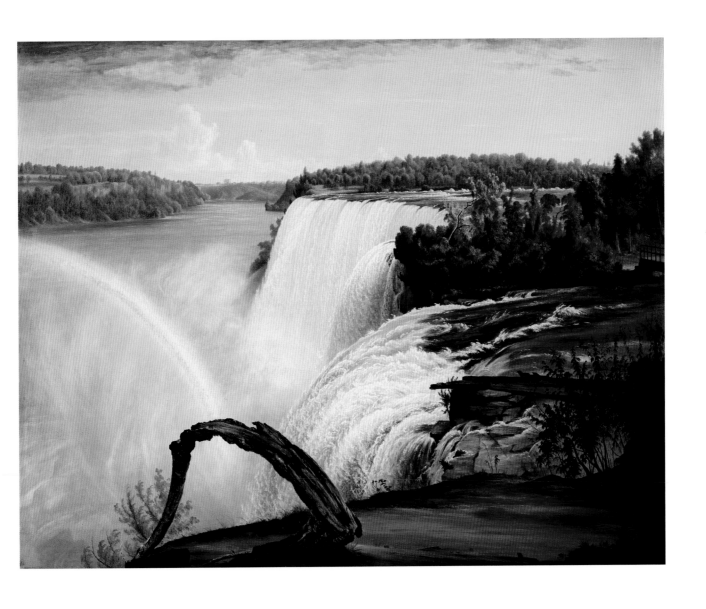

Plate 23
Godfrey Nicholas Frankenstein (1820–1873)
American Falls of Niagara from Goat Island, 1871
Oil on canvas
35 ⅛ x 44 ⁹⁄₁₆ in. (89.2 x 113.2 cm)
Gift of Mrs. William Henry Falls, 1920.160

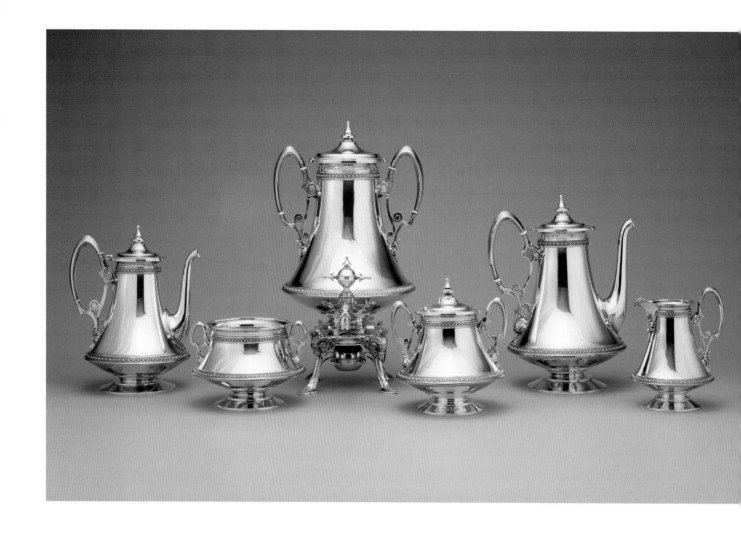

Plate 24

William Wilson McGrew (1832–1892)

Six-Piece Tea and Coffee Service, ca. 1856–75

Silver

Coffeepot: 10½ x 8⅜ x 6⅜ in. (26.7 x 21.3 x 16.2 cm)

Teapot: 9 x 7½ x 6 in. (22.9 x 19.1 x 15.2 cm)

Hot Water Urn: 14 x 7½ x 11¼ in. (35.6 x 19 x 28.6 cm)

Creamer: 5¹³⁄₁₆ x 4⅞ x 4⅛ in. (14.8 x 12.4 x 10.5 cm)

Sugar Bowl: 6½ x 5¾ x 5½ in. (15.9 x 14.6 x 14 cm)

Waste Bowl: 4³⁄₁₆ x 6 x 5¹³⁄₁₆ in. (10.6 x 15.2 cm)

Museum Purchase: Decorative Arts Deaccession Funds, 2000.161 a–f

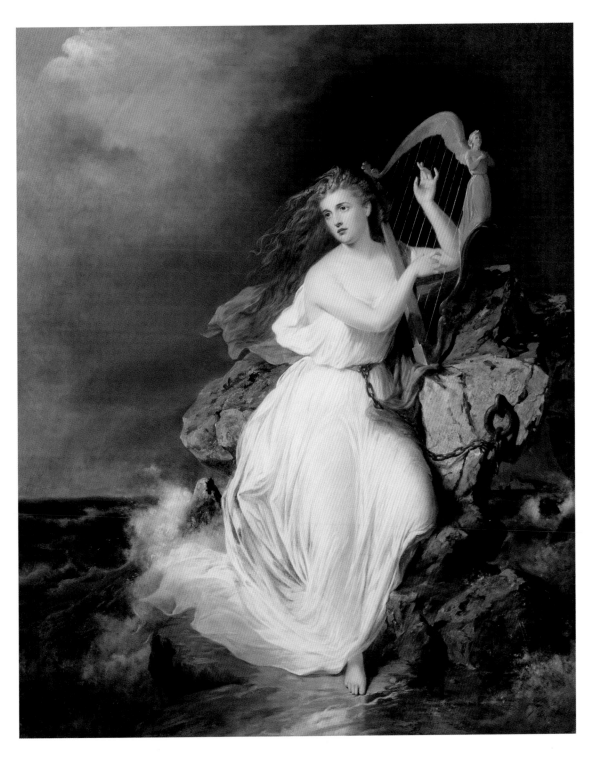

Plate 25
Thomas Buchanan Read (1822–1872)
The Harp of Erin, 1867
Oil on canvas
42 1/16 x 34 3/8 in. (106.8 x 87.3 cm)
Gift of Mrs. Michael M. Shoemaker, 1934.44

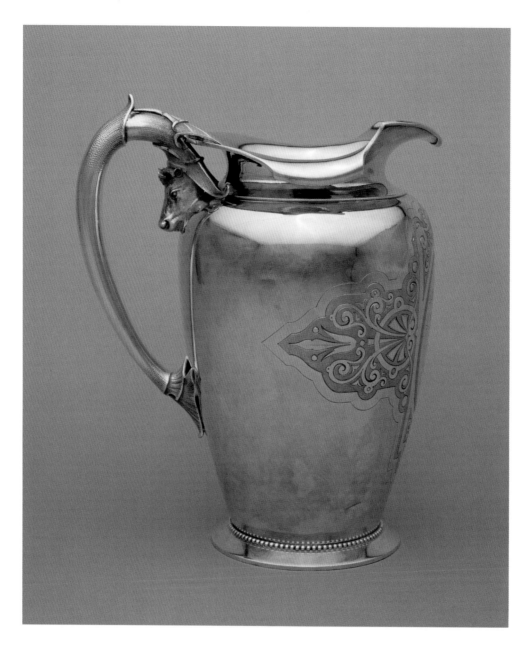

Plate 26

William Wilson McGrew (1832–1892)

Pitcher, ca. 1856–75

Silver

10⅝ x 8⅞ x 6 in. (27 x 22.5 x 15.2 cm)

Museum Purchase: Decorative Arts Deaccession Funds, 2000.160

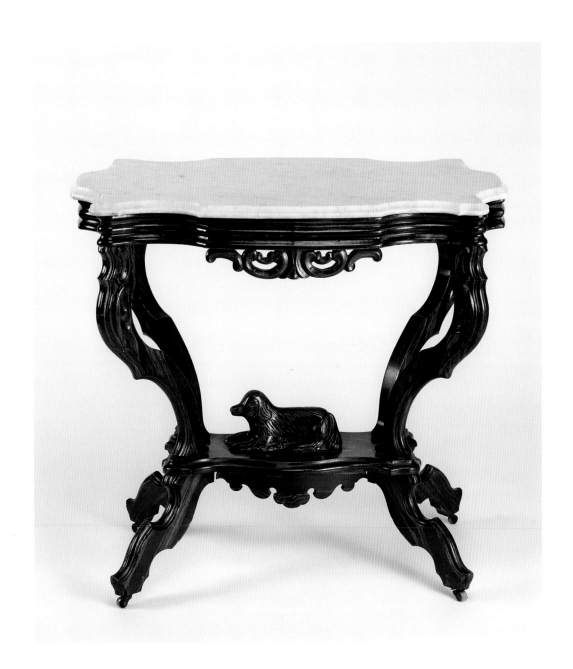

Plate 27
Attributed to H. N. Wenning & Company (1869–1873)
Table, ca. 1869
Walnut and marble
Table: 28¼ x 32½ x 18½ in. (71.8 x 82.6 x 47 cm)
Museum Purchase: Dwight J. Thomson Endowment, 2000.8 a,b

35

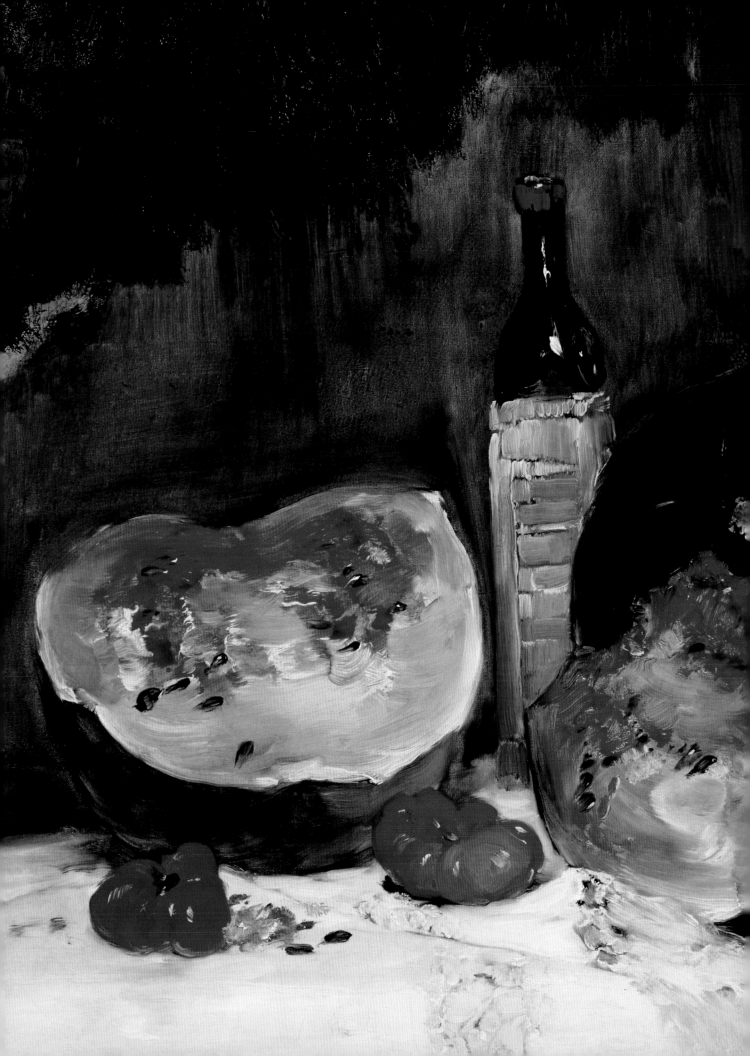

<div style="text-align: center;">

2

A Remarkable Reality and Directness

Frank Duveneck (1848–1919)

The good people of Boston have recently been flattering them-
selves that they have discovered an American Velasquez.

—Henry James, 1875

</div>

No artist is more closely associated with Cincinnati than Frank Duveneck. Indeed, although Duveneck died in 1919, his presence in Cincinnati remains strangely palpable. Why is this painter so thoroughly imbedded in the city's cultural identity? What is it about Duveneck that so endears him to Cincinnatians more than eighty years after his death? The endurance of Duveneck's memory springs from multiple facets of his story. Americans love a rebel and Duveneck fit the bill. The child of working-class German immigrants, he took on the stodgy American art world with a rugged, masculine art that confronted dark subjects with a confident brush and unflinching eye. After the tragic loss of his wife while living in Europe—a story with dramatic appeal—Duveneck chose to return to the Cincinnati area, in lieu of the eastern cities his colleagues preferred. As a charismatic teacher he inspired several generations of grateful art students. It is above all the abiding affection of his many protégés, passed down through generations, which has kept the flame alive. There is, however, another dimension to the Duveneck legacy. In the aftermath of World War I, Cincinnatians tried to suppress the city's Germanic character. However, with the renewed celebration in recent years of the city's German traditions, Duveneck has become the most enduring symbol of that heritage.

Frank Duveneck was born in 1848 in Covington, Kentucky, a town just across the Ohio River from Cincinnati. His parents, Bernard and Catherine Siemers Decker, were Westphalian peasants who left oppressive conditions in their homeland and moved to Cincinnati, drawn by its flourishing German community and institutions. (By 1851 German immigrants comprised 28 percent of Cincinnati's population and supported numerous German-language newspapers.) When Decker died shortly after the birth of his son, Frank's mother married Joseph Duveneck, also from Germany. A successful grocer, Joseph Duveneck established an ale-bottling concern and ran a German beer garden beside their home on Greenup Street. Growing up among German natives, Frank spoke their language and was immersed in Cincinnati's cauldron of Old and New World cultures.

Duveneck's mother fostered his early enthusiasm for drawing. Before marriage she had served in the household of portrait and genre painter James Henry Beard (pl. 8). A devout woman, she hoped her son would aspire to a somewhat higher calling as an artist for the Catholic Church. At first, Duveneck complied, serving as an apprentice with Johann Schmidt and Wilhelm Lamprecht, painters in the city's German Catholic churches. When Frank's parents agreed to send him to Europe for further education, it was to refine his talents as an ecclesiastical painter. However, soon after his arrival in Munich in 1869, he developed other ideas.

Duveneck's choice of Munich for his education undoubtedly stemmed from the city's Catholicism and his familiarity with German language and culture. Although American painters had been studying in Germany throughout the nineteenth century, the earlier generation had preferred Dusseldorf, which promoted a style noted for tightly controlled brushwork, refined surfaces, and sentimental subject matter. This so-called Dusseldorf style dominated American painting of the mid-nineteenth century (pl. 14). Duveneck's arrival in Munich, however, coincided with the rise of a new kind of painting there that differed in every way. It favored realistic portrayals of unseemly characters with a rich, dark palette and paint-laden technique that referenced the Baroque masters of the seventeenth century, particularly Franz Hals and Diego Velasquez. Away from his family's regard, the young artist from Ohio immediately fell in with the most progressive painters in Germany and produced work recognized both in Europe and America as fresh and exhilarating. Among these efforts was his early masterpiece *The Whistling Boy* (pl. 29), painted in 1872 when he was twenty-four years old. With its working-class subject and direct, vigorous paint handling, *The Whistling Boy* became a symbol of artistic rebellion. These thrilling early paintings initially met a cool reception in Cincinnati, but captivated Boston artists and critics when exhibited there in 1875. Writer Henry James proclaimed Duveneck "an unsuspected man of genius" whose paintings' "great quality . . . is their extreme naturalness, their unmixed, unredeemed reality."[1]

Duveneck's relationship with painter Elizabeth (Lizzie) Boott began with his Boston debut. She so admired his paintings that she purchased one. The only child of Francis Boott, a widowed amateur composer and musician from a wealthy Boston family, Lizzie

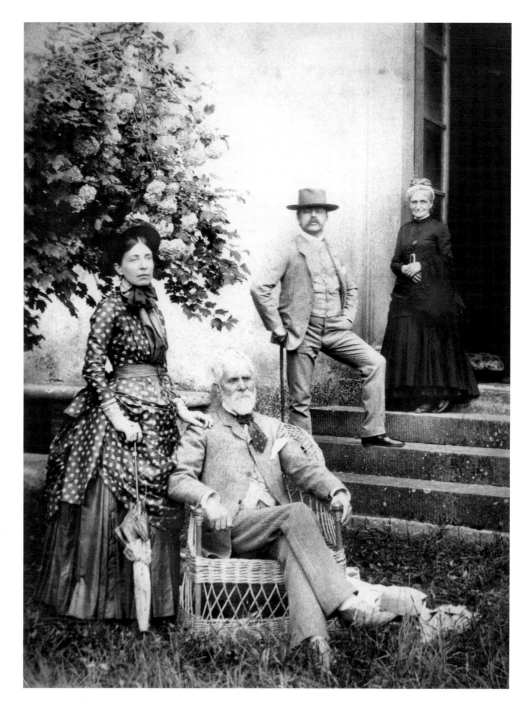

Fig. 4. From left to right: Elizabeth Boott, Francis Boott, Frank Duveneck, and housekeeper Anne Shemstone at Bellosguardo, Italy, 1880. *Frank and Elizabeth Boott Duveneck papers 1851–1972, Archives of American Art, Smithsonian Institution*

grew up in an intellectual environment—Henry James was among her dearest friends —and studied painting in Boston with William Morris Hunt, and in Paris with Thomas Couture (for her painting, see pl. 36). In 1879, because she wished to study with Duveneck, she sought him out in Polling, Germany (pl. 32), where he was leading his raucous group of students known as "The Duveneck Boys." She lured him to the Villa Castellani outside Florence (pl. 37), where she and her father had taken up residence, and encouraged him to establish a school there. A prolonged courtship ensued, made arduous by the objections of Lizzie's father and closest companion, who implicitly wished her to marry James. Duveneck, the Midwesterner with the working-class up-bringing, did not fit in with Boott's witty, erudite circle, although they noted the painter's affable character. Nevertheless, Lizzie's deep love for Duveneck eventually won. She and the painter were married in 1886, and the following year she gave birth to a son. Soon, however, their happiness was tragically cut short. In 1888, after a trip to Paris during which Frank painted his wife's austerely beautiful portrait (pl. 38), she died suddenly of pneumonia. His profound love and deep grief found expression not in a painting, but in a sculpture for her grave made with the assistance of Cincinnati sculptor Clement J. Barnhorn. The bronze memorial, based on Renaissance tomb sculptures, graces Allori Cemetery in Florence and ranks among the finest works of American sculpture. Duveneck later donated a plaster version (pl. 39) to the Cincinnati Art Museum, and a marble made for Francis Boott is at the Museum of Fine Arts, Boston.

In 1890 Duveneck accepted the invitation of mover-and-shaker Maria Longworth Nichols Storer, founder of The Rookwood Pottery Company, to teach painting at the Cincinnati Art Museum. This would not be the artist's first teaching position in the city —he had dazzled a class of young men at the Ohio Mechanics Institute in 1874 between periods of study in Munich. That remarkable class had included John H. Twachtman (pl. 98) and Kenyon Cox (pl. 108), who became leading painters extolling Duveneck's gifts to other young artists. By 1890 Duveneck had largely lost ambition for his paint-ing career but enjoyed a reputation as an inspiring and generous educator. His student Oliver Dennett Grover later claimed that his teacher "had a rare faculty for imparting his knowledge, love of his fellows and an inborn sense of leadership and sympathy."[2] Duveneck accepted a position on the faculty of the Art Academy of Cincinnati in 1900

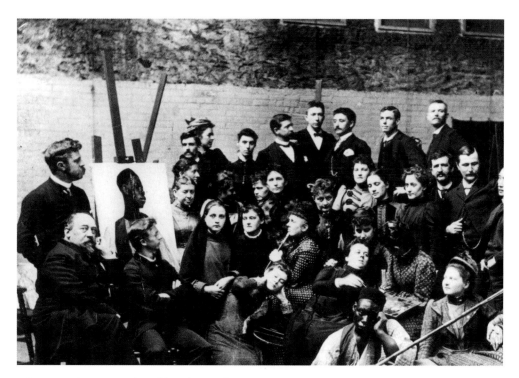

Fig. 5. Frank Duveneck and his class at the Cincinnati Art Museum, 1890–91. *Cincinnati Art Museum Archives*

and became its director in 1905. He continued to teach there until shortly before his death. Many of his students became celebrated painters, including such considerable talents as Robert F. Blum (pl. 102) and Joseph R. DeCamp (pl. 106).

In 1915 Duveneck won a prestigious medal of honor at the Panama-Pacific Exposition in San Francisco, where an entire gallery was devoted to a retrospective of his paintings. Reflecting upon his legacy, the artist decided that year to donate the works of art that remained in his possession to the Cincinnati Art Museum. His donations included a significant body of his own paintings as well as works by his colleagues, such as Twachtman's masterful *Springtime* (pl. 100). With subsequent acquisitions, the museum currently owns 125 oils by Duveneck, more than fifty drawings and watercolors, a complete set of Duveneck's fine etchings, and four rare monotypes. As an advisor to the museum's directors and curators, he also helped in a significant way to shape the collection of American paintings, a lasting legacy indeed.

JA

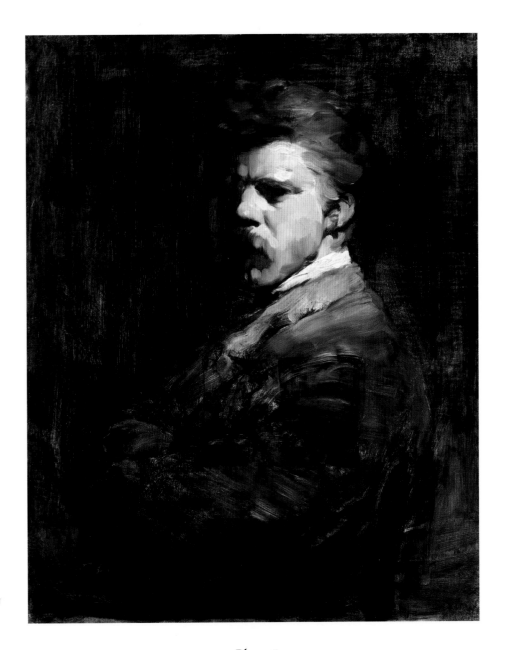

Plate 28
Frank Duveneck (1848–1919)
Self-Portrait, ca. 1877
Oil on canvas
29 ⁵⁄₁₆ x 23 ¹¹⁄₁₆ in. (74.5 x 60.2 cm)
Gift of the Artist, 1915.122

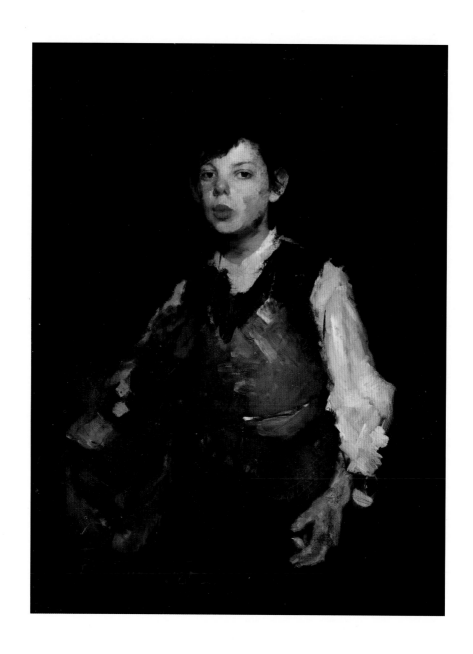

Plate 29
Frank Duveneck (1848–1919)
The Whistling Boy, 1872
Oil on canvas
27 7/8 x 21 1/8 in. (70.8 x 53.7 cm)
Gift of the Artist, 1904.196

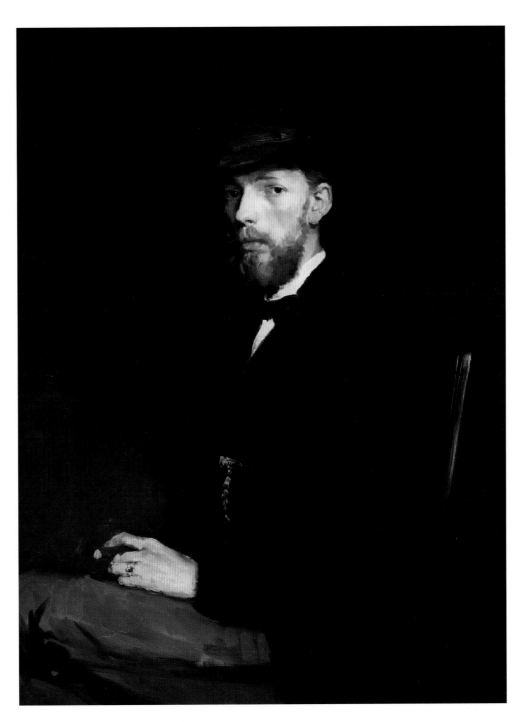

Plate 30
Frank Duveneck (1848–1919)
Portrait of Professor Ludwig Loefftz, ca. 1873
Oil on canvas
37 15/16 x 28 11/16 in. (96.4 x 72.9 cm)
John J. Emery Fund, 1917.8

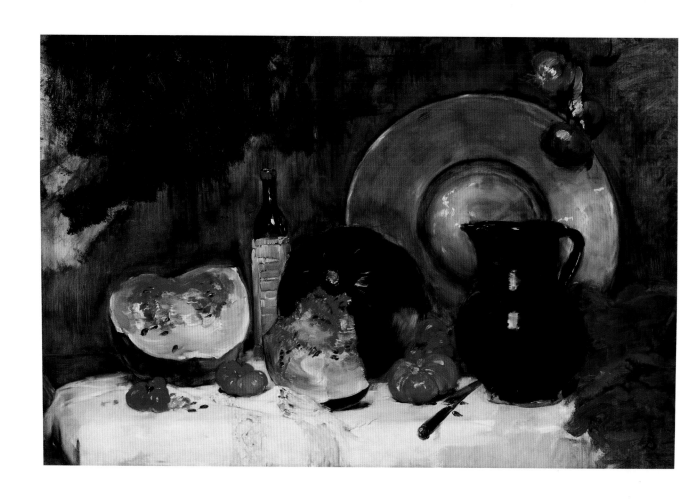

Plate 31
Frank Duveneck (1848–1919)
Still Life with Watermelon, ca. 1878
Oil on canvas
25 1/16 x 38 1/16 in. (63.7 x 96.7 cm)
The Dexter Fund, 1922.109

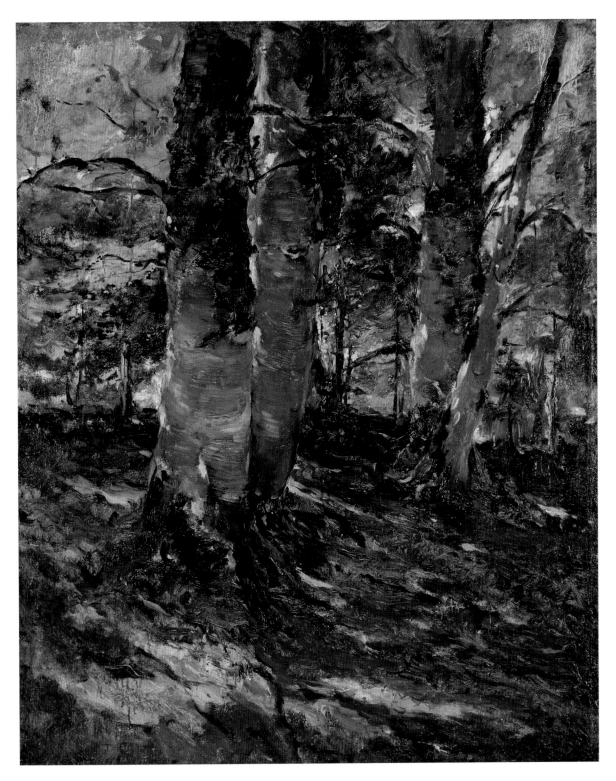

Plate 32
Frank Duveneck (1848–1919)
Beechwoods at Polling, ca. 1876
Oil on canvas
45 ½ x 37 in. (115.6 x 94 cm)
Gift of the Artist, 1915.93

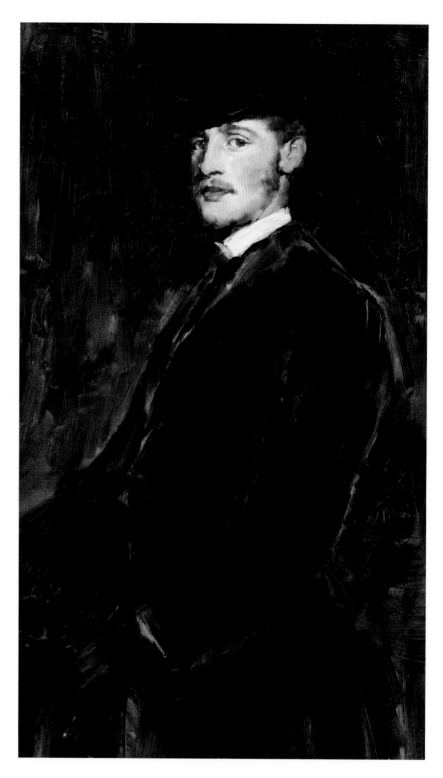

Plate 33
Frank Duveneck (1848–1919)
Portrait of John White Alexander, 1879
Oil on canvas
38 1/16 x 22 1/16 in. (96.7 x 56 cm)
Gift of the Artist, 1908.1216

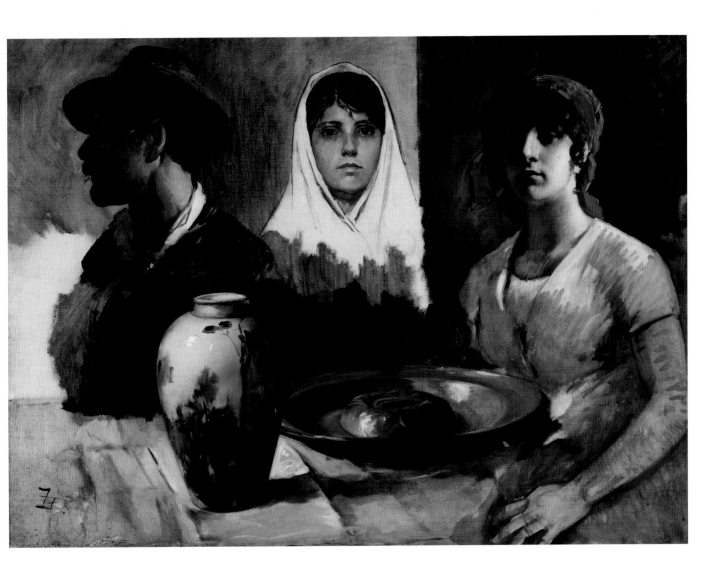

Plate 34
Frank Duveneck (1848–1919)
Study of Three Heads with Salver and Jar, ca. 1879
Oil on canvas
33½ x 44⅞ in. (85.1 x 114 cm)
Gift of the Artist, 1915.77

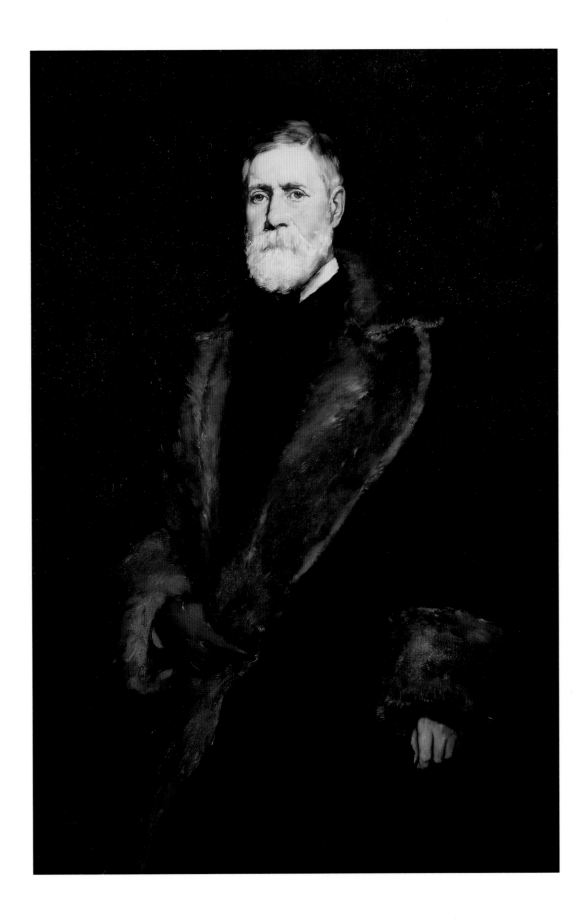

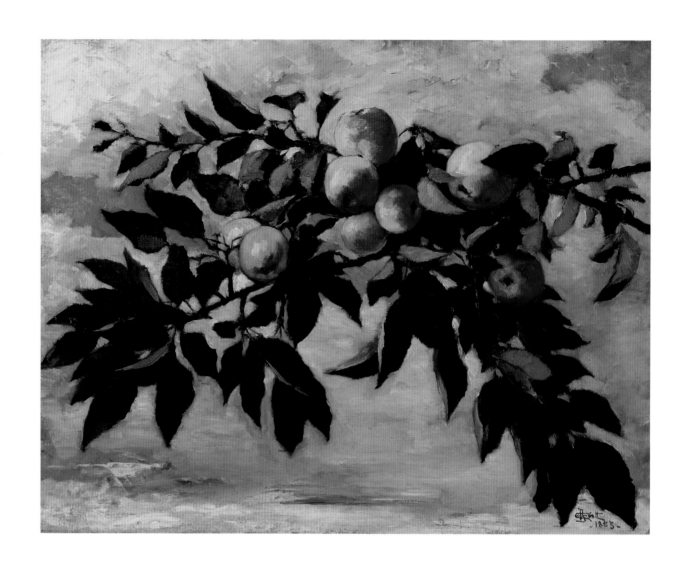

Plate 36
Elizabeth Boott Duveneck (1846–1888)
Apple Tree Branches, 1883
Oil on canvas
26½ x 20⅝ in. (67.3 x 52.5 cm)
Gift of Frank Duveneck, 1915.98:2

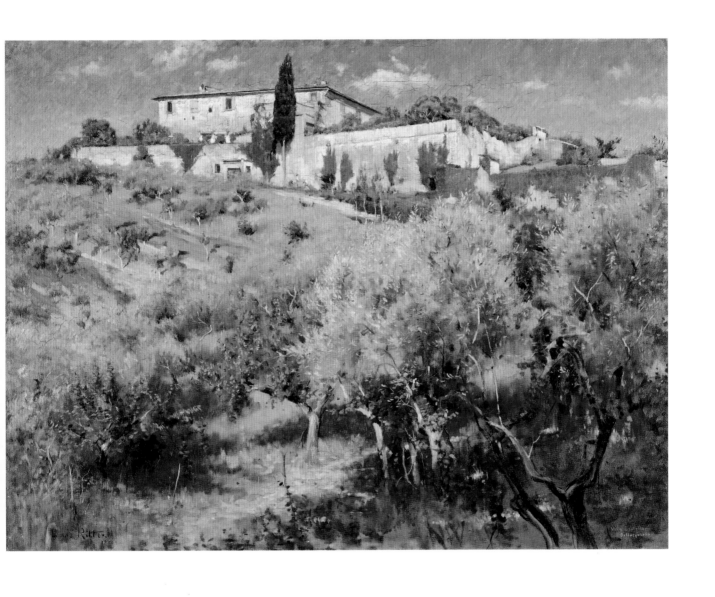

Plate 37

Louis Ritter (1854–1892)

Villa Castellani Near Florence, 1888

Oil on canvas

26⁷⁄₁₆ x 35⁹⁄₁₆ in. (67.2 x 90.3 cm)

Gift of Frank Duveneck, 1915.227

53

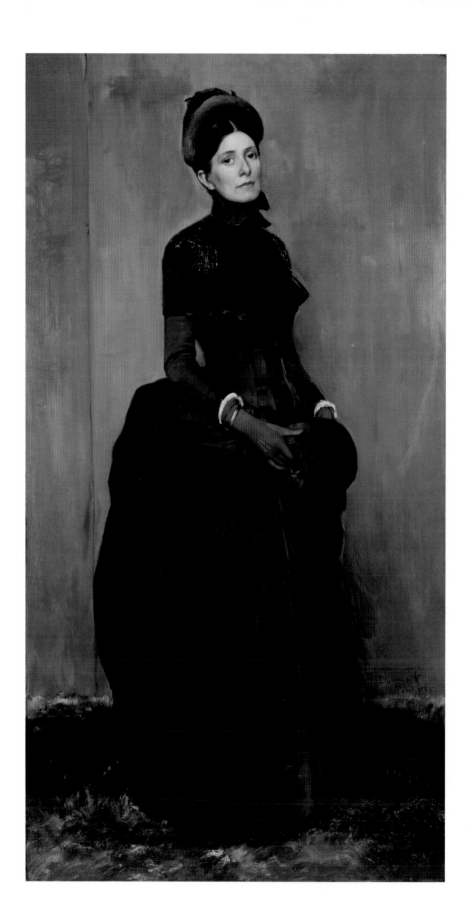

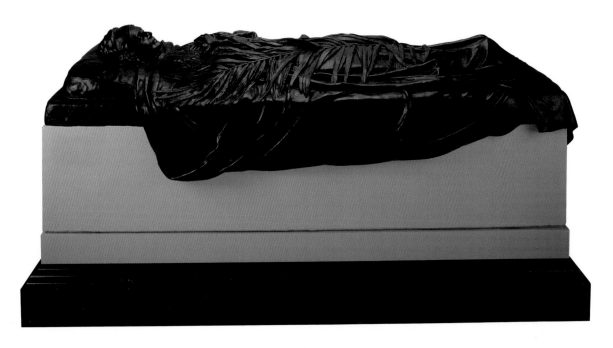

Plate 39
Frank Duveneck (1848–1919) and Clement J. Barnhorn (1857–1935)
Memorial to Elizabeth Boott Duveneck, 1891
Plaster
28 ¾ x 85 ⁹⁄₁₆ x 40 ⁷⁄₁₆ in. (73 x 217.3 x 102.7 cm)
Gift of Frank Duveneck, 1895.146

Plate 38
Frank Duveneck (1848–1919)
Portrait of Elizabeth Boott Duveneck, 1888
Oil on canvas
65 ⅛ x 34 ¾ in. (165.4 x 88.3 cm)
Gift of the Artist, 1915.78

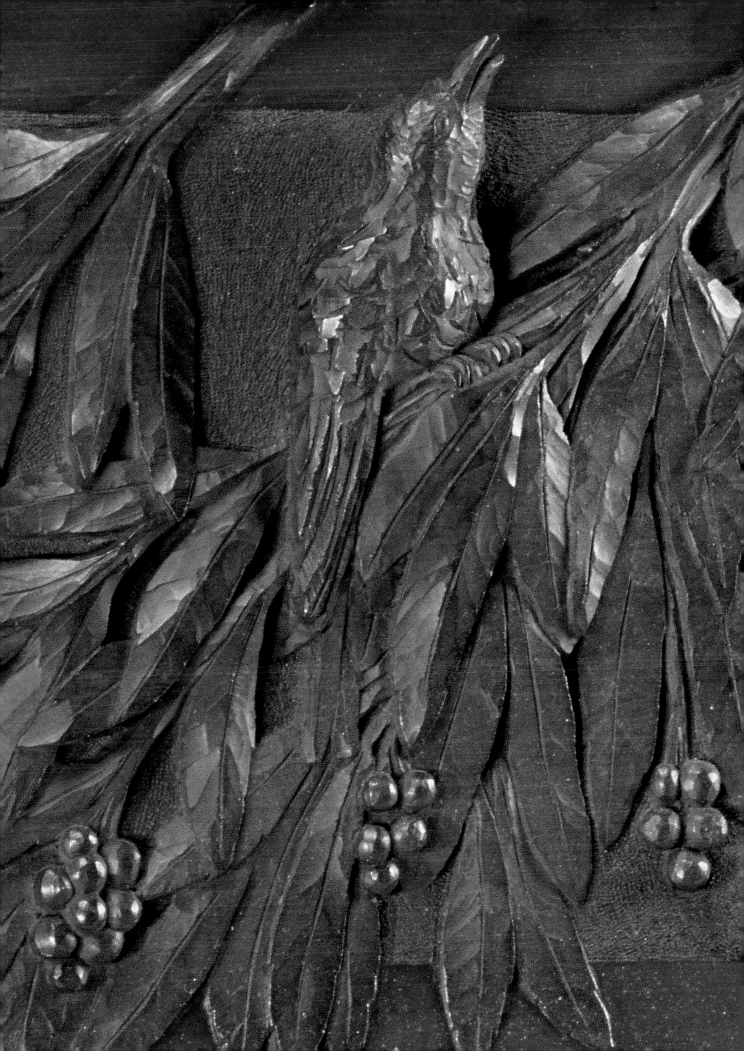

3

Aesthetic Movement Furniture

The hand of woman is better adapted and admirably organized
for some of our work—better fitted for the development of the
beautiful in art.

—Henry L. Fry, 1876

Cincinnati's contribution to late-nineteenth-century American decorative arts has been well recognized, particularly in the area of art pottery. However, just as significant, though not as well known, is the Queen City's contribution in the area of art-carved furniture based on late-nineteenth-century Aesthetic Movement principles. The Aesthetic Movement flourished in Cincinnati with the production of art-carved furniture, introduced and taught by three English immigrants, Henry Lindley Fry (1807–1895), his son William Henry Fry (1830–1929), and Benn Pitman (1822–1910). Woodcarving was taught in Cincinnati for more than fifty years. It became an artistic pursuit primarily for women, who carved objects intended mainly for domestic use.

Henry Fry began his career as a carver and gilder in Cheltenham, England. In 1822, while serving his apprenticeship, he worked on Landsdown Tower, William Beckford's (1760–1844) retreat in Bath, England, that held his art and rare book collections. Henry Fry claimed that he had carved Queen Victoria's throne, and that he had worked on a number of important architectural projects, such as the decorations in the chambers of the houses of Parliament and a screen for Westminster Abbey. These claims, however, have not been substantiated.

Henry Fry arrived in Cincinnati in 1851 and was soon joined by his son William, who had learned woodcarving from his father. By this time Cincinnati was a major center for furniture manufacturing. Carving individual pieces of furniture as well as domestic and ecclesiastical interiors, the Frys established a successful business in Cincinnati. Their business advertisements (see illustration) in the Cincinnati commercial directories boast of their eclectic skills as carvers and designers, as well as their ability to work in a number of styles and materials including wood and iron.

One of the Frys' most important patrons was the eminent Cincinnatian Joseph Longworth. In the late 1850s, the Frys carved the interior of Rookwood, Longworth's country villa, which included an exquisite mantel (pl. 40). The mantel's grapevine motif pays tribute to Joseph Longworth's father, Nicholas, who introduced grape cultivation

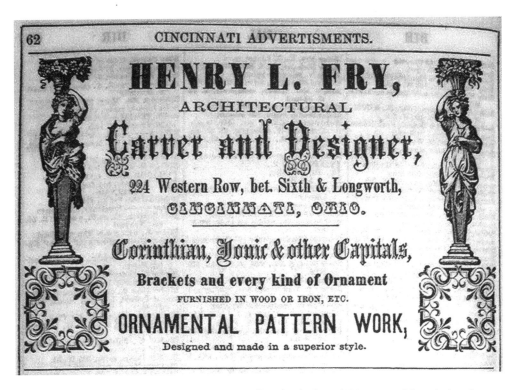

Fig. 6. Henry L. Fry advertisement. From *William's Cincinnati Directory*, 1860. *Cincinnati Historical Society Library*

to the United States. In addition to his own home, Joseph Longworth commissioned the Frys to carve the interior of the home of his daughter, Maria Longworth, and her husband, George Ward Nichols. The Frys worked on the project between 1868 and 1872. Using a variety of local woods, they created a rich interior of carved ceilings, archways, woodwork, and corner cupboards (pl. 42), all of which display a wealth of naturalistic motifs. Visitors to the home were fascinated by the carving and expressed an interest in learning the skill. Henry Fry wrote of the experience, "My son [William H. Fry], whose peculiarity in work is so suggestive, and so artistic in manipulation as to meet with general admiration, has been my principal assistant, and the portion of the work that was especially his own, in the house of George Ward Nichols, claimed so much attention that nearly every one that saw it wished they could be taught how to do it."[1] Consequently, the Frys established private woodcarving classes in the early 1870s.

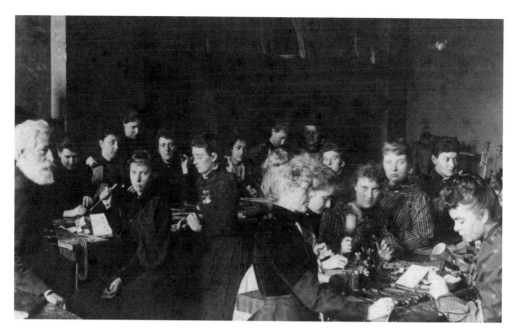

Fig. 7. Benn Pitman and his students. *Benn Pitman Papers. Cincinnati Historical Society Library*

At the same time, Benn Pitman launched the woodcarving department at the School of Design at the University of Cincinnati, which later became the Art Academy of Cincinnati. Pitman had arrived in Cincinnati from England in 1853 and established the Phonography Institute to teach the system of shorthand developed by his brother Sir Isaac Pitman. Before coming to America, Pitman had apprenticed with an architect in Bath, England, in the early 1830s. Soon after, he worked in the printing business, learning techniques of etching and engraving on metal. This experience in printing provided Pitman with the skills necessary to master woodcarving, in which he apparently had no formal training. Pitman did not establish a woodcarving business like the Frys, but dedicated himself to teaching and lecturing. He worked with his students on large projects, such as the carving of the interior of his home. As subjects for their carvings, the students utilized the flora and fauna on the adjacent hillside.

The Frys and Pitman upheld the tenets of the Aesthetic Movement, which originated in England as a reaction to industrialization. Proponents of the movement, such as John Ruskin (1819–1900) and William Morris (1834–1896), sought to elevate the decorative

arts to the status of the fine arts and advocated the production of artistic household goods and utilitarian wares. The Frys and Pitman, inspired by Ruskin and Morris, believed that nature provided the greatest source of inspiration for decorative motifs. They were also influenced by the work of architect Augustus Welby Northmore Pugin (1812–1852), a champion of the Gothic revival style.

Although inspired by similar sources, the Frys and Pitman maintained distinct differences in their motivations for woodcarving. Benn Pitman, although a talented artist, was primarily a philosopher and spokesman for Aesthetic Movement ideals. He lectured and published extensively and strove to define a truly American style for the decorative arts. Pitman insisted on the moral purity of the applied arts and carved only those naturalistic elements that were indigenous to America. In this, he closely adhered to Ruskin's beliefs. The Frys, on the other hand, although supreme craftsmen, were consummate businessmen who carved any style or motif requested by a patron. Their work, unlike Pitman's, is embellished with fantastical figures such as griffins and with naturalistic motifs not indigenous to America.

Through the efforts of the Frys, Pitman, and their students, Cincinnati gained national recognition in the 1870s as a center for woodcarving, which had become primarily a feminine pastime. Most of the woodcarving students were women who had the means to indulge in leisure pursuits. Some, however, learned woodcarving in order to gain employment as art teachers or as carvers in the furniture trade. The Frys and Pitman believed that women were better suited for woodcarving than men, and encouraged their natural artistic inclinations. Henry Fry wrote, "Women had many advantages over men in the art of wood carving, especially when the objects represented are meant to be a suggestion of the kingdom of nature. Women generally have a more delicately organized instrument in the human hand, possess more refined sentiment and I believe they work for less sordid ends."[2]

While attending the 1876 Philadelphia Centennial Exhibition, William Fry wrote to his father, "The work of the women has, to me, a far deeper significance than its intrinsic value. It is for women the beginning of a new era, defining for them clearly and truly the doctrine of woman's rights."[3] The Frys' and Pitman's woodcarving students displayed over two hundred pieces of furniture and objects to great acclaim in the

Women's Pavilion at the Centennial. The types of objects exhibited ranged from small items such as picture frames, caskets, and hatboxes, to large pieces such as hanging cabinets, easels, and mantels. Pitman's daughter Agnes, an adept carver, displayed a chest of drawers (pl. 47) with six drawers, each adorned with carved floral motifs representing the six flowering months of the year. Reviewers of the Centennial hailed Cincinnati women for their unparalleled achievements in woodcarving and encouraged other artists to follow their lead.

Interest in woodcarving waned in Cincinnati after the turn of the century, and the movement officially ended in 1926 when William Fry taught his last class at the Art Academy. Stylistically, woodcarving had changed very little over the fifty years it was taught. However, during its peak in the 1870s and 1880s, Aesthetic Movement woodcarving enjoyed a success in Cincinnati that no other city could rival.

JH

Plate 40
Henry L. Fry (1807–1895) and William H. Fry (1830–1929)
Mantel, 1851–68
Oak
50 x 60¼ x 8½ in. (127 x 153 x 21.6 cm)
Anonymous gift, 1977.140

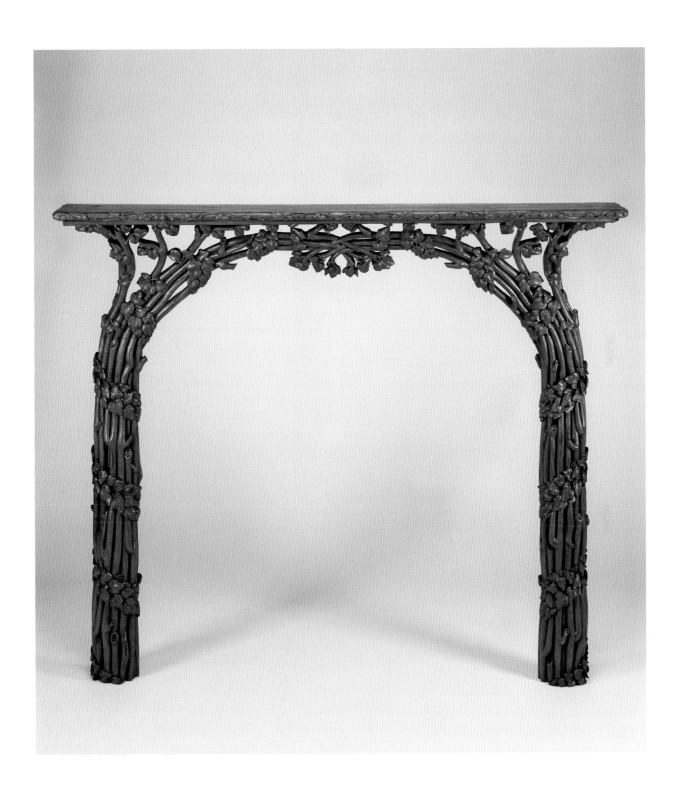

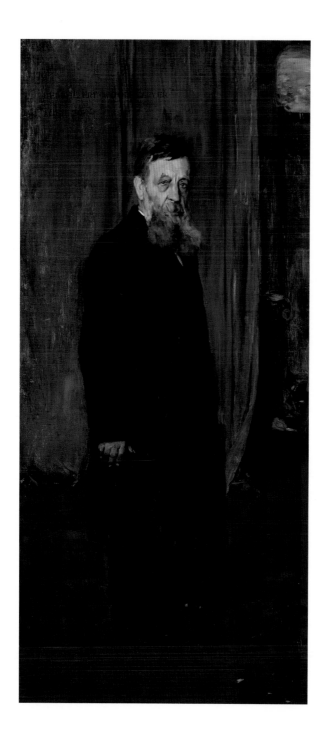

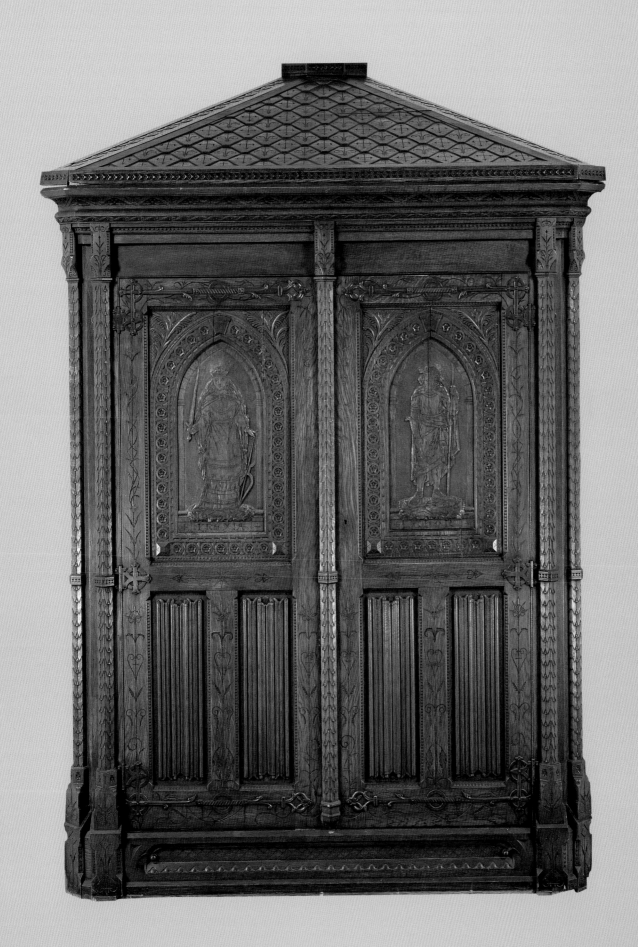

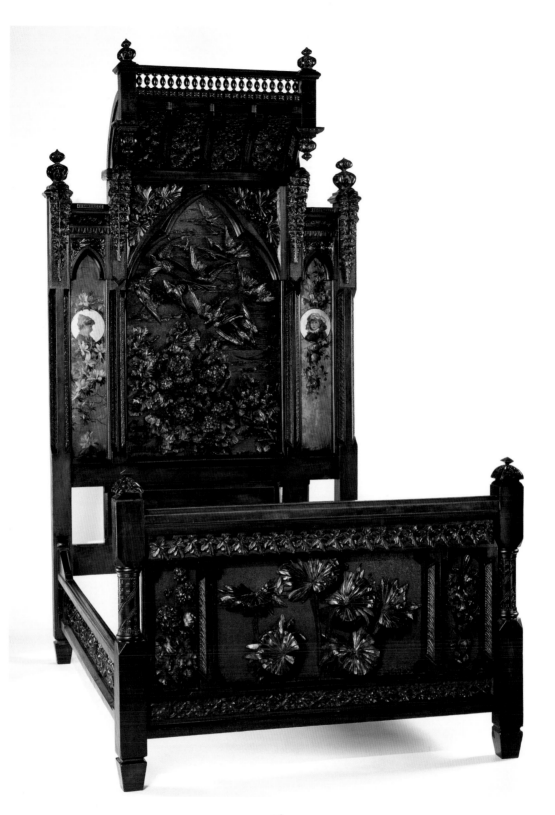

Plate 43

Benn Pitman (1822–1910), designer, Adelaide Nourse Pitman (1859–1893),
carver, and Elizabeth Nourse (1859–1938), painter

Bedstead, 1882–83

Mahogany and painted panels

110 x 59 ¼ x 85 in. (279.4 x 150.5 x 215.9 cm)

Gift of Mary Jane Hamilton in memory of her mother, Mary Luella Hamilton,
made possible through Rita S. Hudepohl, guardian, 1994.61

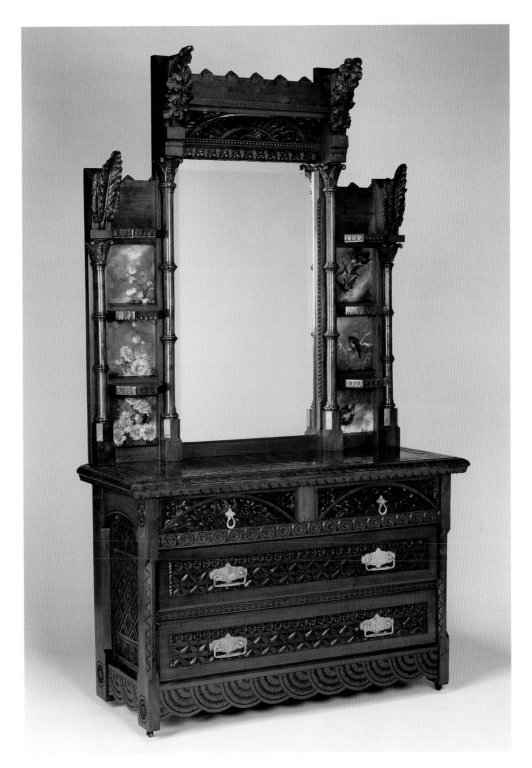

Plate 44

Benn Pitman (1822–1910), designer, Adelaide Nourse Pitman (1859–1893),
carver, and Elizabeth Nourse (1859–1938), painter

Dresser, ca. 1882–83

Mahogany, white oak, painted panels, glass, and gilded brass

91 1/16 x 53 1/4 x 21 1/4 in. (231.4 x 135.3 x 54 cm)

Gift of Mary Jane Hamilton in memory of her mother, Mary Luella Hamilton,
made possible through Rita S. Hudepohl, guardian, 1994.62

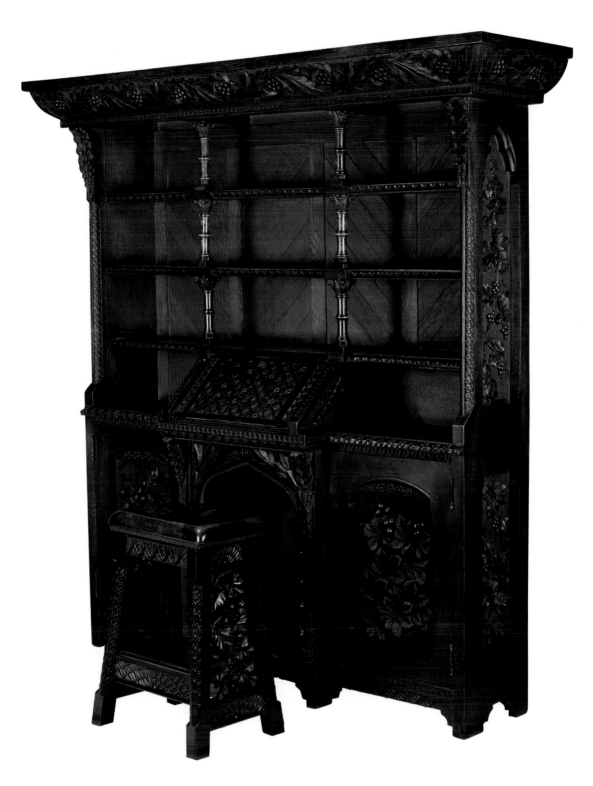

Plate 45

Benn Pitman (1822–1910), designer, Adelaide Nourse Pitman (1859–1893), carver,
and Agnes Pitman (1850–1946), carver

Secretary-Bookcase and Stool, ca. 1884

White oak and American black walnut

Secretary-Bookcase: 88 ½ x 88 ¼ x 21 ¼ in. (224.8 x 224.2 x 54 cm)

Stool: 29 x 22 x 16 ½ in. (73.7 x 55.9 x 41.9 cm)

Gift of Melrose Pitman, 1969.387 a,b

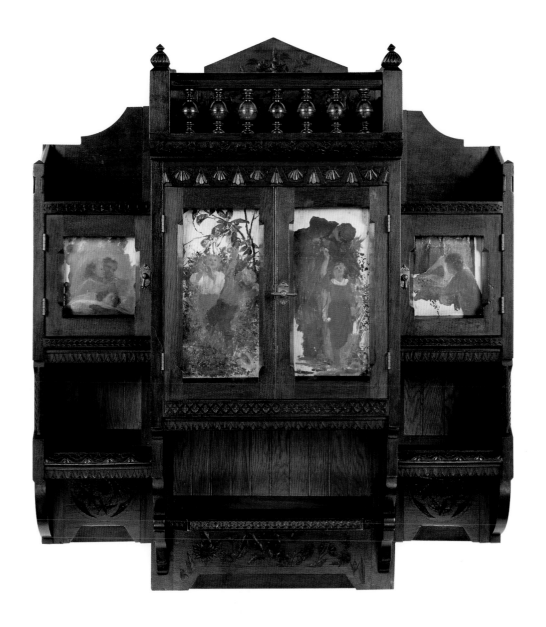

Plate 46

Benn Pitman (1822–1910), designer, Emma Marqua (ca.1860–living 1880),
carver, and Charles T. Webber (1825–1911), painter

Hanging Cabinet, 1880

American black walnut, white oak, painted panels, and brass
38 ¼ x 34 ½ x 9 ⅝ in. (97.2 x 87.6 x 24.4 cm)
Gift of the descendents of William Henry Venable, 1996.47

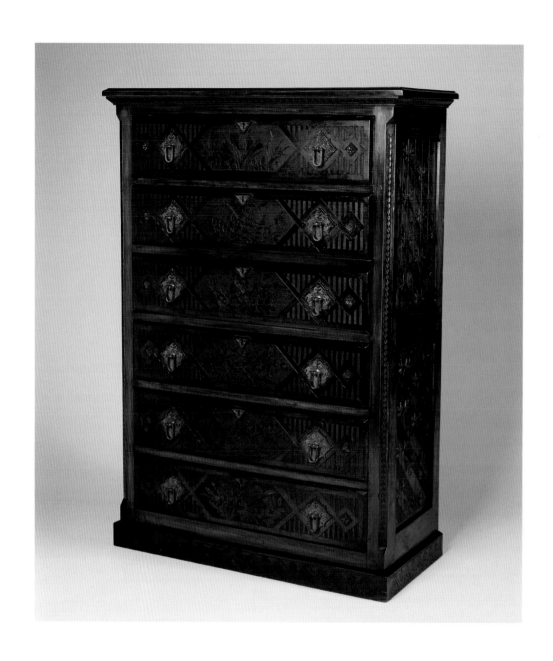

Plate 47

Agnes Pitman (1850–1946)

Chest of Drawers, 1876

American black walnut, pine, yellow poplar, and nickel-plated brass

54⅜ x 38¾ x 18 in. (138.1 x 98.4 x 45.7 cm)

Gift of Miss Melrose Pitman, 1970.164

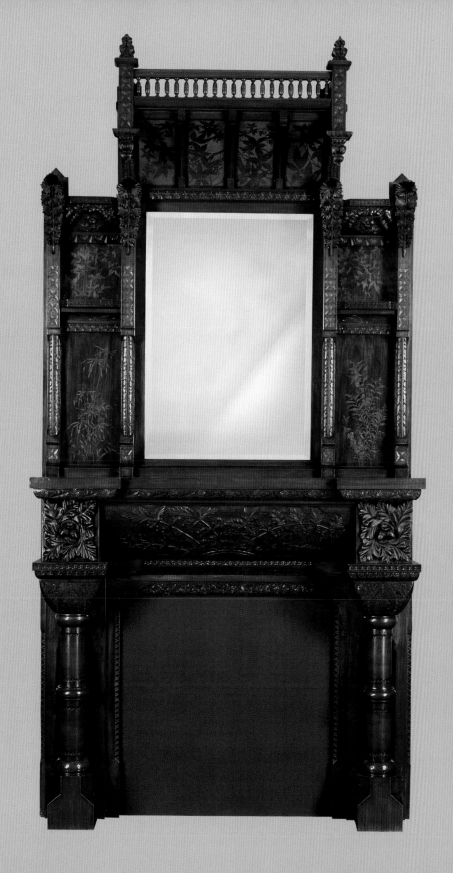

Plate 48

Emma Bepler (1864–1947)

Fireplace Mantel and Overmantel, 1893

American black walnut and glass

123 x 62⅝ x 16⅞ in. (312.4 x 159.1 x 42.9 cm)

Gift of Mrs. Carl W. Bieser, 1979.96 a–c

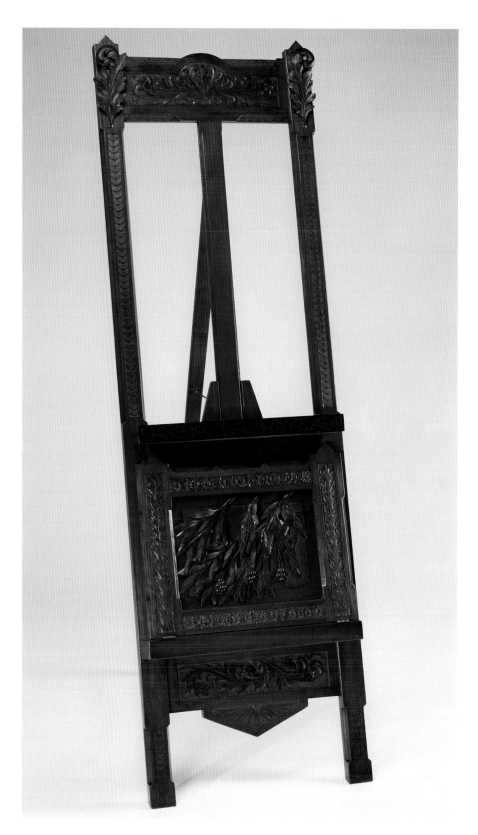

Plate 49
Emma Bepler (1864–1947)
Easel, ca. 1885–90
Mahogany and brass
77 x 24 x 48 in. (195.6 x 61 x 121.9 cm)
Gift of Mrs. Carl W. Bieser, 1979.98

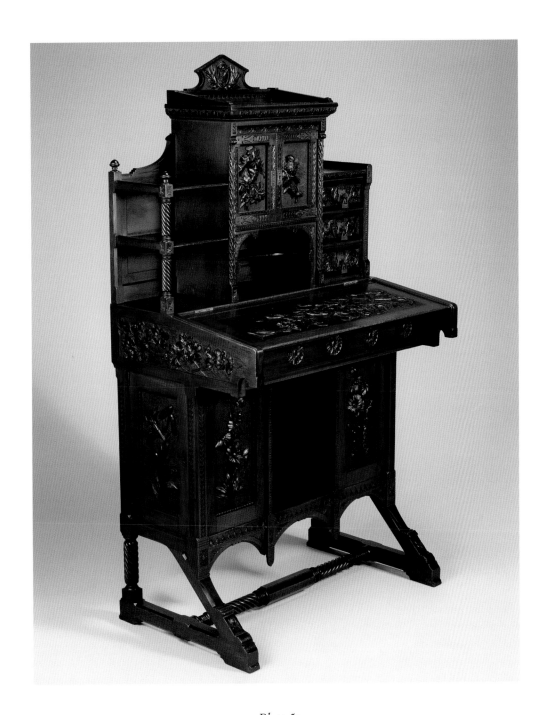

Plate 50
Catherine Peachey (dates unknown)
Writing Desk, 1870s
American black walnut, mahogany, black cherry, yellow poplar, and brass
54 x 30 x 19¾ in. (137.2 x 76.2 x 50.2 cm)
Gift of Miss Irene Edwards, 1979.4

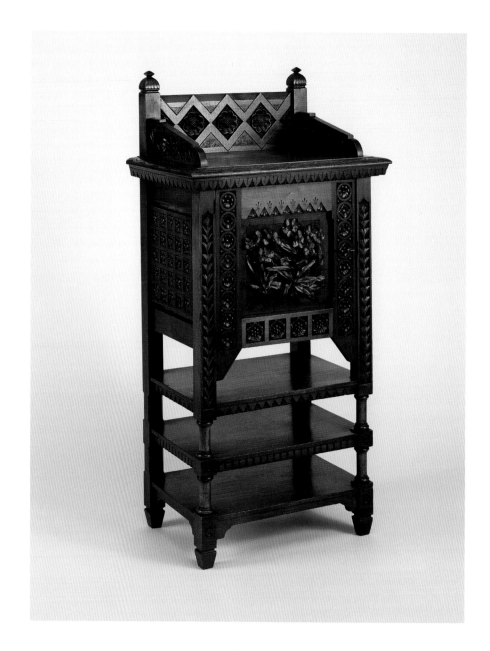

Plate 51

Unknown maker

Music Cabinet, late 19th century

American black walnut and brass

48¾ x 24¼ x 16¼ in. (123.8 x 61.6 x 41.3 cm)

Museum Purchase with funds provided by the Fleischmann Foundation
in memory of Julius Fleischmann, 2001.71

74

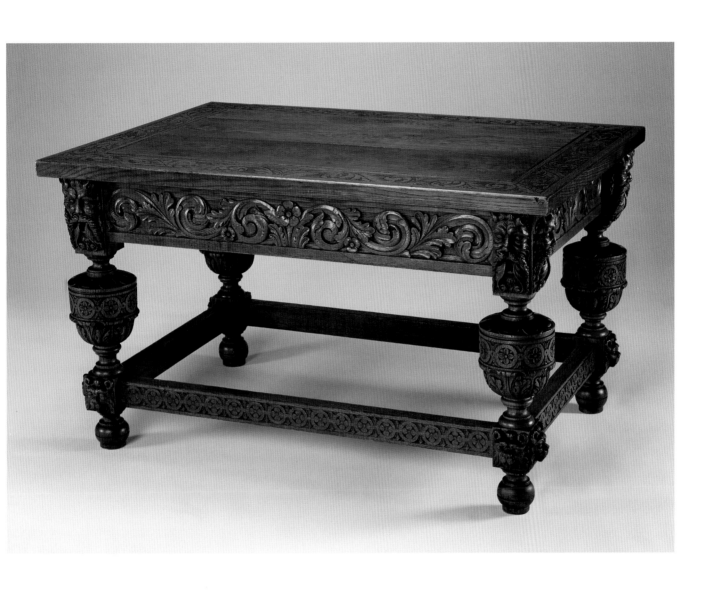

Plate 52
Attributed to William H. Fry (1830–1929)
Table, 1860–80
White oak and steel
29 ½ x 51 ⅝ x 35 ⅞ in. (74.9 x 131.1 x 91.1 cm)
Gift of W. H. Hinkle, 1922.24

75

4

The Academic Tradition

There is no extravagance of speech in saying that altogether the
most thorough school in the United States for art education is that
which is now attached to the Museum Association of Cincinnati.

—*The Courier (Cincinnati)*, 1884

The last three decades of the nineteenth century have been called "The Golden Age" of Cincinnati art. Although one may challenge the appropriateness of this designation, it is impossible to deny the city's great achievements in those years. The era saw the initiation of the celebrated May Choral Festival (1873), the opening of Music Hall and the founding of the College of Music (1878), the birth of The Rookwood Pottery Company (1880), the establishment of the Cincinnati Art Museum (1881), and the first concert of the Cincinnati Symphony Orchestra (1895). Not only did the city's ceramic and furniture industries earn international fame, but Cincinnati also reinvigorated its reputation as a leading center for art education.

Before the Civil War, art training in the Queen City was a haphazard endeavor that transpired in various short-lived academies and artists' studios. During the war years the arts floundered, but with the amassing of industrial fortunes during the conflict, the arts in the following decades experienced an unprecedented boom in the building of cultural institutions. Central to the story of the fine and decorative arts is the opening in 1869 of the McMicken School of Design, affiliated with the new McMicken University (now the University of Cincinnati). In 1884 the University transferred the School of Design to the Cincinnati Museum Association, and the school was reborn as the Art Academy of Cincinnati. In 1887 a Romanesque-style building with state-of-the-art facilities for studio instruction was unveiled to great fanfare in the national press. A place of dedicated work and spirited camaraderie, the school has remained at the heart of the city's art world for more than a century.

The 1870s were remarkable years for the city's artistic identity. Cincinnati's exhibition venues—including the celebrated Industrial Expositions from 1870 to 1888—and art-related industries, such as its renowned lithographic firms, encouraged young people to consider art careers. An extraordinary roster of gifted painters and sculptors —including John H. Twachtman, Elizabeth Nourse, Kenyon Cox, Joseph R. DeCamp, Robert F. Blum, Charles Niehaus, Joseph H. Sharp, and Edward H. Potthast—came together at the McMicken School of Design before moving on to careers elsewhere.

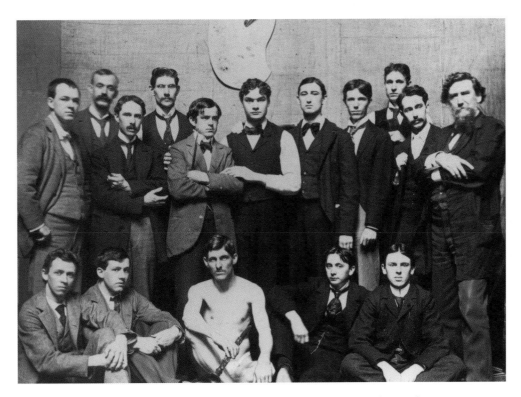

Fig. 8. Thomas Noble (right) and his Men's Life Class at the Art Academy of Cincinnati, ca. 1890. *Cincinnati Art Museum Archives*

Frank Duveneck, who returned to the city in 1873 after his first trip to Munich, brought a vitality to the city's art scene that remained tangible long after his departure for Europe two years later and was renewed in 1890 when he returned permanently to teach.

The principal of the School of Design from its founding until 1904 was Thomas Satterwhite Noble. Paris-trained, Noble modeled the curriculum on academic programs in Germany and France. Students drew from engravings before approaching three-dimensional objects, such as plaster casts of ancient statuary, and thoroughly mastered drawing before taking up the brush. Noble expressed his firm belief that "insufficient rudimentary training leaves the artist weak. . . . Hence we do not allow our pupils to go faster than they are prepared to go. We keep the pupil upon the simplist [*sic*] forms, drawing in outline until the greatest possible accuracy is secured."[1] The value of this pedagogical approach was debated in the local press. Some restless young talents found

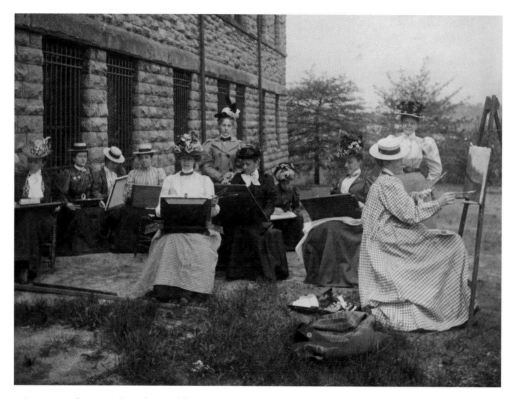

Fig. 9. Caroline Lord (right) and her painting class outdoors at the Art Academy of Cincinnati, 1892–94. *Cincinnati Art Museum Archives*

it tedious beyond measure, but for other students, Noble's methodology supplied tools to excel. For the finest artists, the school served as an adequate stepping-stone to further education on the East Coast or in Europe.

A subject of controversy in the early years of the conservative School of Design was the drawing of the human form, the cornerstone of academic European art, in which the figure was preeminent. Duveneck, from 1874 to 1875, was the first to offer Cincinnatians the opportunity to work before the live model in his class for men only at the Ohio Mechanics Institute. This landmark class included Kenyon Cox, later the consummate draftsman and painter of the body (pl. 108). After Cox and other ambitious students at the School of Design rebelled by initiating their own evening sessions with live models, Noble in 1877 added life classes to the curriculum. However, only male students could study the nude. It was not until 1885 that women, in a separate class, were provided

access to nude models. Nourse was among the first to benefit from the fledgling women's life class shortly before she departed for further training in France.

There is nothing definably "Cincinnati" about either the style or the subjects of works by artists who studied in the Queen City. Those committed to the tenets of academic art took up subjects preferred by the official venues, such as the government-sponsored Salon exhibitions of Paris. The Salon juries favored themes with moral weight. These included literary subjects as well as genre paintings that explored the piety and unaffected decency of country folk, as seen in Nourse's *Peasant Women of Borst* (pl. 57) and Henry Mosler's *Chimney Corner* (pl. 60). Historical subjects—even fairly recent ones, such as in *The Underground Railroad* by Charles T. Webber (pl. 59) —could be similarly uplifting. At the same time that oppressive Jim Crow laws rocked the country's foundations, this painting (and the fact it was selected in 1893 for the World's Columbian Exposition in Chicago) expressed pride in America's progress and compassion.

The most popular paintings during the late nineteenth century did not embrace contemporary urban life and the harsh realities wrought by industrialization. They were escapist, but escapism could take a variety of forms. Nothing could be further from virtuous peasant imagery than Orientalism. Orientalism refers to images of North Africa and the Near and Far East made by Europeans and Americans, many of whom had never been there. Gazing upon these largely imaginative works could transport audiences vicariously into tantalizing, exotic worlds. Such paintings as Duveneck's impressive *Guard of the Harem* (pl. 62) display a sensuality both dangerous and exciting. In this large, sketchy work, the powerful virility of the model is perfectly matched by the physicality of the assertive brushwork and uncontrolled dripping (the opposite of Noble's studied approach). Orientalism so enticed Cincinnati artists that painter John Rettig claimed that the students were "Arab mad."[2] Decorative artists in the Queen City were not immune to this fad and inventively adapted Eastern motifs and forms in various media. One notes, for example, the *"Alhambra" Vase* by Cordelia A. Plimpton (pl. 65), a silver "Turkish" coffeepot by Duhme & Co. (pl. 67), and a tabouret or stand manufactured by the Robert Mitchell Furniture Company (pl. 63).

Many of the artists trained in Cincinnati in the late nineteenth century remained

indebted to the Queen City's instruction, encouragement, and collegial artist community. Joseph H. Sharp gave a rare visual expression to the vital role of the artist in the fabric of the city's life in his 1892 painting *Fountain Square Pantomime* (pl. 72): he includes portraits of artist friends among a motley crowd gathered downtown to watch a performance staged on a department store balcony. Although many artists grew discontent with the city's resources and chose to settle elsewhere, their national and international accomplishments became sources of civic pride for their hometown and have remained so to this day. By exhibiting and purchasing their work, the Cincinnati Art Museum, from the very beginning of its existence, bolstered their careers and built the foundations for the deep and rich collections of work by local artists the institution shares with the public today.

JA

Plate 53
Moses J. Ezekiel (1844–1917)
Eve Hearing the Voice, modeled ca. 1876, cast by 1904
Bronze
55 ¾ x 41 ½ x 36 in. (141.6 x 105.4 x 91.4 cm)
Gift of Dr. Merlyn McClure and the Family of
Dr. George W. McClure, 1997.152

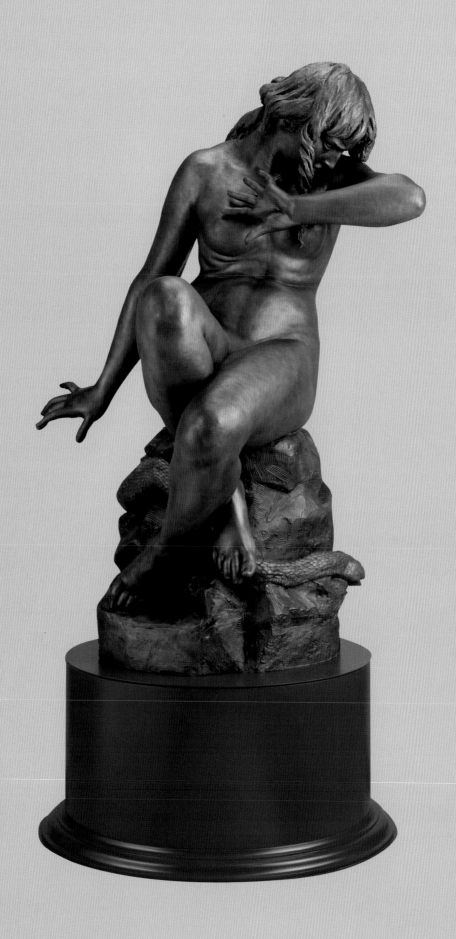

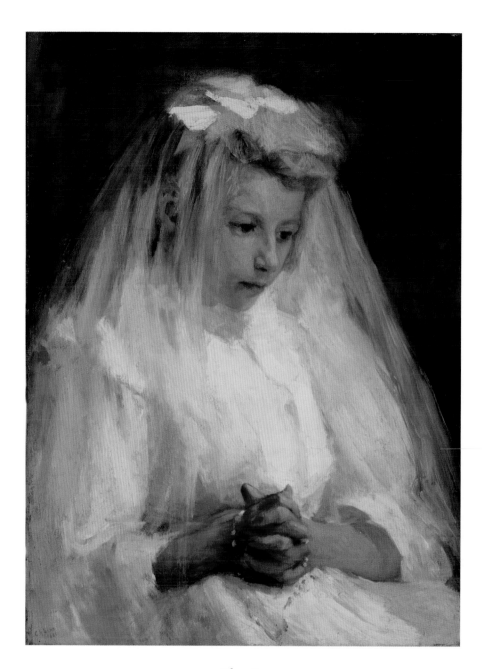

Plate 54

Caroline Lord (1860–1927)

First Communion, 1901

Oil on canvas

22 15/16 x 16 15/16 in. (58.3 x 43 cm)

Gift of the Artist, 1906.194

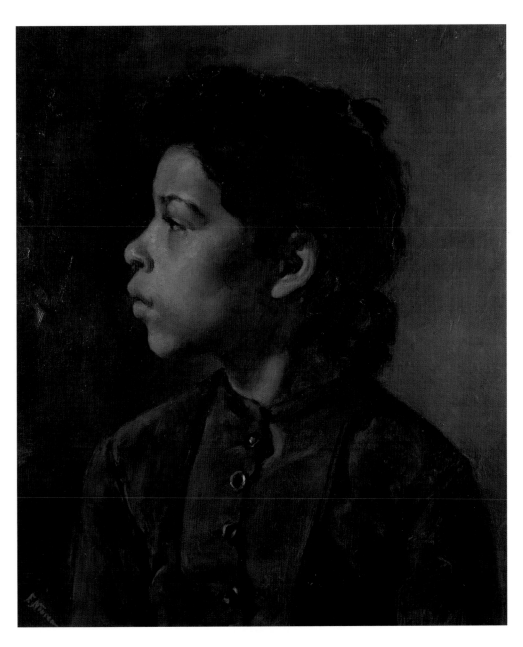

Plate 55
Elizabeth Nourse (1859–1938)
Head of a Negro, ca. 1882
Oil on canvas mounted on academy board
18 11/16 x 16 1/8 in. (47.5 x 41 cm)
Gift of Harley I. Procter, 1924.490

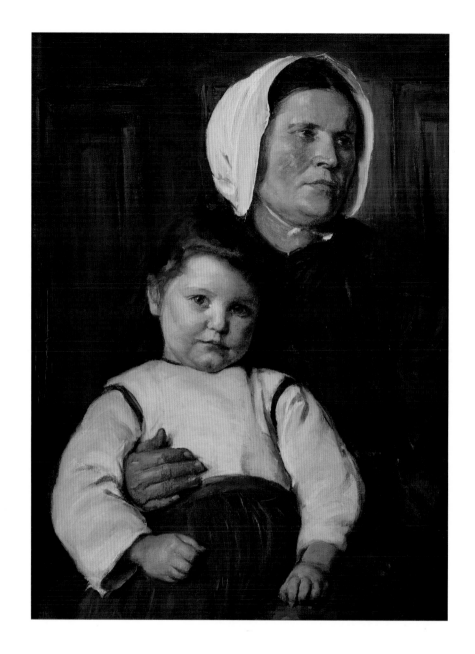

Plate 56

Elizabeth Nourse (1859–1938)

Normandy Peasant Woman and Her Child, 1900

Oil on canvas

25 ¹⁄₁₆ x 18 ¾ in. (63.7 x 47.6 cm)

Gift of Mrs. C. F. Dickson in memory of her father and mother,
Mr. and Mrs. James Bullock, 1936.834

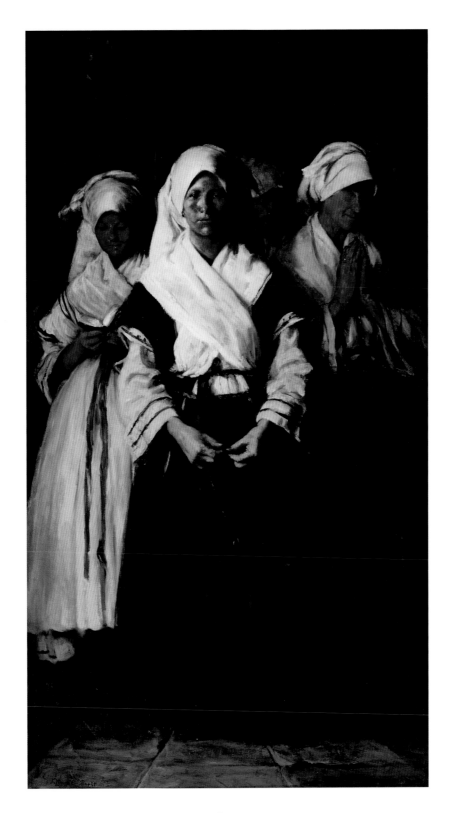

Plate 57

Elizabeth Nourse (1859–1938)

Peasant Women of Borst, 1891

Oil on canvas

38 ⅝ x 21 ⅝ in. (98.2 x 54.9 cm)

Gift by Subscription, 1892.3

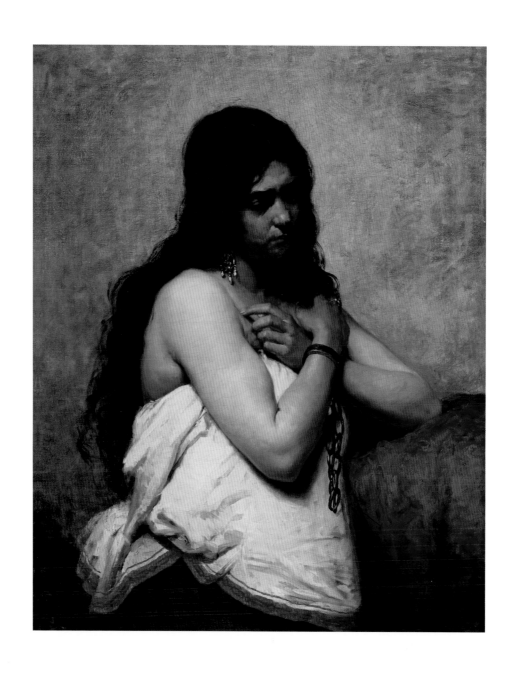

Plate 58

Henry Mosler (1841–1920)

The Quadroon Girl, 1878

Oil on canvas

39 ½ x 32 in. (100.3 x 81 cm)

Gift of Louise F. Tate, 1976.25

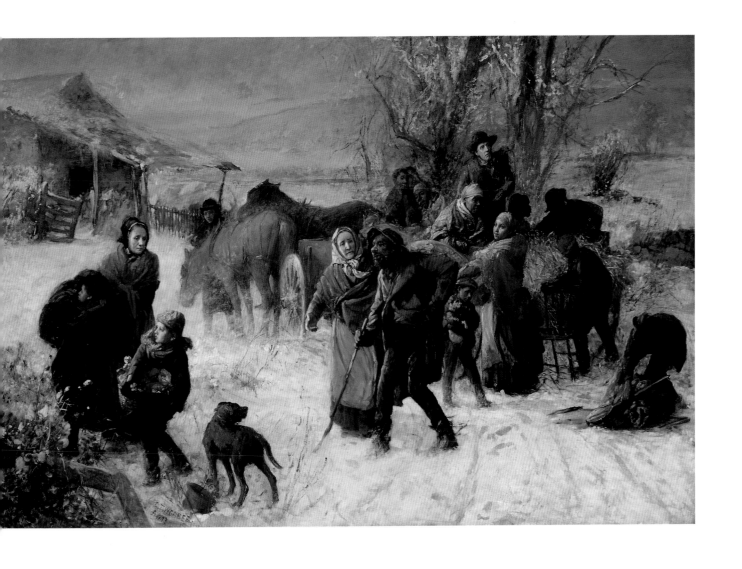

Plate 59
Charles T. Webber (1825–1911)
The Underground Railroad, 1893
Oil on canvas
52 ³⁄₁₆ x 76 ⅛ in. (132.6 x 193.4 cm)
Subscription Fund Purchase, 1927.26

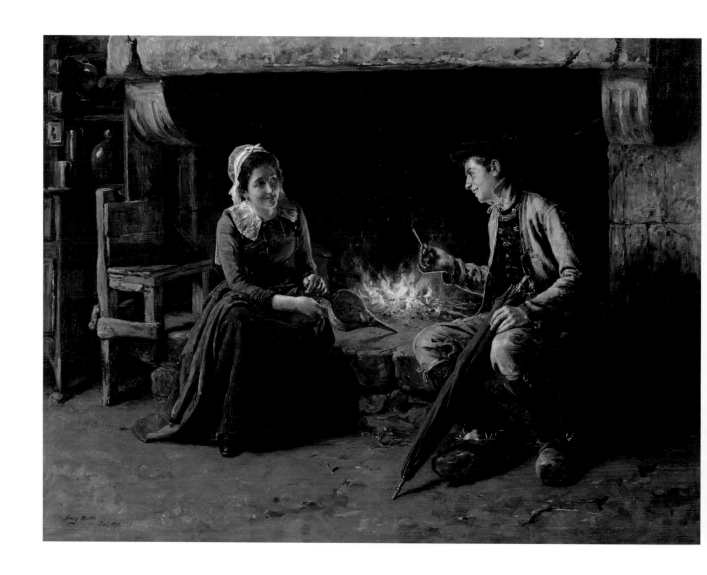

Plate 60

Henry Mosler (1841–1920)

Chimney Corner, 1893

Oil on canvas

38 ¼ x 51 ⁵⁄₁₆ in.

Gift of Mrs. Samuel B. Sachs, 1928.136

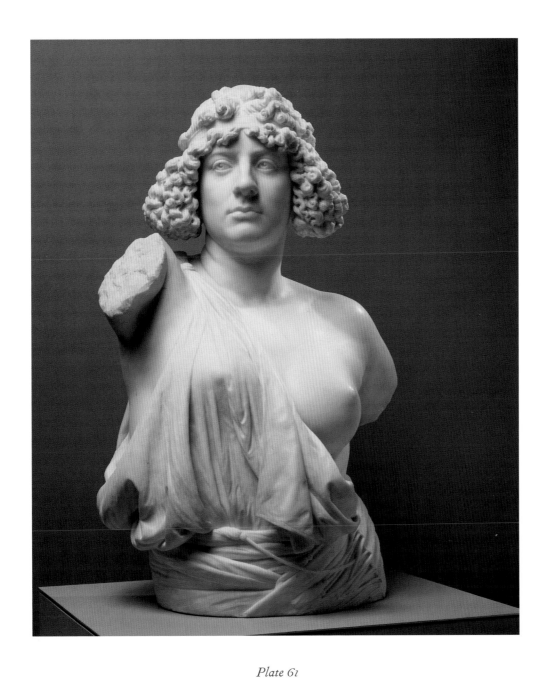

Plate 61

Moses J. Ezekiel (1844–1917)

Judith, ca. 1880

Marble

30⅞ x 18⁵⁄₁₆ x 15⁹⁄₁₆ in. (78.4 x 46.5 x 39.5 cm)

Bequest of Margaret Rives Nichols, Marquise de Chambrun, 1952.66

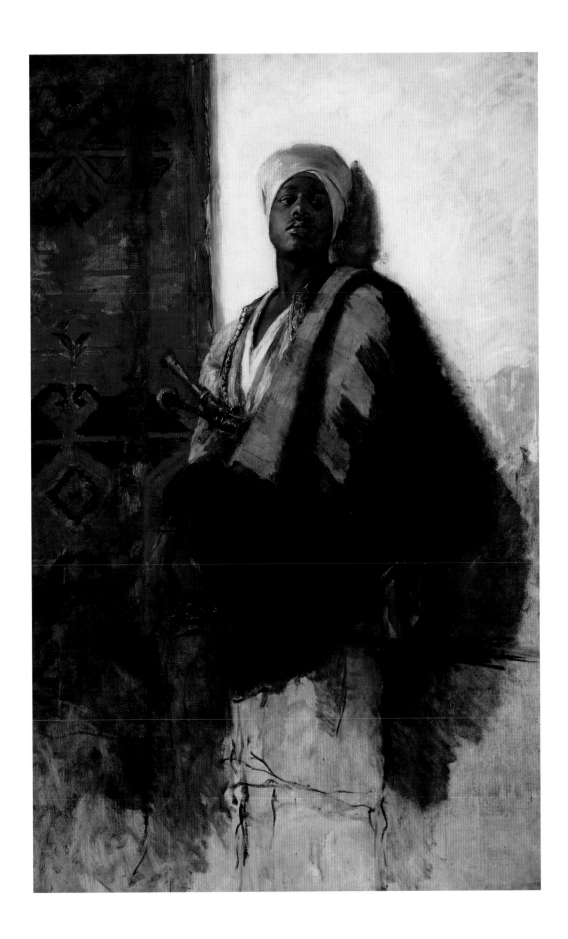

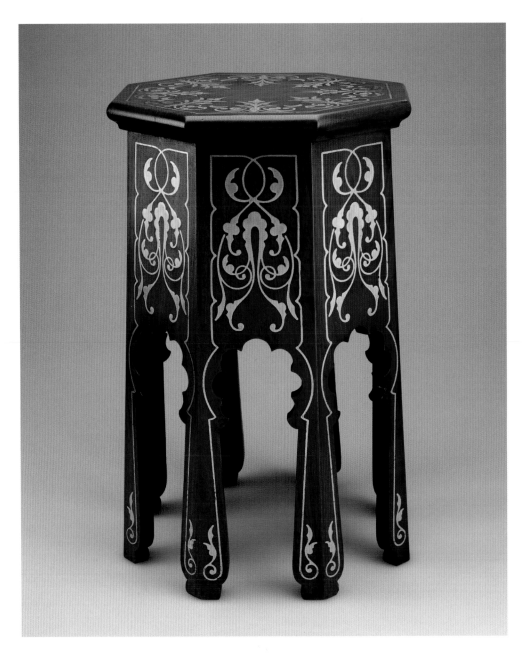

Plate 63

Robert Mitchell Furniture Company (1881–1930s)

Tabouret, 1881–90

Walnut with pewter inlay

H. 22 ½ in., diam. 15 ⅛ in. (h. 57.2 cm, diam. 38.4 cm)

Museum Purchase with funds provided by the Oliver Charitable Trust and various funds, 1999.167

Plate 64

Henriette Wachman (1851–1954)

Rue de Tunis (Street in Tunis), ca. 1894–1909

Oil on canvas

17 15/16 x 12 7/8 in. (45.6 x 32.7 cm)

Gift of Carl and Eleanor Strauss, John and Gladys Strauss,
and the Honorable S. Arthur and Louise Spiegel, 1999.247

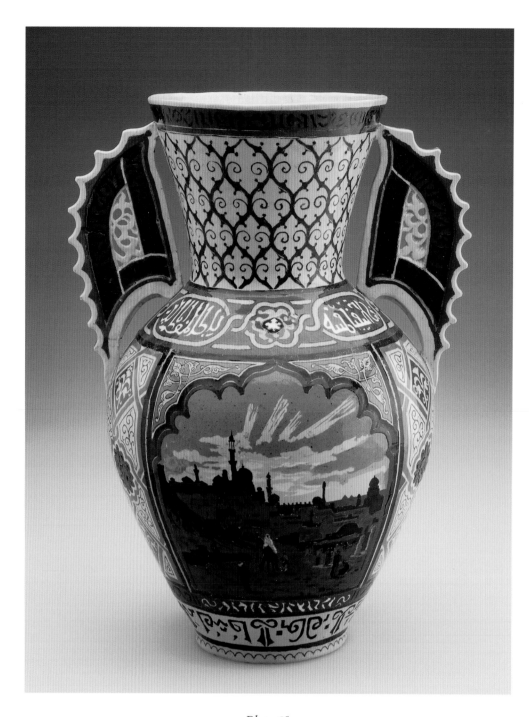

Plate 65

Cordelia A. Plimpton (1830–1886), decorator,
and Lucien F. Plympton (1856–1931), designer
Cincinnati Pottery Club (1879–1890)
Frederick Dallas Hamilton Road Pottery (1865–1882)
"Alhambra" Vase, 1881

Earthenware

16½ x 12³⁄₁₆ x 10⅛ in. (41.9 x 31 x 25.7 cm)

Gift of the Women's Art Museum Association, 1881.61

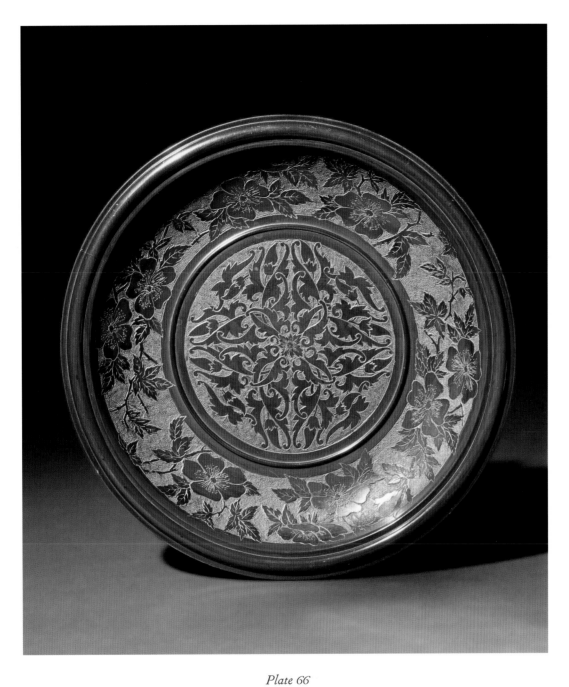

Plate 66

Emma Bepler (1864–1947)

Fruit Plate, ca. 1886–94

Cherry

H. 1 ⅞ in., diam. 12 ¼ in. (h. 4.8 cm, diam. 31.1 cm)

Gift of Mrs. Carl W. Bieser, 2000.154

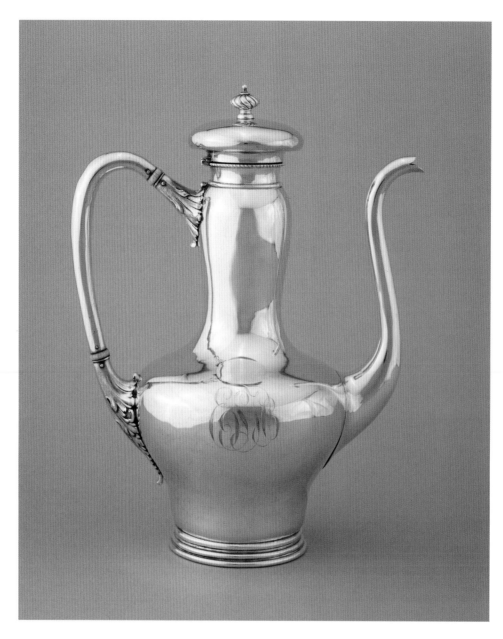

Plate 67
Duhme & Co. (1842–1910)
Turkish Coffeepot, ca. 1875–85
Silver
11 ⅜ x 8 ¾ x 5 ½ in. (28.9 x 22.2 x 14 cm)
Museum Purchase: Decorative Arts Deaccession Funds, 2000.157

Plate 68

Charles Meurer (1865–1955)

Still Life, 1903

Oil on canvas

33 x 22 in. (83.8 x 55.9 cm)

Gift of Stanley and Frances D. Cohen, 1999.246

Plate 69

Elizabeth Nourse (1859–1938)

In the High Meadow, 1904

Oil on panel

23 9/16 x 28 13/16 in. (59.8 x 73.2 cm)

Gift of David Alfred Gantz, Emily Gantz McKay, and Katherine Gantz Morse,
in honor of our mother Edwina Bookwalter Gantz, our aunt Emily Bookwalter Levy Demar,
and our grandparents Alfred Guitner Bookwalter and Amy Mitchell Shuey Bookwalter, 2001.41

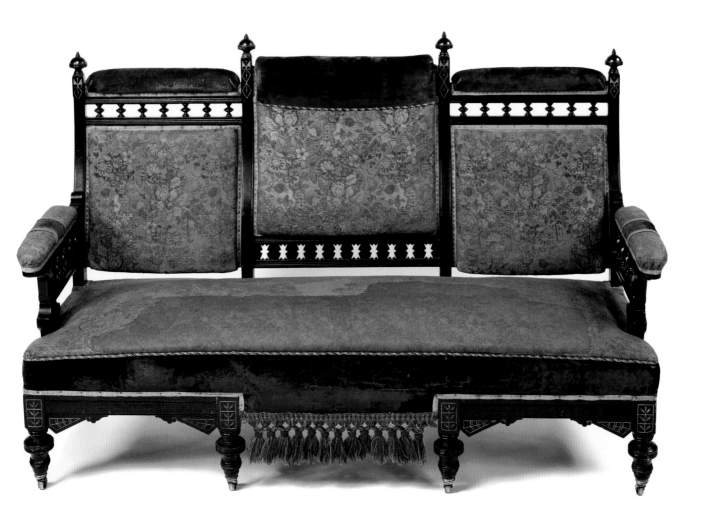

Plate 70

Mitchell & Rammelsberg Furniture Company (1847–1881)

Sofa, 1876–81

Ebonized and gilded wood and original upholstery

40½ x 65 x 29 in. (102.9 x 165.1 x 73.7 cm)

Henry Meis Endowment, 1987.63.1

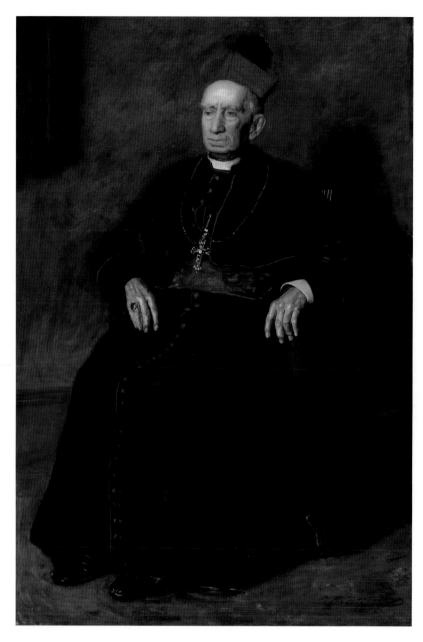

Plate 71

Thomas Eakins (1844–1916)

Archbishop William Henry Elder, 1903

Oil on canvas

66⅛ x 41⅛ in. (168 x 104.5 cm)

Museum Purchase: Louis Belmont Family in memory of William F. Halstrick,
Bequest of Farny R. Wurlitzer, Edward Foote Hinkle Collection,
and Bequest of Frieda Hauck, by exchange, 1978.370

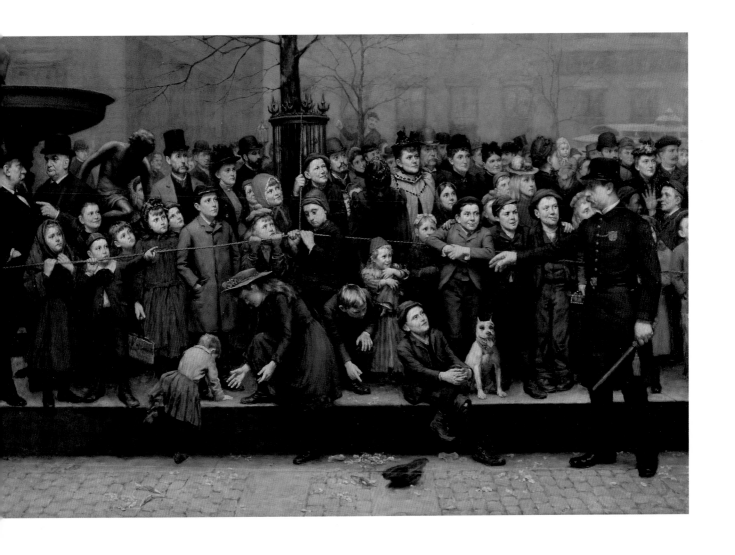

Plate 72

Joseph Henry Sharp (1859–1953)

Fountain Square Pantomime, 1892

Oil on canvas

40 x 60 in. (101.6 x 152.3 cm)

*The Edwin and Virginia Irwin Memorial
and Gift of the CAM Docent Organization
in celebration of its 40th Anniversary, 2000.68*

Cincinnati Ceramics

The Cradle of American Art Pottery

For a time it was a wild ceramic orgy.

—M. Louise McLaughlin

Cincinnati was destined for ceramic greatness because its location offered abundant wood and coal for fuel, endless deposits of fine clay, river transportation for distribution, and a growing population. What destiny did not guarantee was that it became one of the most important cities in the world for art pottery.

By 1859 the Queen City had twelve potteries employing seventy people who turned out an aggregate product for the year worth $90,000, or slightly more than $1.7 million in today's market. These firms were producing a great variety of useful wares such as bowls, pitchers, jars of all kinds, milk dishes (shallow bowls used to remove or "skim" cream from the surface of milk), baking dishes, spittoons, teapots, ewers, and basins. Late in the 1860s the notion of art pottery began to grow. Art pottery is pottery that includes an artist in the design or decoration of the ware, and is usually more artistic than useful. Contributing to the notion of art pottery was the profound influence of the philosophy and moral guidance of English author and critic John Ruskin, who insisted that beautiful surroundings make people virtuous. By extension, if the home were beautifully appointed, the family would benefit greatly in moral aptitude. This placed a serious moral responsibility on women to beautify their homes. One way they could do this with society's blessing was to decorate ceramics.

Two Cincinnati women, Maria (pronounced Mar-EYE-a) Longworth Nichols Storer and M. Louise McLaughlin, became so important in this movement that all books on the history of American art pottery begin their story in Cincinnati. By 1874 many women, including Maria Longworth Nichols Storer and Louise McLaughlin, were painting porcelain to beautify their homes. In the spring of 1875, the ladies of Cincinnati held a Centennial Tea Party to raise money to display their objects in the Exhibition building of the 1876 Centennial Exhibition in Philadelphia. The Centennial Exhibition was the first international fair produced in this country, and displaying work there held the promise of international recognition. On the Saturday night of the Tea Party, with virtually all Cincinnati's high society attending, thirty-five cups and saucers decorated by the ladies were auctioned. The highest bid for a china-painted cup and saucer was

Fig. 10. M. Louise McLaughlin. *Cincinnati Historical Society Library*

$25 ($367 in today's market). Two sets went for this price: one was by Storer, the other by McLaughlin. This tie for highest bid began a long and bitter rivalry between these women who became the dueling divas of Cincinnati ceramics.

Flushed with success from the Philadelphia Centennial Exhibition, Louise McLaughlin wrote the first guidebook in the United States on china painting. Published in the fall of 1877, *China Painting: A Practical Manual for the Use of Amateurs in the Decoration of Hard Porcelain* had a major impact on china painting in America. The book was so popular that it was published in no fewer than ten editions and sold more than twenty thousand copies.

At the Centennial fair Louise first saw the amazing work of Haviland & Company's Paris studio. It was the first pottery to be decorated under the glaze (glassy skin of the vessel). Prior to this, almost all forms of ceramic polychrome decoration, including painted porcelain, had been over the glaze. To paint a decoration under the glaze meant that the decoration would not chip, smear, or rub off, and would last as long as the vessel itself. McLaughlin returned to Cincinnati determined to discover the secret of Haviland's technique. The fact that it took the ceramic world centuries to develop the technique did not daunt her; it took her a little over three months. By January 1878, when perhaps two or three potteries in the world knew the secret, McLaughlin became the first American to produce pottery decorated under the glaze. This achievement soon won her international notoriety; examples of her work were exhibited in New York and Paris. In 1879 McLaughlin founded the Cincinnati Pottery Club, the first women's pottery club in America. Storer, who was invited to join, insisted that she did not get the invitation and snubbed the Pottery Club throughout its eleven-year existence. (Perhaps she did not want to become a mere member of a club whose president was Louise McLaughlin.) In 1880 McLaughlin produced a manual on decorating pottery under the glaze, and created the largest vase ever made utilizing that technique. She dubbed this famous example the *Ali Baba* vase (pl. 84).

Maria Longworth Nichols Storer was not one to idly stand by while Louise McLaughlin was winning national and international accolades. Within months Maria used Louise's technique to produce her own version of the largest vase ever to be decorated under the glaze, and called it the *Aladdin* vase (pl. 85). With Louise becoming famous, and Maria looking like a follower, Maria took one last step to best Louise: in the fall of 1880 she tapped her family's unbounded wealth and started her own pottery, The Rookwood Pottery Company. Because it had access to McLaughlin's underglaze decorating technique and, unlike other art potteries of the time, the Longworth family fortune, Maria's company went very far, very fast. Meanwhile, with the death of Frederick Dallas and the closing of his Hamilton Road Pottery in 1881, Louise McLaughlin and her Pottery Club needed a place to fire their wares. A fragile agreement was worked out whereby the Pottery Club rented a room at The Rookwood Pottery Company and had access to its kilns. Barely a year later the Pottery Club was evicted. This marked the

Fig. 11. Maria Longworth Nichols Storer. *Cincinnati Historical Society Library*

beginning of the end of pottery decorating for Louise McLaughlin and her Pottery Club. Without access to the necessary kilns, they turned once again to china painting. As The Rookwood Pottery Company became more and more famous, McLaughlin's notoriety began to fade.

In 1898 Louise McLaughlin built a kiln in her backyard and became the first American to work in studio porcelain, her final contribution to American ceramics. In 1900 Maria's Rookwood Pottery Company won the Grand Prix at the Paris Universal Exposition, marking it as the finest art pottery in the world. Rookwood had perfected McLaughlin's technique, and by 1900 its decorators could paint anything under the glaze that could be painted with oils on canvas. Rookwood went on to win the highest prizes at international fairs for many years to come. It continued its successful competition with the great art potteries of Europe through the 1920s. Unable to weather the Great Depression of the 1930s, Rookwood struggled in a diminished state until 1967, when it finally closed.

In the end, Cincinnati can boast of Louise McLaughlin, the leader of the china-painting movement in America and writer of the first guidebook on the subject, the first American to discover the underglaze decorating technique and write a manual about it, and the first American to work in studio porcelain. Cincinnati can take equal pride in Maria Longworth Nichols Storer's Rookwood Pottery Company, the finest art pottery in America, and one of the leading art potteries in the world. No other city in the United States can boast so much about its ceramic industry.

AJE

Plate 73
Mary Louise McLaughlin (1847–1939), decorator
Cincinnati Pottery Club (1879–1890)
Haviland & Co. blank
Plaque, 1882
Porcelain
Diam. 11 ¼ in. (diam. 28.6 cm)
Gift of the Women's Art Museum Association, 1881.54

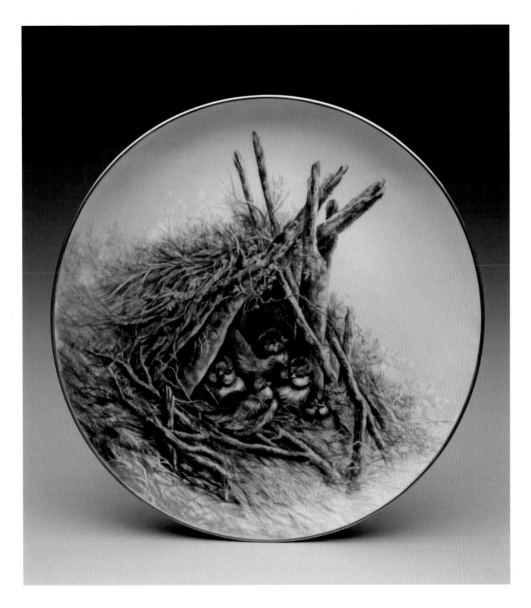

Plate 75

Jane Porter Hart Dodd (1824–1911), decorator

Cincinnati Pottery Club (1879–1890)

Frederick Dallas Hamilton Road Pottery (1865–1882)

Haviland & Co. blank

Plaque, 1881–82

Porcelain

Diam. 13½ in. (diam. 34.29 cm)

Gift of the Women's Art Museum Association, 1881.15

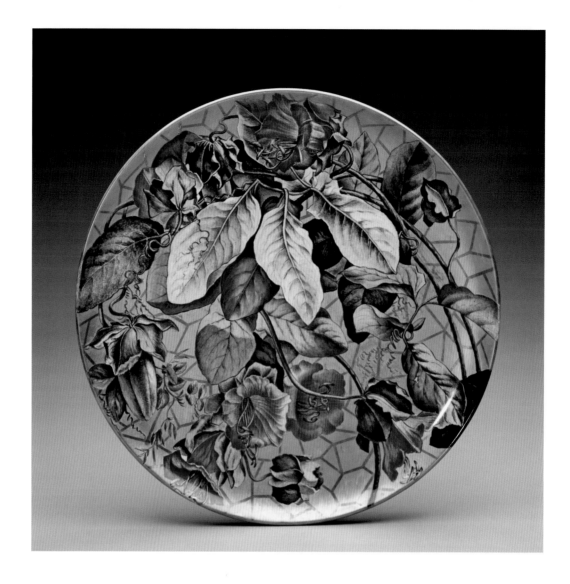

Plate 76
Henrietta D. Leonard (1830–1912), decorator
Cincinnati Pottery Club (1879–1890)
Frederick Dallas Hamilton Road Pottery (1865–1882)
Plaque, 1882
Porcelain
Diam. 16¼ in. (diam. 41.3 cm)
Gift of the Women's Art Museum Association, 1881.60

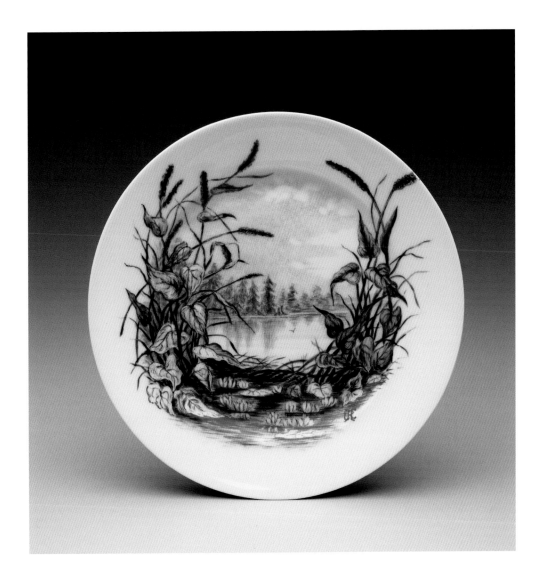

Plate 77

W. S., decorator

Plate, ca. 1875–ca. 1900

Porcelain

Diam. 8½ in. (diam. 21.6 cm)

Gift of Theodore A. Langstroth, 1970.643

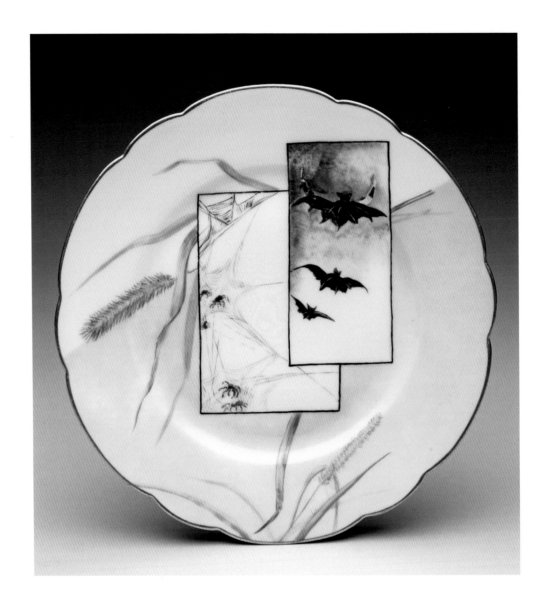

Plate 78

M. M., decorator

Possibly Cincinnati Pottery Club (1879–1890)

Haviland & Co. blank

Plate, 1884

Porcelain

Diam. 8⅜ in. (diam. 21.3 cm)

Gift of Theodore A. Langstroth, 1970.642

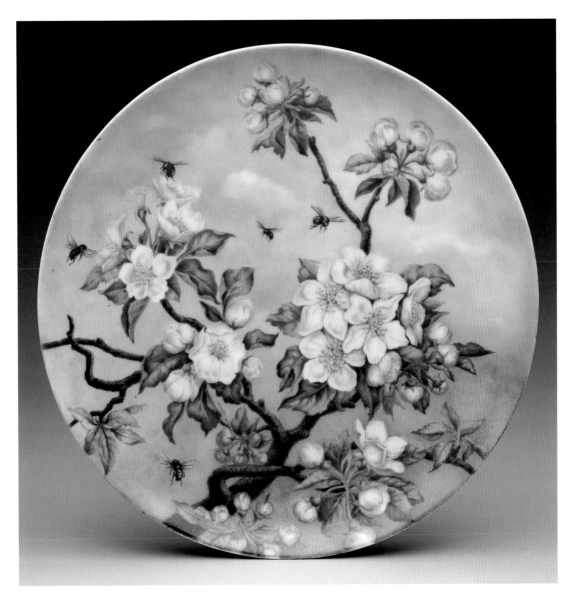

Plate 79

Amanda Merriam (Mrs. Andrew B.) (1827–1903), decorator

Cincinnati Pottery Club (1879–1890)

Frederick Dallas Hamilton Road Pottery (1865–1882)

Haviland & Co. blank

Plaque, 1882

Porcelain

Diam. 12 ¼ in. (diam. 31.1 cm)

Gift of the Women's Art Museum Association, 1882.238

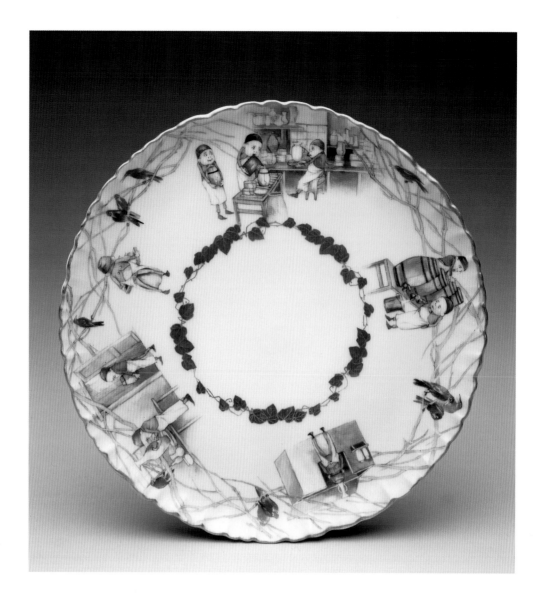

Plate 80
Kataro Shirayamadani (1865–1948), decorator
The Rookwood Pottery Company (1880–1967)
Haviland & Co. blank
Plate, 1887–98
Porcelain
Diam. 8 in. (diam. 20.3 cm)
Gift of W. W. Taylor, 1913.363

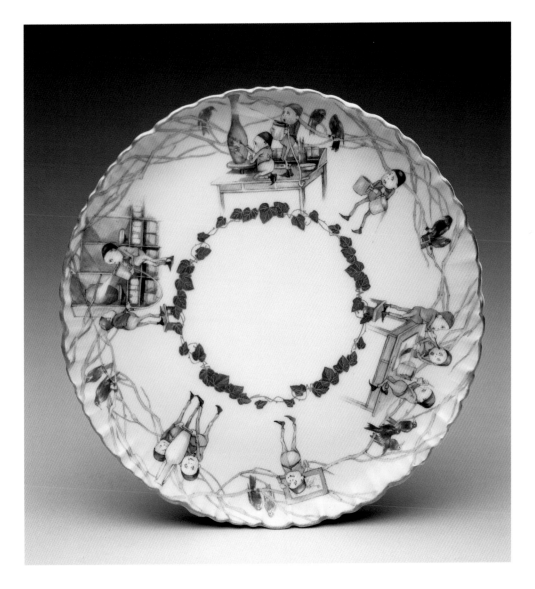

Plate 81
Kataro Shirayamadani (1865–1948), decorator
The Rookwood Pottery Company (1880–1967)
Haviland & Co. blank
Plate, 1887–98
Porcelain
Diam. 8 in. (diam. 20.3 cm)
Gift of W. W. Taylor, 1913.364

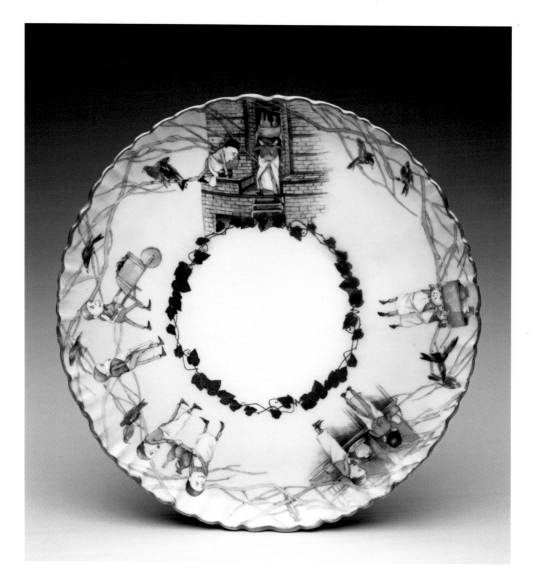

Plate 82
Kataro Shirayamadani (1865–1948), decorator
The Rookwood Pottery Company (1880–1967)
Haviland & Co. blank
Plate, 1887–98
Porcelain
Diam. 8 in. (diam. 20.3 cm)
Gift of W. W. Taylor, 1913.365

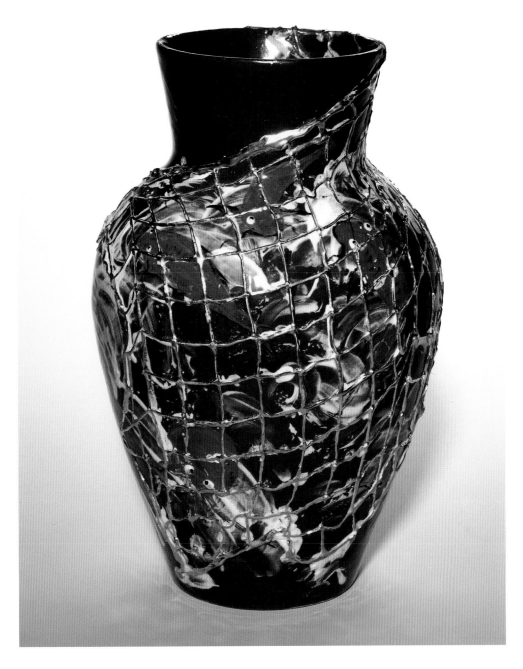

Plate 83
The Rookwood Pottery Company (1880–1967)
Maria Longworth Nichols Storer (1849–1932), decorator
Vase, 1882
Earthenware, Limoges glaze line
H. 13½ in., diam. 9 in. (h. 34.3 cm, diam. 22.9 cm)
Gift of Florence I. Balasny-Barnes in memory of parents
Elizabeth C. and Joseph Balasny, 1992.86

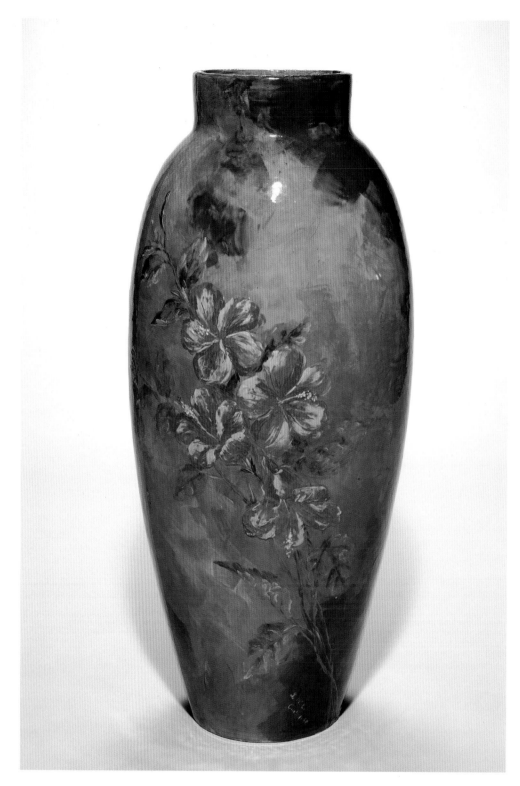

Plate 84
Mary Louise McLaughlin (1847–1939), decorator
Cincinnati Pottery Club (1879–1890)
Frederick Dallas Hamilton Road Pottery (1865–1882)
"Ali Baba" Vase, 1880
Earthenware
H. 37½ in., diam. 16½ in. (h. 95.3 cm, diam. 41.9 cm)
Gift of the Women's Art Museum Association, 1881.239

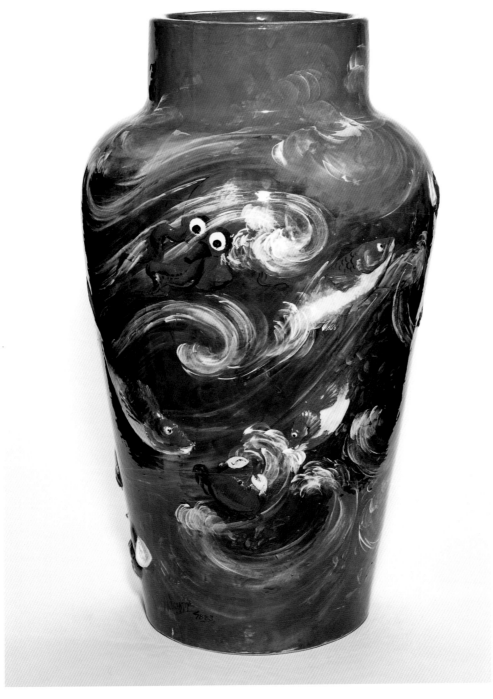

Plate 85

The Rookwood Pottery Company (1880–1967)

Albert Robert Valentien (1862–1925), decorator

Aladdin Vase, 1883

Earthenware, Limoges glaze line

H. 30 in., diam. 18 ½ in. (h. 76.2 cm, diam. 47 cm)

Gift of The Rookwood Pottery Company, 1952.404

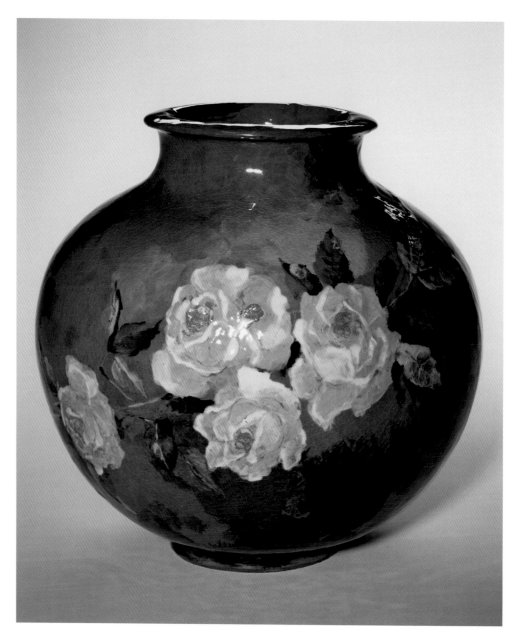

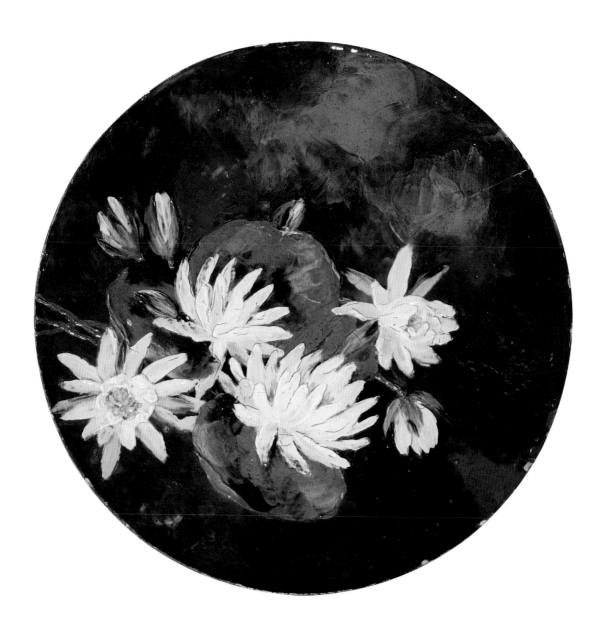

Plate 87
Mary Louise McLaughlin (1847–1939)
Cincinnati Pottery Club (1879–1890)
Possibly Frederick Dallas Hamilton Road Pottery (1865–1882)
Charger, 1879
Buff clay body with underglaze slip decoration
Diam. 19⅜ in. (diam. 49.2 cm)
Gift of Jay A. and Emma Lewis, 1991.266

125

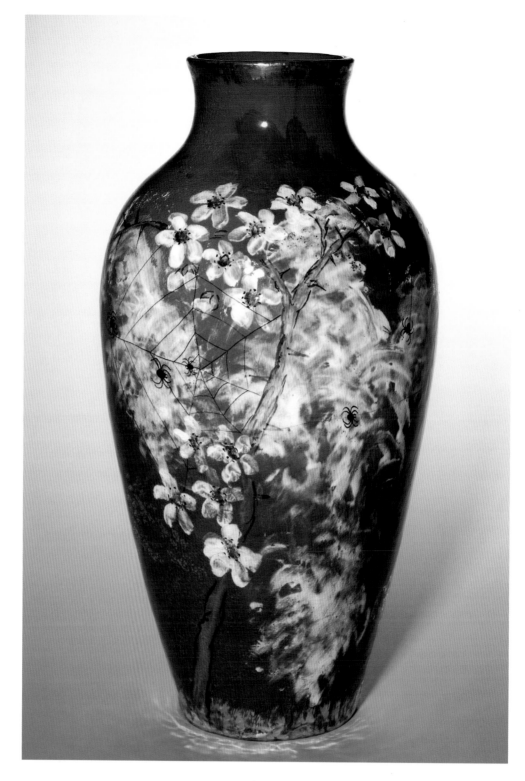

Plate 88

The Rookwood Pottery Company (1880–1967)

Maria Longworth Nichols Storer (1849–1932), decorator

Vase, 1882

Earthenware, Limoges glaze line

H. 18 in., diam. 9 in. (h. 45.7 cm, diam. 22.9 cm)

Gift of Mrs. Julius Fleischmann in memory of Julius Fleischmann, 1971.197

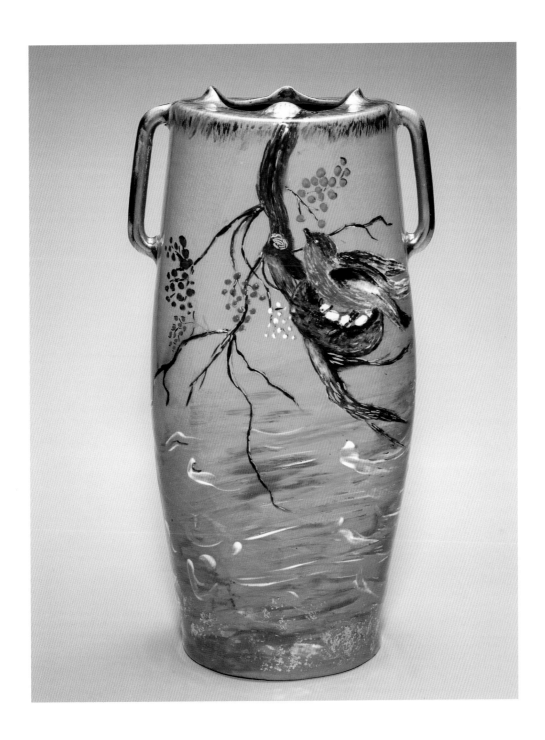

Plate 89

The Rookwood Pottery Company (1880–1967)

Attributed to Maria Longworth Nichols Storer (1849–1932), decorator

Crushed Vase, 1882

Earthenware, Limoges glaze line

H. 14¾ in., diam. 8¼ in. (h. 37.5 cm, diam. 21 cm)

Gift of Florence I. Balasny-Barnes in memory of parents

Elizabeth C. and Joseph Balasny, 1992.84

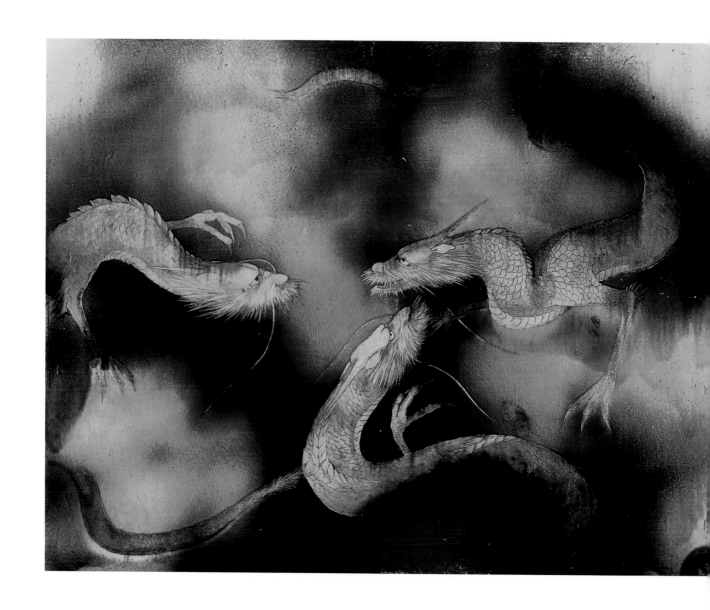

Plate 90

The Rookwood Pottery Company (1880–1967)

Kataro Shirayamadani (1865–1948), decorator

Plaque: A Trinity of Dragons—Earth, Fire and Water, ca. 1892

Earthenware, Standard glaze line

25 x 31 ½ x 1 ½ in. (63.5 x 80 x 3.8 cm)

Gift of Wm. Held MacDonnell, James M. Smith, Ernest V. Thomas, 1974.365

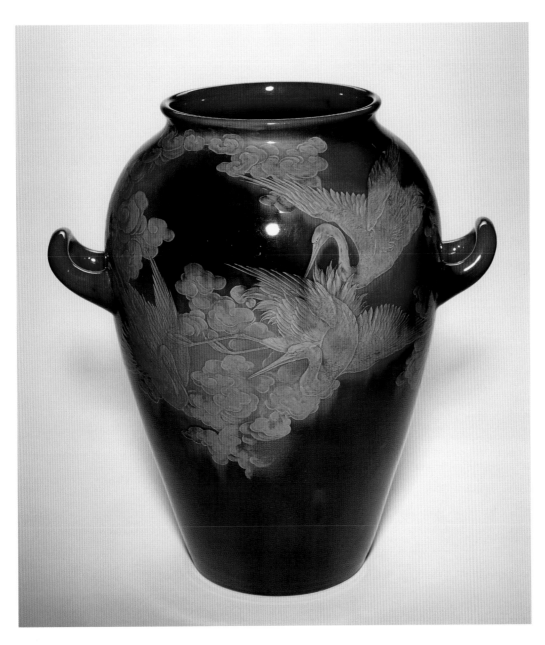

Plate 91
The Rookwood Pottery Company (1880–1967)
Albert Robert Valentien (1862–1925), decorator
Vase, 1893
Earthenware, Mahogany glaze line
H. 19⅝ in., diam. 13 in. (h. 49.8 cm, diam. 33 cm)
Museum Purchase: Lawrence Archer Wachs Trust, 1999.211

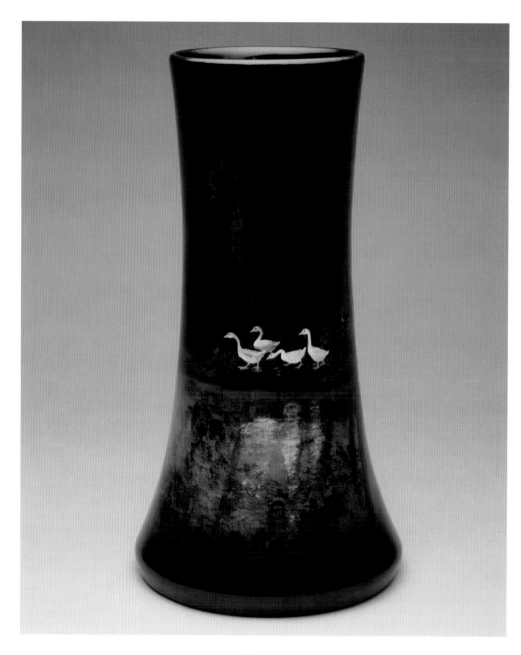

Plate 92

The Rookwood Pottery Company (1880–1967)

Kataro Shirayamadani (1865–1948), decorator

Vase, 1909

Stoneware, Black Iris glaze line

H. 13 in., diam. 7 in. (h. 33 cm, diam. 17.7 cm)

Gift of Mr. and Mrs. James J. Gardner, 2000.142

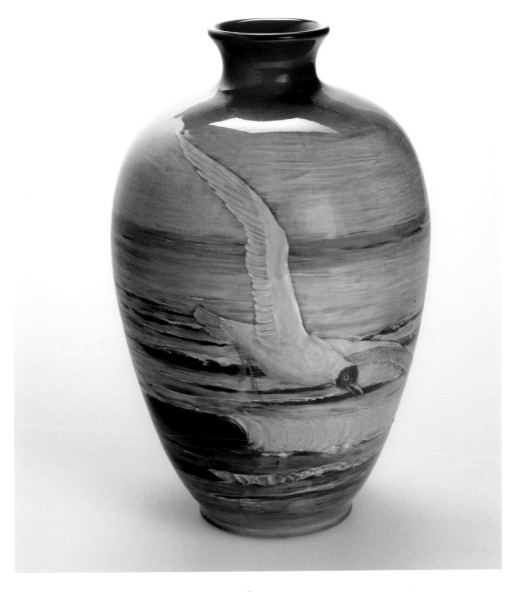

Plate 93

The Rookwood Pottery Company (1880–1967)

Artus Van Briggle (1869–1904), decorator

Vase, 1897

Stoneware, Sea Green glaze line

H. 11 in., diam. 7¾ in. (h. 27.9 cm, diam. 19.7 cm)

Gift of Walter E. Schott, Margaret C. Schott,
Charles M. Williams, and Lawrence H. Kyte, 1952.306

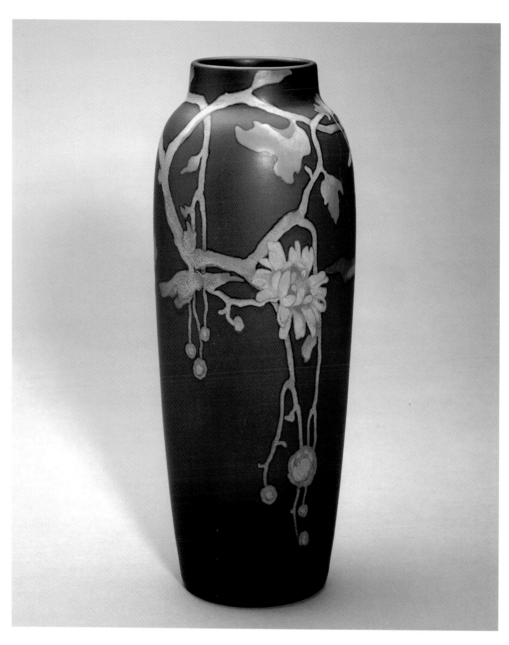

Plate 94

The Rookwood Pottery Company (1880–1967)

Harriet Elizabeth Wilcox (1869–1943), decorator

Vase, 1906

Faience body, Painted Mat Inlay glaze line

H. 13 ¹³⁄₁₆ in., diam. 3 ⅞ in. (h. 35.1 cm, diam. 9.8 cm)

Gift of the Louis Haffner family, 1975.6

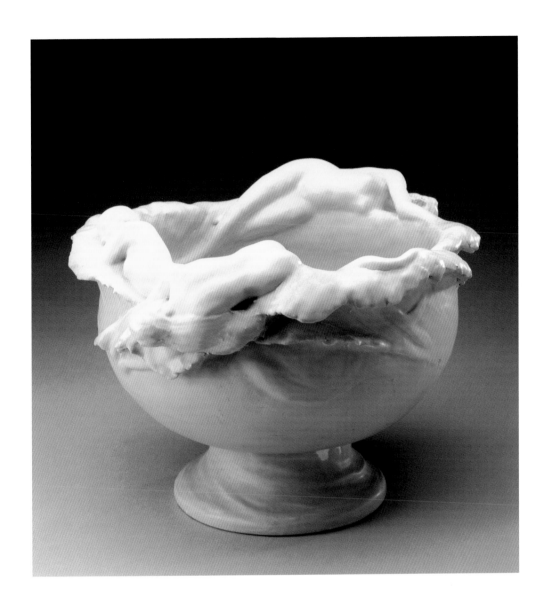

Plate 95

The Rookwood Pottery Company (1880–1967)

Anna Marie Valentien (1862–1947), decorator

Punch Bowl, 1900

Faience body, Modeled Mat glaze line

11 x 17 x 14½ in. (28 x 43.2 x 36.8 cm)

Gift of Mr. and Mrs. Randy Sandler, 2000.143

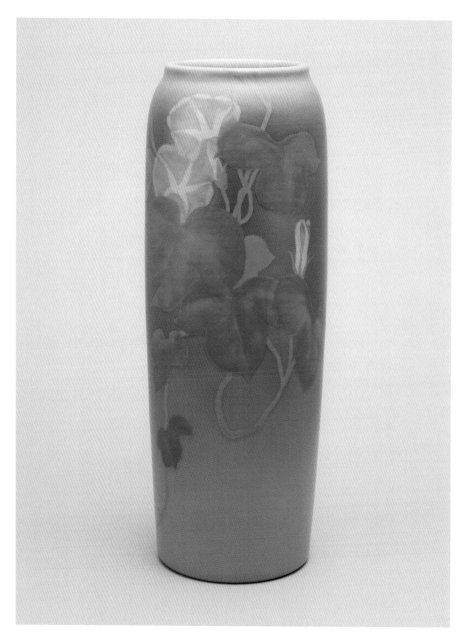

Plate 96

The Rookwood Pottery Company (1880–1967)

Harriet Elizabeth Wilcox (1869–1943), decorator

Vase, 1906

Faience body, Painted Mat glaze line

H. 12 ½ in., diam. 5 ¾ in. (h. 31.8 cm, diam. 14.6 cm)

Gift of William A. Stout, 2000.276

Plate 97
The Rookwood Pottery Company (1880–1967)
William Purcell McDonald (1865–1931), designer
Dutch Landscape, ca. 1921
Mat glazed faience
45 ⅞ x 64 in. (116.5 x 162.6 cm)
Gift of Mr. and Mrs. Roger Barkley, 1983.50

6

American Impressionism
and the Queen City

It is in brushwork that most of the artists who studied under
Duveneck excel. . . . [He] was able to help others to freedom of
expression, but he never imposed his style on his pupils. The
technique which they developed under him was quite their own,
developed and strengthened by the wise guidance of a great
master.

—Rilla Evelyn Jackman

Several of the leading artists associated with American Impressionism came from Cincinnati and enjoyed their first instruction in the Queen City. Most notable were John H. Twachtman, Robert F. Blum, Joseph R. DeCamp, and Edward H. Potthast. At first, the differences among the works of these four men appear more striking than their similarities. The term American Impressionism has been loosely applied to a wide spectrum of late-nineteenth- and early-twentieth-century paintings that take modern life and landscape for their subjects. In many instances, the stylistic debt to the French Impressionist group—Claude Monet, Auguste Renoir, etc.—is actually limited. However, American Impressionists did share several attitudes with the French artists: the desire to paint subjects from the life around them without narrative content; an emphasis on brushwork rather than line; a stress on subjective impressions of nature; and an interest in alternative ways to articulate space and light. These tendencies were not restricted to the French Impressionists, but were international impulses that changed the face of European painting in the 1870s. For Twachtman, Blum, DeCamp, and Potthast, a first encounter with many of these notions came not from France, but from the Munich avant-garde via Frank Duveneck.

In the late nineteenth century, the painting most familiar to Cincinnati residents was the work of the so-called Dusseldorf School of Germany favored by the city's collectors. By the 1870s such work, with its emphasis on storytelling and hard-edged precision, was fast becoming old-fashioned in Europe and on the East Coast, but remained popular in conservative Cincinnati. When Duveneck arrived from Munich in 1873, he introduced painterly realism, which was a revelation to art students surrounded by Dusseldorf paintings.

Twachtman, Blum, DeCamp, and Potthast had much in common. All were born in the 1850s, and each was a first-generation American whose parents had emigrated from Germany to Cincinnati. Their childhood experiences would have been similar, as they grew up in close proximity to one another in Over-the-Rhine, the city's boisterous German neighborhood. In fact, Twachtman and Blum knew each other as boys and

Fig. 12.
John Henry Twachtman.
Peter A. Juley & Son Collection,
Smithsonian American Art
Museum

shared an early enthusiasm for art. None of the four was of the upper classes. Of their fathers, Blum's never settled on a profession, but the other three were artisans: Twachtman's a painter of scenes on window shades, DeCamp's a brick mason, and Potthast's a cabinetmaker. Linked by common backgrounds, they all developed a deep respect and affection for Duveneck, who was only a few years older. Although Duveneck had grown up in Covington, Kentucky, he too was the American-born son of German parents. He forged close bonds with these four artists, three of whom would become his students. Potthast never studied with Duveneck, yet they would cross paths on numerous occasions and Potthast benefited from his influence.

The early years of Cincinnati's McMicken School of Design saw the enrollment of all four American Impressionists-to-be, who valued their tutelage under Thomas Noble. (DeCamp often credited his refined draftsmanship to his studies there.) Nevertheless, provided the opportunity to study with Duveneck at the Ohio Mechanics Institute,

Twachtman, DeCamp, and Blum eagerly enrolled in his life class. While McMicken students were laboring over drawings from the Antique, Duveneck's protégés were out on the streets looking at unvarnished reality with fresh eyes. Noting their contribution to a student exhibition of head studies in both crayon and oil, an amazed critic said, "With these faces on its walls the hall was powerfully suggestive of the interior of an infirmary or municipal lodging house."[1] Duveneck's commitment to the study of nature and his method of working in paint after only a quick sketch on the canvas profoundly impressed these young men.

Cincinnati offered other significant opportunities for these budding talents. For Blum and Potthast, the drive toward contemporary subject matter resulted not only from Duveneck's impact but also from the need to make a living. Both worked for many years drawing illustrations for Cincinnati's famous lithography industry and later for popular national magazines. Many of their assignments involved images of modern life. The celebrated Industrial Expositions that began in Cincinnati in 1870 exposed them to contemporary work not seen elsewhere in the city. This was particularly critical for Blum, who discovered the paintings of Mariano Fortuny and Giovanni Boldini, whose sparkling colors, dazzling light, and sure, quick brushstrokes were inspirational.

Each in his own time, these painters left Ohio for study in the great art centers of Europe. Impressed with Duveneck's bold paintings and his stories of the progressive work of the artists in Munich, all these young talents journeyed there. When Duveneck himself returned to Munich in 1875 after only a short time in Cincinnati, Twachtman accompanied him. Later in the decade, Twachtman and DeCamp were among the "Duveneck Boys," the spirited group that studied with the "Old Man," in Munich, Polling (Bavaria), Florence, and Venice. All four of these artists eventually made their way to France, where the Impressionists were beginning to make an impact on the international community of painters studying in Paris. The Old Masters and contemporary paintings all around them, these Americans developed their individual styles and then returned home.

In 1883 Twachtman and DeCamp (with Kenyon Cox, Louis Ritter, and several other painters who had absorbed modern tendencies in Europe) staged an exhibition at A. B. Closson's gallery in Cincinnati. Local critics took interest in the show and their

commentary was largely positive. One, for example, perceptively observed, "These young men have had the audacity to see nature with their own eyes and not through Dusseldorf spectacles. . . . In this sense they may be said to be of one school, although their works are individual in character."[2] The attention of the press did not generate sales, however, and the painters moved away from Cincinnati feeling unappreciated and disheartened by the prospects for the city's artistic progress.

By the 1880s New York offered the greatest opportunities in America for patronage. It was an irresistible lure for artists from smaller cities all across the country that mourned their departures. In 1900 an article in the *Cincinnati Enquirer* titled "What Ohio Has Given to New York Art" noted that DeCamp, Blum, Twachtman, and Cox were all instructors at New York's Art Students League, where years earlier Duveneck had also taught. These artists soon became identified with the places where they painted many of their finest mature works: Blum with Italy and Japan, Twachtman with Connecticut, DeCamp with Boston, and Potthast with the sunny beaches of the Northeast. Cincinnatians did not forget them, however, and as taste evolved, began to admire and collect their works. The Cincinnati Art Museum was the first museum in the country to purchase one of Twachtman's paintings (pl. 114). This was part of the museum's groundbreaking practice of acquiring works by contemporary American artists, the pride of Lewis Henry Meakin (pl. 109), the city's resident American Impressionist and the museum's curator of paintings.

During the late nineteenth century, when painters were reacting to new developments in European art and industrialization, decorative artists in Cincinnati responded to similar forces. Like Blum (pl. 102) and Duveneck (pls. 103, 104), decorative artists showed a reverence for Italy, a favorite destination of both artists and tourists for centuries. A micromosaic tabletop depicting Roman architecture was obviously purchased in Italy and set into the William Fry Center Table (pl. 105) carved in what Fry called the "Italianate" style. The Rookwood vase (pl. 101) that Carl Schmidt painted with a quiet, evocative scene of Venetian fishing boats likewise demonstrates a fascination with Italy. Schmidt shared aesthetic concerns with painters who worked on canvas. This vase, like Twachtman's *Springtime* (pl. 100), reflects a desire to suggest delicate nuances of mood, space, and atmosphere through innovative techniques. While painters avoided

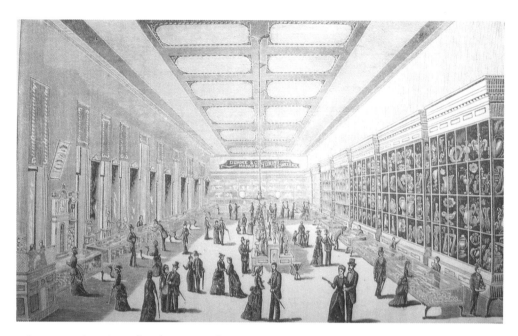

Fig. 13. Interior view of Duhme & Co.'s. *From* Kenny's Illustrated Cincinnati of 1875.
Cincinnati Historical Society Library

the soot-blackened city as subject, decorative artists of the time directly responded to industrialization. For example, the footed bowl (pl. 113) and the fish serving set (pl. 115) bear the Japanese influence of visible hammer marks, as if the touch of the artist—like vivid Impressionist brushstrokes—offered proof they were handmade objects, not machine-made, debased products of industry. Counter to this, the remaining silver articles illustrated in this section revel in various styles that include design motifs—such as bird finials (pl. 107) and rolled banding (pl. 116)—made easier to produce by industrial techniques. These tendencies and responses in decorative arts, like those in Impressionist painting, were not unique to the Queen City. Cincinnati's artists of the late nineteenth century were active participants in the national and international movements of their day and made noteworthy contributions to the history of American art and culture.

JA/AJE

Plate 98

John H. Twachtman (1853–1902)

Snow Scene, 1882

Oil on canvas

12 1/16 x 16 1/16 in. (30.6 x 40.8 cm)

Bequest of Louise Drude, 1916.9

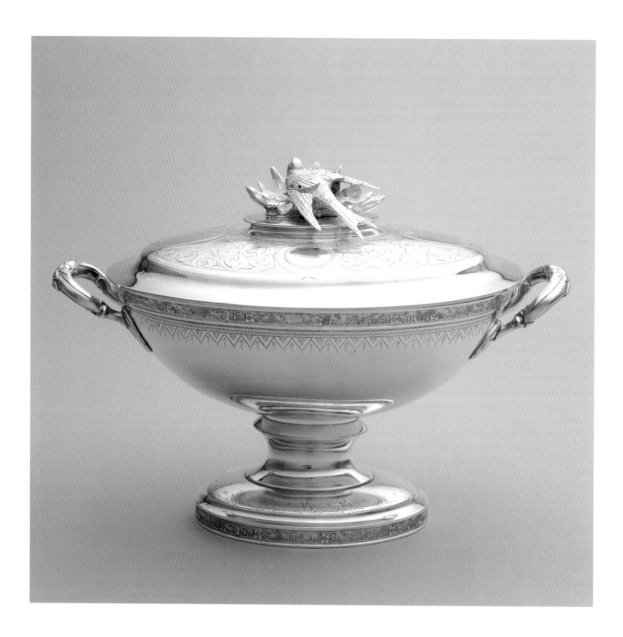

Plate 99

Duhme & Co. (1842–1910)

Tureen, 1870s

Silver

8 ½ x 13 x 7 ¼ in. (21.6 x 33 x 18.4 cm)

Museum Purchase: John S. Connor Endowment, Mark Herschede Endowment,
and Dwight J. Thomson Endowment, 1999.207

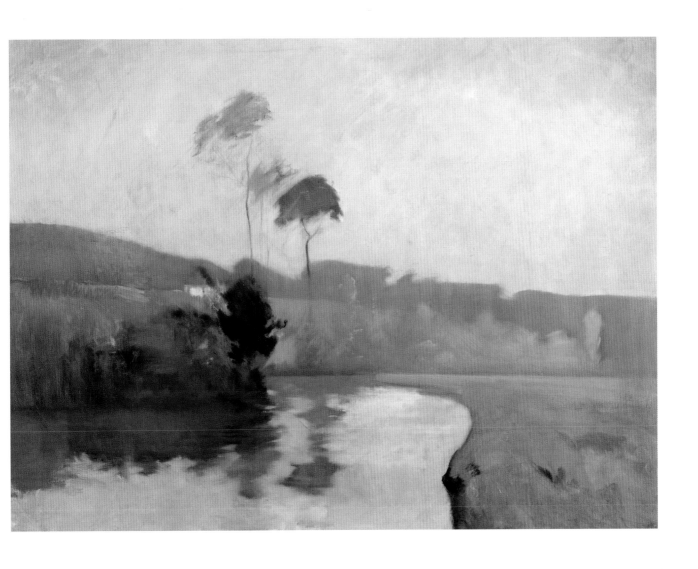

Plate 100

John H. Twachtman (1853–1902)

Springtime, ca. 1884

Oil on canvas

36⅞ x 50 in. (93.7 x 127 cm)

Gift of Frank Duveneck, 1908.1218

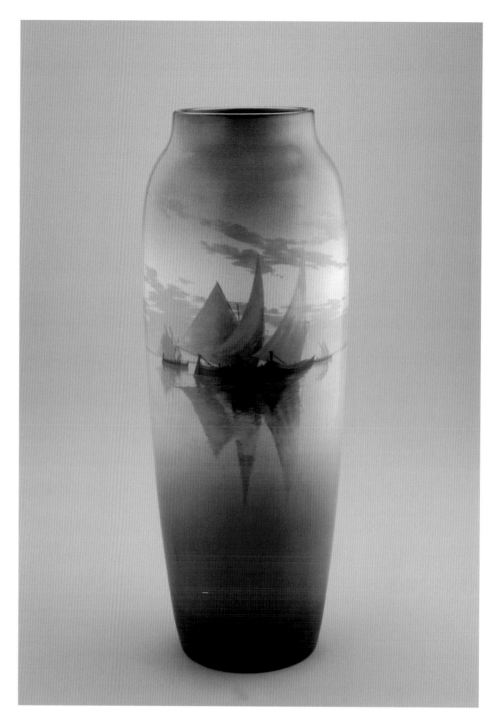

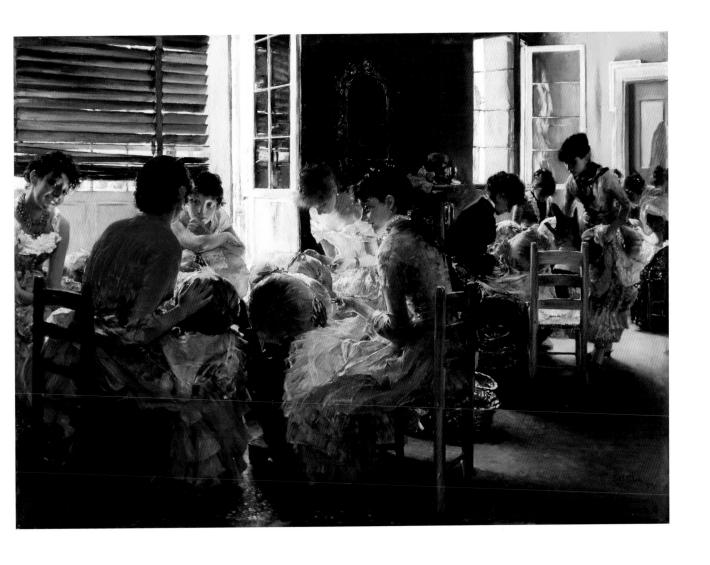

Plate 102
Robert Frederick Blum (1857–1903)
Venetian Lace Makers, 1887
Oil on canvas
30⅛ x 41¼ in. (76.5 x 104.8 cm)
Gift of Elizabeth S. Potter, 1905.8

147

Plate 103
Frank Duveneck (1848–1919)
Italian Courtyard, 1886
Oil on canvas
22 ¼ x 33 ³⁄₁₆ in. (56.5 x 84.3 cm)
Gift of the Artist, 1915.76

148

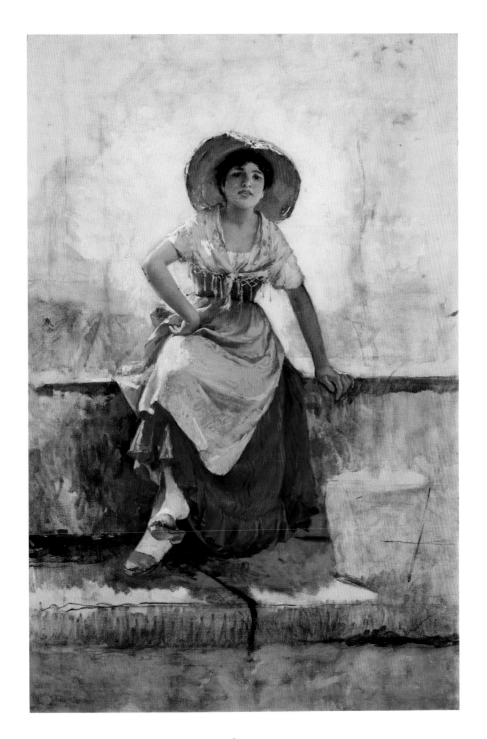

Plate 104

Frank Duveneck (1848–1919)

Florentine Flower Girl, ca. 1886

Oil on canvas

38 ¹⁄₁₆ x 25 ¼ in. (96.7 x 64.1 cm)

Gift of the Artist, 1915.70

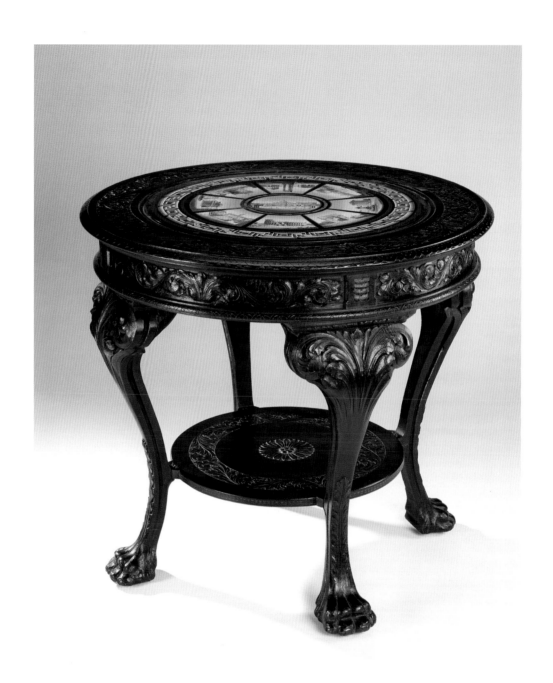

Plate 105
William H. Fry (1830–1929)
Table, ca. 1860–80
Ebonized white oak and Italian micromosaic
H. 29 3/16 in., diam. 32 1/2 in. (h. 74.1 cm, diam. 82.5 cm)
Gift of Mrs. Ida McGowen, 1926.56

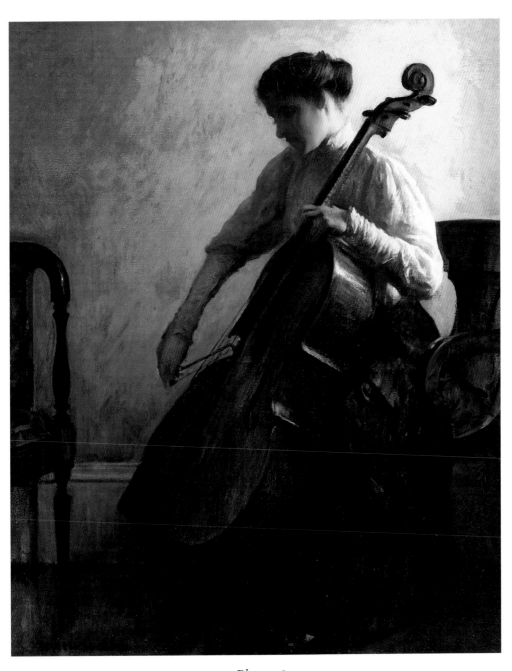

Plate 106

Joseph R. DeCamp (1858–1923)

Cellist, ca. 1907–8

Oil on canvas

28 x 23 ¹⁄₁₆ in. (71.1 x 58.6 cm)

John J. Emery Fund, 1924.476

151

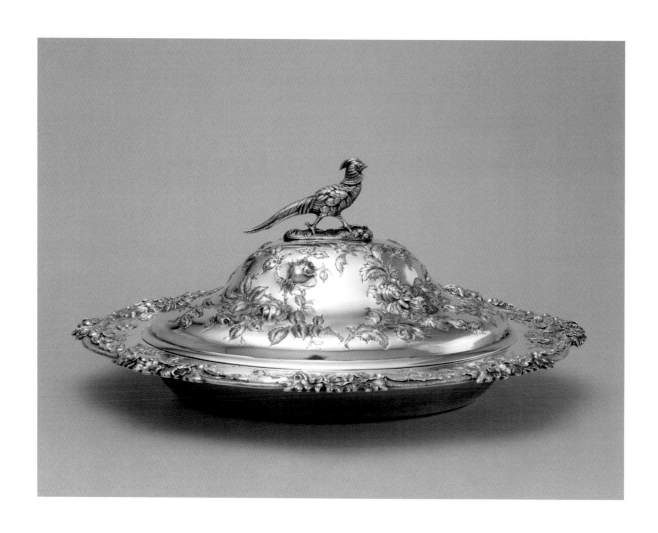

Plate 107
Loring Andrews & Co. (1896–1958), retailer
Covered Vegetable Dish, ca. 1890–1905
Silver
6½ x 14 x 11⅜ in. (16.5 x 35.6 x 28.9 cm)
From the Collection of Mrs. Frank L. Wright II, 2001.1 a,b

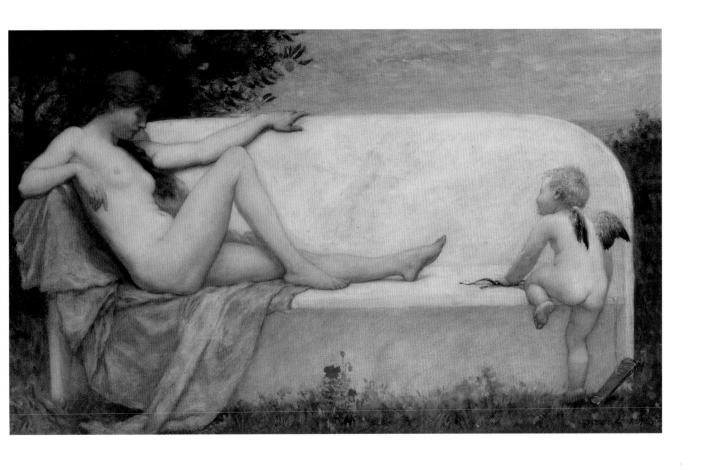

Plate 108

Kenyon Cox (1856–1919)

The Approach of Love, 1890–93

Oil on canvas

18 ⅛ x 30 ¼ in. (46 x 76.8 cm)

Gift of Mrs. John De Witt Peltz and Leonard Updycke
in memory of their parents Leonard E. and Edith Updycke, 1946.73

Plate 109

Lewis Henry Meakin (1850–1917)

Salt Marsh, Cape Ann, 1892

Oil on canvas

21 ³⁄₁₆ x 33 ⅛ in. (53.8 x 84.1 cm)

Gift of the Lewis Henry Meakin Estate, 1936.645

154

Plate 110

Edward H. Potthast (1857–1927)

Brother and Sister, ca. 1915

Oil on canvas

24⅛ x 20⅛ in. (61.3 x 51.1 cm)

Bequest of Mr. and Mrs. Walter J. Wichgar, 1978.333

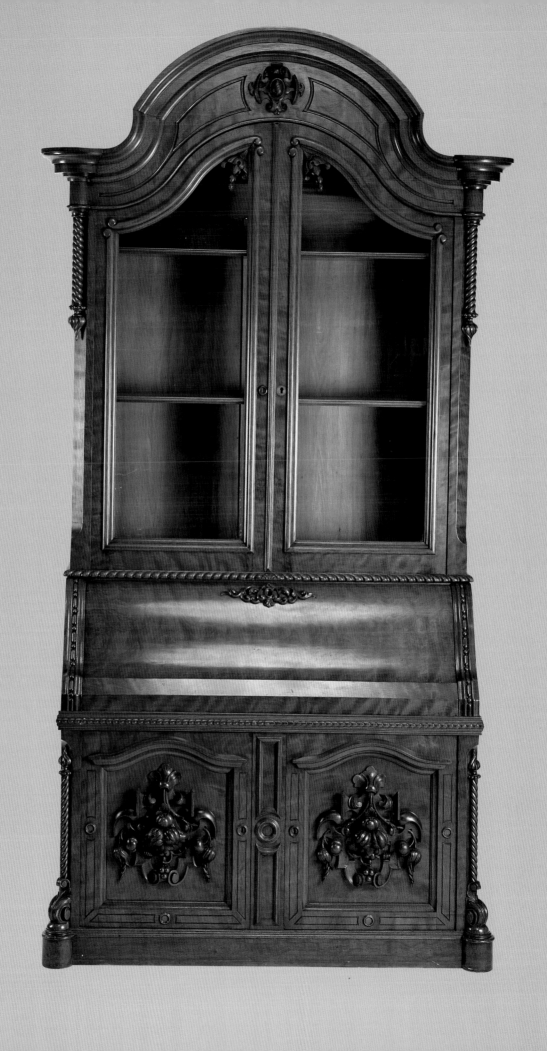

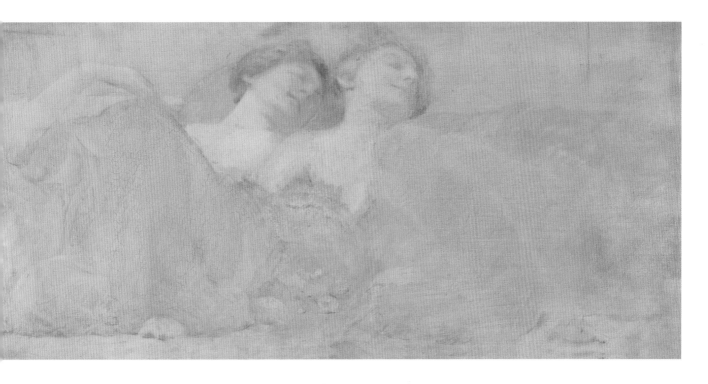

Plate 112

Robert Frederick Blum (1857–1903)

Mural Study, ca. 1893–98

Oil on canvas

13 ⅝ x 28 ¾ in. (34.6 x 73 cm)

Gift of Charles and Patricia Weiner, 1999.243

Plate 111

Attributed to Carl Dannenfelser (1854–1916)

Secretary-Bookcase, 1870–1900

Walnut veneer, maple, bird's eye maple, poplar, and glass

108 x 57 x 23 ½ in. (274.3 x 144.8 x 59.7 cm)

Gift of Mrs. Carolyn Marcus, 1969.507

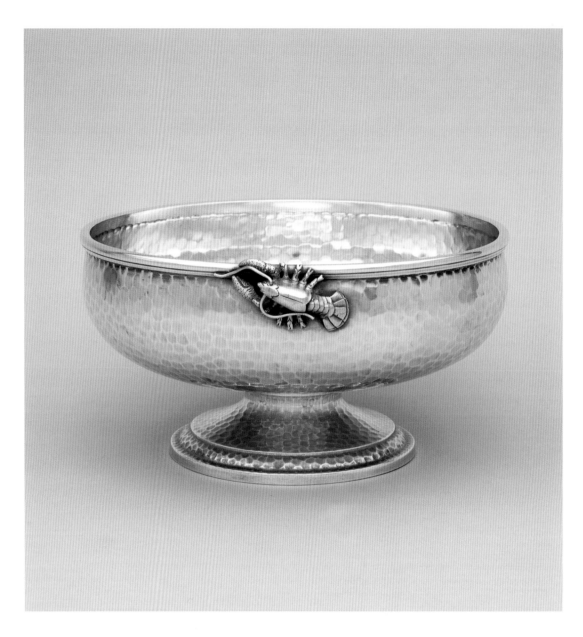

Plate 113

Duhme & Co. (1842–1910)

Footed Bowl, ca. 1880s

Silver

H. 4¼ in., diam. 8¾ in. (h. 10.8 cm, diam. 22.2 cm)

Museum Purchase: Decorative Arts Deaccession Funds, 2000.156

Plate 114

John H. Twachtman (1853–1902)

Waterfall, Blue Brook, ca. 1899

Oil on canvas

25 ⅛ x 30 1/16 in. (63.8 x 76.4 cm)

Annual Membership Fund, 1900.44

Plate 115

Duhme & Co. (1842–1910)

Fish Serving Set, 1887

Silver and silver gilt

Fish Slice: 12 9/16 in. (31.9 cm)

Fork: 9 3/4 in. (24.8 cm)

Gift of Dorothy Krug Newstedt, 1975.266 a,b

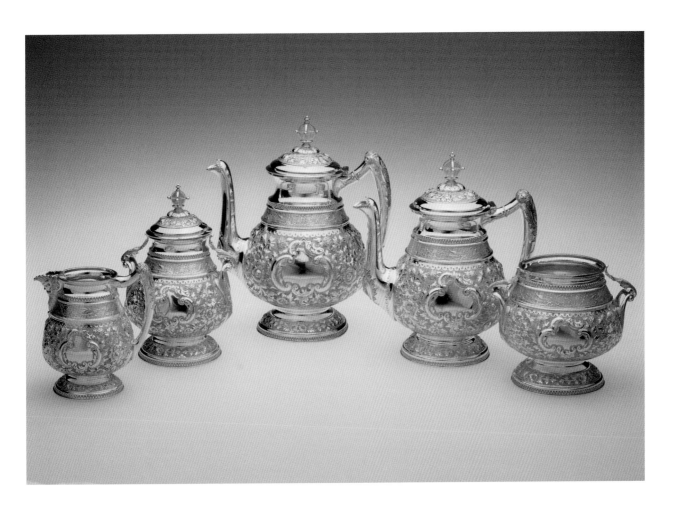

Plate 116

Duhme & Co. (1842–1910)

Tea and Coffee Service, 1870s

Silver

Coffeepot: 10 ½ x 9 x 6 ¼ in. (26.7 x 22.9 x 15.9 cm)

Teapot: 9 ¼ x 8 ½ x 5 ⅝ in. (23.5 x 21.6 x 14.3 cm)

Creamer: 5 ¼ x 5 ¼ x 5 in. (13.3 x 13.3 x 12.7 cm)

Sugar Bowl: 8 x 5 ½ x 5 in. (20.3 x 14 x 12.7 cm)

Waste Bowl: 5 ¼ x 6 ½ x 5 ½ in. (13.3 x 16.5 x 14 cm)

Gift of Dr. and Mrs. James L. Hecht, 1984.198–202

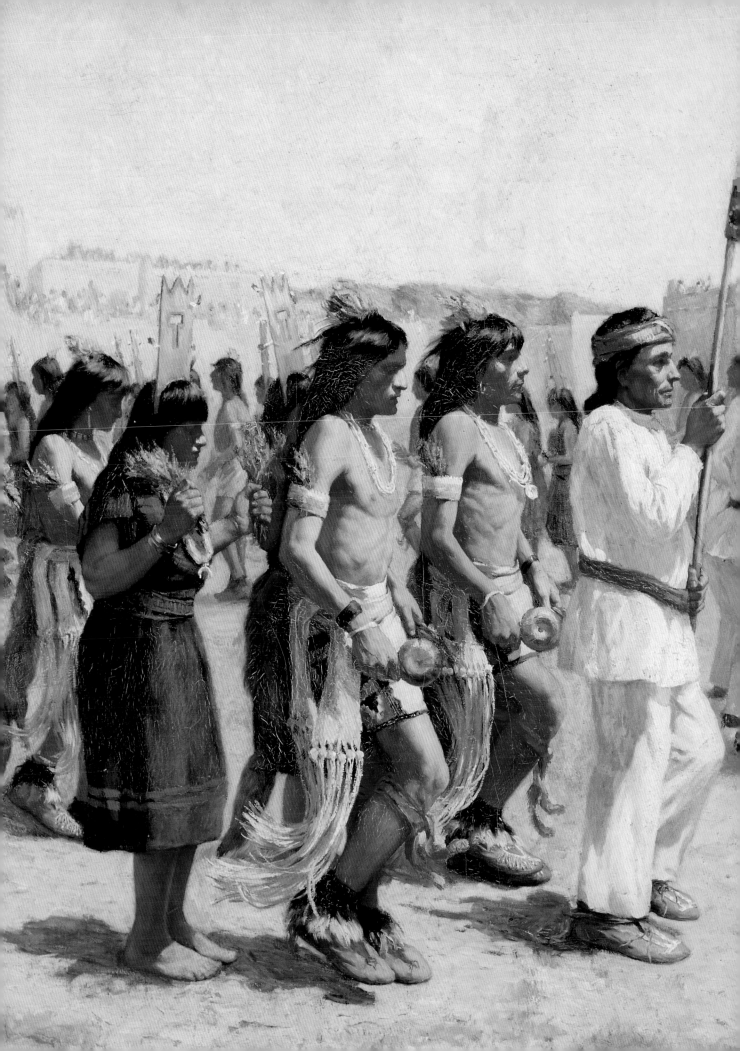

Cincinnati Looks West

Henry Farny and Joseph H. Sharp

The Indian is becoming a factor for distinctly American pictures and Western artists in particular seem to be grasping his importance as a picturesque motif.

—Joseph H. Sharp, 1899

By 1880 Cincinnati could no longer declare itself the Queen of the West. Through Manifest Destiny, the nation had expanded from coast to coast, leading the federal government to officially close the frontier in 1890. The city on the Ohio had evolved from a bastion of urban culture on the brink of the nation's wilderness to one of many portals to the South and West. (Cincinnati's resident artists, however, proudly deemed themselves "Western" to make a distinction from those in East Coast cities.) It was in the latter decades of the nineteenth century, during the last phase of forced removal of native peoples onto reservations, that the widespread concept of the American West rose in popularity. Nationalism, nostalgia, romance, and often racism shaped the concept of the Wild West that remains potent today because of vivid paintings and novels made one hundred years ago or more. While Frederic Remington invented the classic cowboy image, two Cincinnati painters, Henry Farny and Joseph H. Sharp, created some of the most compelling, sympathetic, and iconic imagery of Native American life.

Born in France in 1847, Henry Farny arrived in America at age six. His family first settled in western Pennsylvania, where he became fascinated with American Indians. In 1859, seeking urban amenities, the family moved to Cincinnati. However, the death of Farny's father in 1863 dimmed the family's prospects. Henry had to leave school, but soon found work as an illustrator. His skills grew quickly and by 1865 he was an employee of *Harper's Weekly* in New York. Farny brought his gifts as a raconteur to his illustrations, and later to his paintings. Determined to become a painter, Farny studied in Europe for several years. With a thorough knowledge of art, he created a unique hybrid style with which he soon eloquently expressed American themes.

In 1881 Farny made his first trip west to Fort Yates in the Dakota Territory, then settled in Cincinnati. Full of enthusiasm, he declared "the plains, the buttes, the whole country, and its people fuller of material than any other country in Europe."[1] He returned armed with sketches, artifacts, and photographs for composing paintings in his studio, his customary practice. To acquire new materials and fresh inspiration, he would

Fig. 14. Nancy Cones, *Henry François Farny*, ca. 1902, gum kallitype, 6 ⁹⁄₁₆ x 4 ⅝ in. *Cincinnati Art Museum; Centennial Gift of Mrs. Sells Stites, 1981.281*

travel west again on several occasions, the last time in 1894. During these trips, he became intimately familiar with Native Americans and their artifacts, customs, and languages.

Critics unfailingly lauded Farny's works for unromantic accuracy, by which they meant the paintings told a true story. *The Unwelcome Guests* (pl. 118) of 1887 is a fine example. The painting shows a tense encounter between Indians and settlers, a familiar occurrence in the conflict over control of the Plains. The work demonstrates Farny's knowledge of government policies, such as the one that forbade Whites to hunt on Indian lands. The accumulation of precise details—for example, the liquor bottle tossed in the snow at far left—conveys truthfulness and builds a compelling narrative. As in all his best work, here Farny's careful composition and spare, elegant landscape enhance the narrative with their drama and beauty. His precise recording of details obscures the fact that he sometimes mixed artifacts of different Indian tribes. However, the minutiae of historical and ethnographic accuracy were not Farny's greatest concern. His firsthand

knowledge met a fertile imagination. Like many examples, *The Unwelcome Guests* depicts Plains life as Farny imagined it during its glory days (about 1740–1875), before he himself set foot in the West.

Farny's younger colleague, Joseph Henry Sharp, shared his desire to preserve the American Indian on canvas before the old traditions and picturesque character were forever lost. Born in 1859 in Bridgeport, Ohio, Sharp came to Cincinnati to study art, then, like Farny, traveled abroad to absorb lessons from the European art centers. Although deaf from a childhood swimming accident, Sharp was an excellent communicator in writing and a successful teacher at the Art Academy of Cincinnati for ten years beginning in 1892, when he painted *Fountain Square Pantomime* (pl. 72).

Sharp once provided the following explanation of his interest in Native Americans: "I guess it was Fenimore Cooper who first attracted me to the Indian. . . . Then when I came to know them I liked them for themselves. Perhaps they attracted me as subjects to paint because of their important historical value as the first Americans. Then the color of their costumes and dances, this no less attracted me."[2] One could add the importance of Farny's example. With Farny's advice, Sharp traveled west for the first time in 1883. However, it was a visit to Taos, New Mexico, ten years later that resulted in Sharp's first important paintings of Native Americans, including *Harvest Dance* (pl. 119), which was immediately purchased by the Cincinnati Art Museum. These works also signaled a dramatic change in his style—in modern French painting he had found the broad brushwork and high-keyed palette he would use to capture the sun-drenched landscapes and colorful dress of the native people of the Southwest.

Less interested than Farny in composing narratives, Sharp painted his subjects directly (he admired the naturalism and immediacy of Frank Duveneck's work) and concentrated much of his effort on portraiture and landscapes painted *en plein air* (in open air). He spent a number of summers in New Mexico depicting the Pueblo, and in Montana and the Dakotas painting the Crow, Blackfoot, Sioux, and Cheyenne. In 1901 the federal authorities allowed him to build a cabin on the Crow Indian Agency in Montana, where he painted striking and sensitive portraits in brilliant hues. Collectors valued his works as both art and ethnology—a large group was placed at the Smithsonian, and another was purchased by Phoebe Hearst to form a "Tribal History of

Fig. 15. Joseph Henry Sharp in his Cincinnati studio, 1896, age 37. *Buffalo Bill Historical Center, Cody, Wyoming; PN.22.95, Gift of Forrest Fenn*

America" at the University of California. Farny and Sharp are both renowned for paintings of western Indians, but while Farny was content to work in his Cincinnati studio, Sharp moved permanently to Taos in 1912 to be close to his subjects. The artists differed in other respects. Farny concentrated on the people of the Plains; he admired their warrior skills and nomadic lifestyle that had focused on the buffalo. Following his move to the Southwest, Sharp found renewed inspiration among the Pueblo people, whose ceremonies and life revolved around the growing of corn.

Both Farny and Sharp were disheartened by cultural losses and regulations imposed by the government, Indian agents, and missionaries. When a regulation requiring Indians to cut their hair passed in 1902, Sharp wrote a heartfelt letter of protest to the Department of the Interior and stated, "It is too much as tho' you yourself were *forced* to renounce your religion and love & hopes of the future."[3] In 1915, the year before his death, Farny lamented, "The Indian painter, like the Indian himself, is of a dying race. . . . The reason is that there are so few Indians worth painting. The Indian is wearing store clothes and acquiring a shabby veneer of civilization."[4] Sharp, however, continued to celebrate the resilience and enduring traditions of the Native Americans whom he knew and adored until his death in 1953.

JA

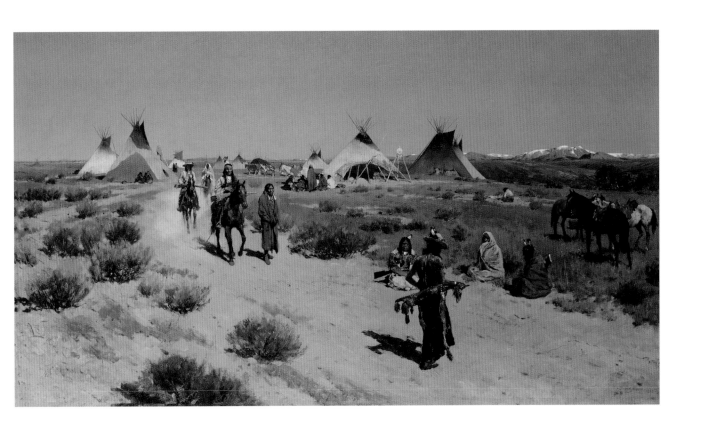

Plate 117
Henry Farny (1847–1916)
Hunting Camp on the Plains, 1890
Oil on canvas
22⅛ x 38⅝ in. (56.2 x 98.1 cm)
Bequest of Mrs. William A. Julian, 1949.43

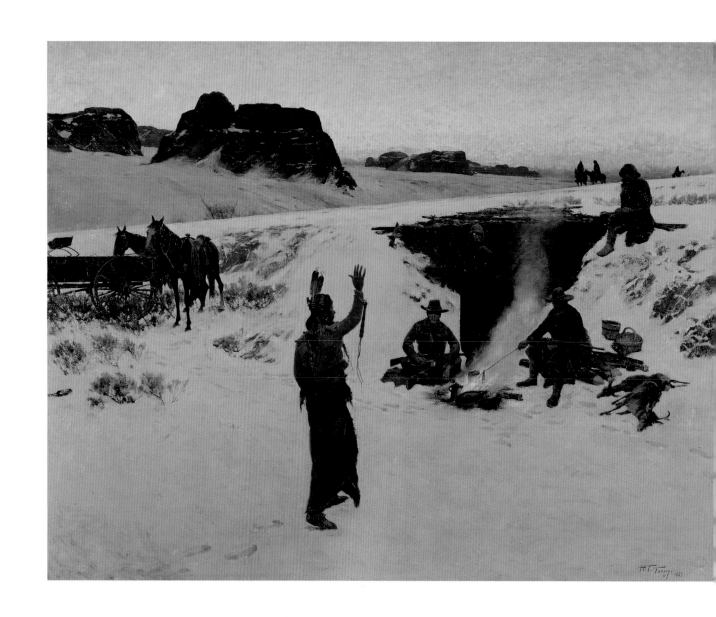

Plate 118

Henry Farny (1847–1916)

The Unwelcome Guests, 1887

Oil on canvas

38 1/16 x 48 3/16 in. (96.7 x 122.4 cm)

Bequest of Harry S. and Eva Belle Leyman, 1943.14

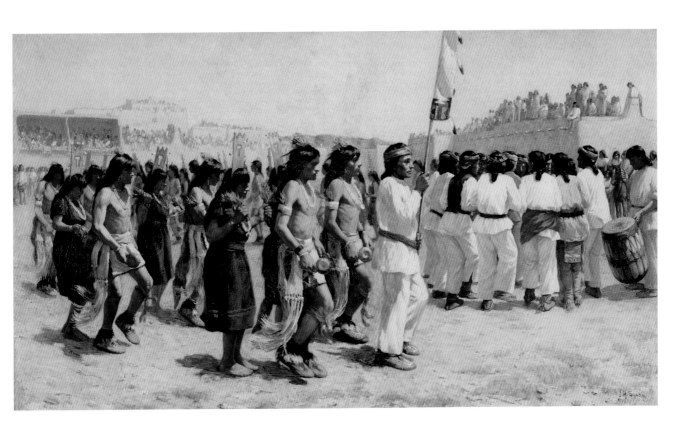

Plate 119
Joseph Henry Sharp (1859–1953)
Harvest Dance, 1893–94
Oil on canvas
27 11⁄$_{16}$ x 48 ⅝ in. (70.3 x 123.5 cm)
Museum Purchase, 1894.10

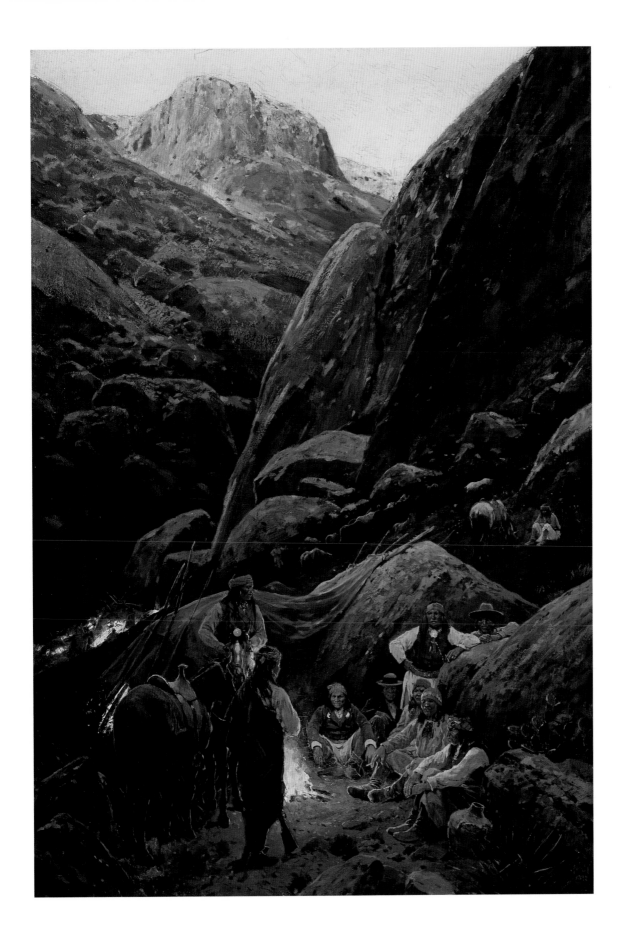

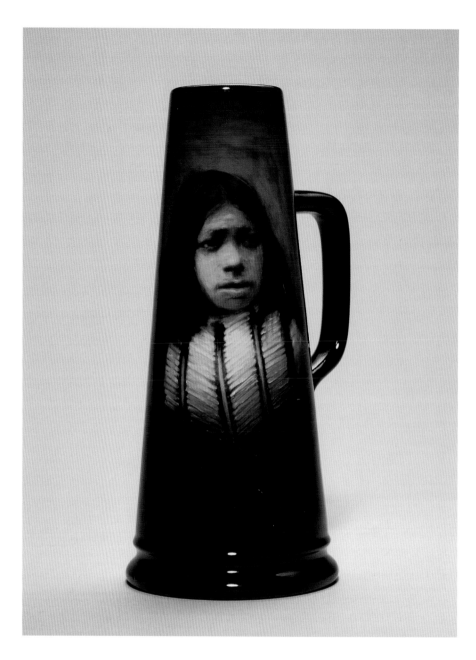

Plate 121

The Rookwood Pottery Company (1880–1967)

Sadie Markland (?–1899), decorator

Tankard: Buffalo Hump, 1898

Stoneware, Standard glaze line

H. 8⅞ in., diam. 4⅞ in. (h. 22.5 cm, diam. 12.4 cm)

Gift of Mary Mills Ford, 1978.288

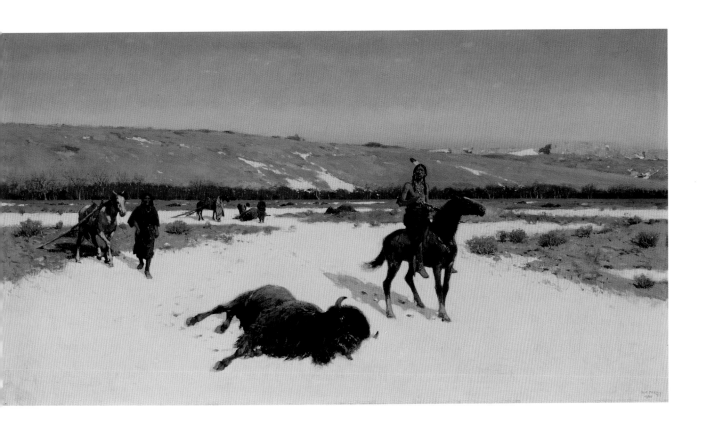

Plate 122

Henry Farny (1847–1916)

The Last of the Herd, 1906

Oil on canvas

22 x 39 ¹⁵⁄₁₆ in. (55.9 x 101.4 cm)

Farny R. and Grace K. Wurlitzer Foundation, 1964.321

Plate 123

Unknown maker, Cheyenne

Moccasins, ca. 1890–1904

Deer hide, trade beads, sinew sewn

Each 9 ½ x 3 ¼ in. (24.1 x 8.3 cm.)

Gift of J. H. Sharp, 1930.381 a,b

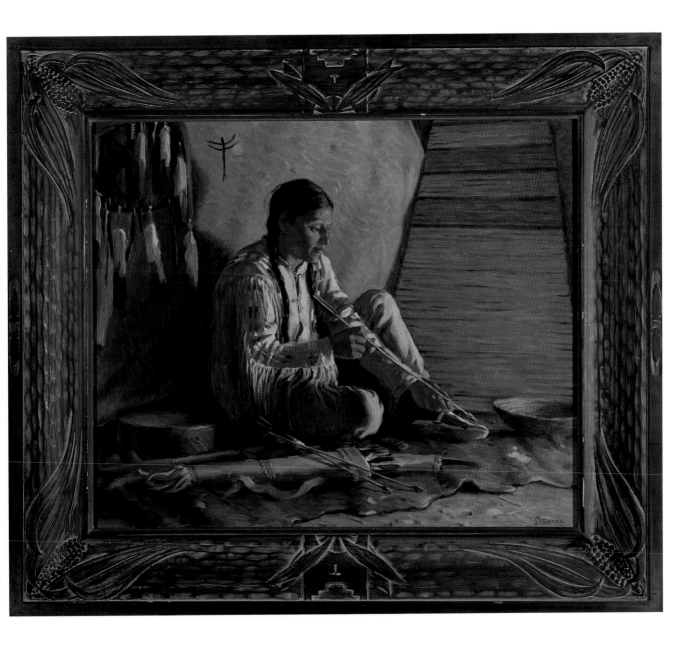

Plate 124

Joseph Henry Sharp (1859–1953)

The Arrow Maker, ca. 1920

Oil on canvas in frame designed by the artist

22 x 27 ⅛ in. (55.9 x 68.9 cm)

Bequest of Melba R. Townsend in memory of her parents,
Mr. and Mrs. Louis Schott, 2001.60

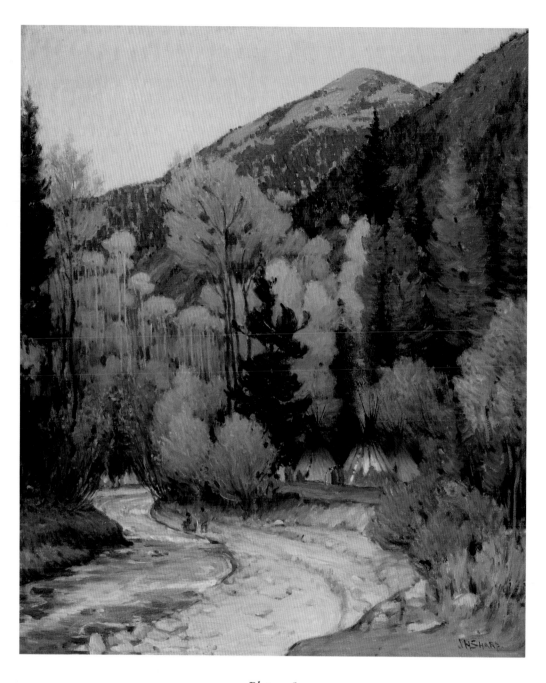

Plate 125
Joseph Henry Sharp (1859–1953)
Apache Camp in Hondo Cañon, New Mexico, ca. 1900–ca. 1920s
Oil on canvas
24 ⅛ x 20 ⅛ in. (61.3 x 51.1 cm)
Bequest of Miss Alice R. Werk, 1997.119

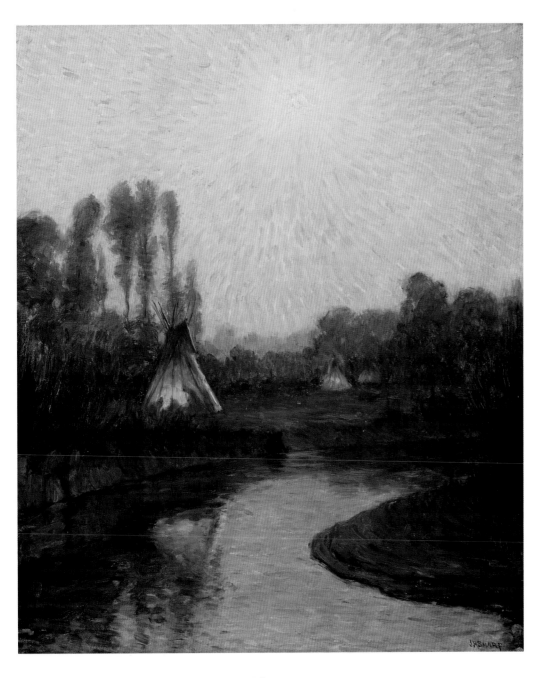

Plate 126
Joseph Henry Sharp (1859–1953)
Early Moonlight, Crow Reservation, ca. 1900–ca. 1920s
Oil on canvas
24 ¼ x 20 ⅛ in. (61.6 x 51.2 cm)
Bequest of Miss Alice R. Werk, 1997.120

Arts and Crafts Metalwork

There is a decided Japanese character to her [Maria Longworth
Nichols Storer's] work, which is weird and unique. The model-
ling [*sic*] is in low relief, broad, sketchy and suggestive, possess-
ing that decorative quality found in Japanese art.

—*Keramic Studio,* 1900

In the late nineteenth and early twentieth centuries, the production of Arts and Crafts metals flourished in America. In part, the interest in the medium was sparked at the 1876 Philadelphia Centennial Exhibition, where the display of Japanese metalwork enthralled fairgoers. Looking to the Japanese for inspiration, American artists experimented with metals, creating unique styles and techniques. A number of American cities, such as Chicago, cultivated Arts and Crafts communities where metalwork abounded. Although such a community did not develop in Cincinnati, metalworkers in the Queen City worked in a manner consistent with Arts and Crafts principles, experimenting across media and guiding the process of artistic manufacture from design to production.

The Cincinnati artists who excelled in metalworking are better known for their accomplishments in other media, and most began work in metals late in their careers. The Cincinnati Art Museum's collection of Cincinnati Arts and Crafts metals includes pieces by Maria Longworth Nichols Storer (1849–1932), M. Louise McLaughlin (1847–1939), Edward Timothy Hurley (1869–1950), Benn Pitman (1822–1910), Edna Boies Hopkins (1873–1937), and Anna Maria Riis (1865–1945). This notable collection of eclectic work reveals a wide range of style and technique.

Maria Longworth Nichols Storer is best known as the founder of The Rookwood Pottery Company. She began working in metals in 1897 with the assistance of Yosakichi Asano, a Japanese metalworker. Between 1897 and 1900, while living in Brussels and Spain, Storer produced over forty unique pieces in metal, including plaques (pl. 127), vases, pitchers, chalices (pl. 130), baskets (pl. 128), and paperweights. These functional forms (although not intended for use) possess a wonderful textural and sculptural quality. Although Storer's metalwork is made of tin, she used an elaborate fabrication technique to give her sculptures the appearance of aged bronze. Like her work in ceramics, Storer's metalwork—adorned with dragons, monkeys, sea creatures, mermaids, and grotesque figures—reflects her avid interest in Japanese art. She exhibited her metalwork to great acclaim at the Exposition Universelle in Paris in 1900. The display earned Storer

Fig. 16. Plaque, standard and bowl, vase, ca. 1897–1900. *From William Walton, André Saglio, Victor Champier,* Exposition Universelle, 1900: The Chefs-d'Oeuvre, *vol. 9 (Philadelphia: n.p., 1901).*

a gold medal, and several of her works were illustrated in an exposition guide (see illustration). In addition to the Paris exposition, she exhibited her metalwork at the Cincinnati Art Museum in 1898 and 1901, and at the Pennsylvania Academy of the Fine Arts in 1902. Storer returned briefly to metalworking in the 1910s with a series of copper repoussé plaques that lacked the bizarre and fantastic quality of her earlier work.

Like Storer, M. Louise McLaughlin is known more for her contributions in ceramics than for her work in metals. McLaughlin had a profound influence on the art pottery movement in the United States. In her 1880 book *Pottery Decoration Under the Glaze*, she publicized the underglaze slip technique that she was the first to develop in the United States. In addition to her work in pottery and porcelain, McLaughlin was a skilled painter, woodcarver, printmaker, and metalworker. In metals, McLaughlin worked primarily in copper, etching Japanese-inspired designs on vases and bowls (pl. 131, 132). She often looked to nature as a source for design and used motifs such as flowers and

spider webs. McLaughlin's metalwork stylistically relates to her woodcarving; both emphasize low-relief line and pattern. The artist embellished her carved furniture with decorative copper plaques and hand-wrought hardware. There are very few known examples of McLaughlin's metalwork, so it is assumed that her output in the medium was small.

Edward Timothy Hurley, a celebrated decorator at The Rookwood Pottery Company from 1896 to 1948, was a Cincinnati native who studied at the Art Academy of Cincinnati. Hurley experimented with a variety of media including painting, printmaking, and metalworking. He began working in bronze in the early twentieth century, and created a variety of objects including candlesticks (pl. 133), ashtrays, covered boxes, letter openers, and bowls. Hurley's motifs—seahorses, lobsters, and spiders—are similar to Storer's, yet they are far more restrained and clearly rendered. The surfaces of his pieces are enhanced with rich green and black patinas. Hurley's bronzes are quite functional, yet they emphasize his interest in subtle design flourishes. During his lifetime, Hurley received far more notice as a printmaker than as a metalworker. Only recently has his metalwork garnered attention.

Benn Pitman, a native of England, is best known artistically as a teacher of Aesthetic Movement woodcarving in Cincinnati. While working in the printing industry in England, Pitman had learned to etch and engrave on metal. He taught these techniques to his woodcarving students, who incorporated decorative metalwork in the form of inset panels, brasses, and escutcheons into their furniture. Stylistically, Pitman's metalwork and woodcarving reflect the revival of the Gothic style in the nineteenth century. He often incorporated quotes from literature or the Bible into his works. For example, Pitman's brass plaque (pl. 134) is embellished in medieval lettering with a quote from Shakespeare's *Hamlet*. This plaque may have been set into the door of a carved cupboard, or perhaps into the lid of a carved box. Since Pitman was so skilled in metalwork, it is unfortunate that so few examples of his work are known.

Edna Boies Hopkins studied at the Art Academy of Cincinnati in the late 1890s. She excelled at color woodblock printing, a technique she refined during a trip to Japan, where it had thrived for centuries. Hopkins's bronze works, as well as her prints, reflect her interest in Japanese art. In both media she succeeded in rendering Japanese-inspired

motifs with an unusual sensitivity, as seen on her ginger jar (pl. 135), which is delicately embellished with Japanese blossoms in relief. This ginger jar is the only known bronze by Hopkins. It offers a striking companion to her work on paper. One hopes that more of Hopkins's bronzes will become known, allowing for a greater understanding of her strength in the medium.

Anna Maria Riis, born in Norway, studied in the 1880s at the University of Applied Arts in Vienna and at the Royal Norwegian School of Art and Industry. Proficient in a number of media, she taught china painting, enameling on metals, bookbinding, and ornamental leatherwork at the Art Academy of Cincinnati from 1890 to 1930. In metalwork, Riis focused on painted enamels on copper. With particular sensitivity, she painted portraits and landscapes on small boxes and medallions. The Cincinnati Art Museum has a number of Riis's painted enamels, including an exquisite box (pl. 136) depicting a windmill set against a rural landscape. This piece demonstrates Riis's mastery of painting realistic representations in rich colors on a small surface.

Each of these Cincinnati artists approached metalworking from a unique position and sought inspiration from a variety of sources. Although they were not connected by a single style or technique, they were unified by their intention: to experiment creatively with the process of artistic production. During their lifetimes these artists were celebrated primarily for their work in other media. Today, fortunately, their work in metals is receiving deserved recognition.

JH

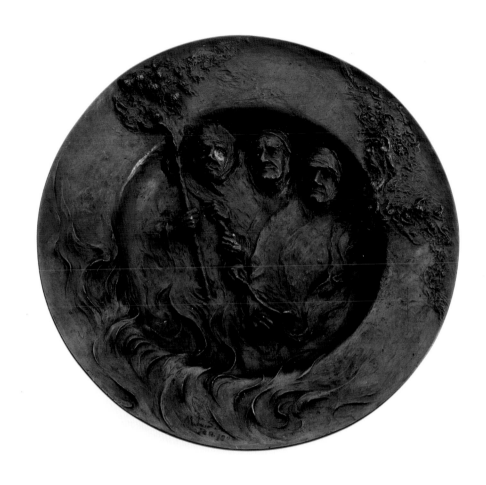

Plate 127

Maria Longworth Nichols Storer (1849–1932)

Plaque, 1900

Copper electroplated on tin and semiprecious stones

Diam. 13 3/16 in. (diam. 33.49 cm)

Gift of Mrs. M. L. Storer, 1903.396

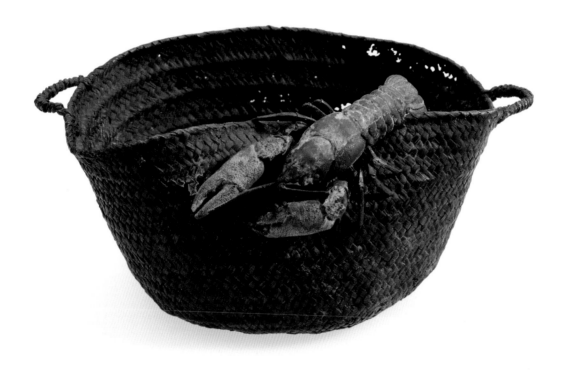

Plate 128

Maria Longworth Nichols Storer (1849–1932)

Basket, ca. 1897–1900

Copper electroplated on tin and semiprecious stones

4⅞ x 10¼ x 9⅛ in. (12.3 x 26 x 23.1 cm)

Gift of Mrs. M. L. Storer, 1903.395

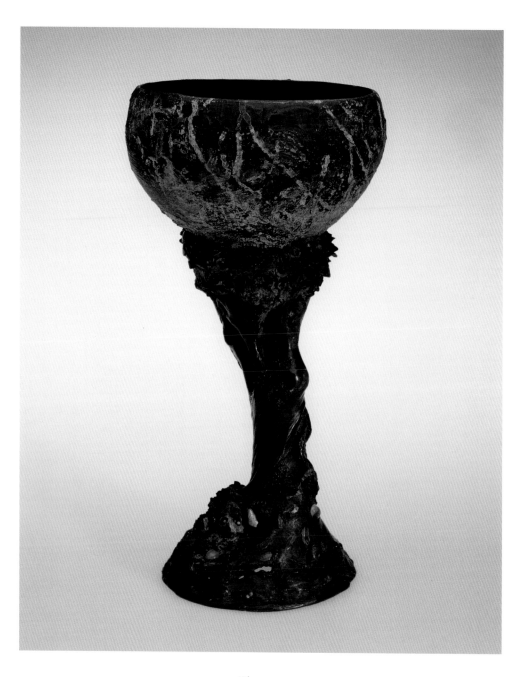

Plate 129

Maria Longworth Nichols Storer (1849–1932)

Bowl and Standard, 1898

Copper electroplated on tin, semiprecious stones and pearls

H. 17⅞ in., diam. 8⁵⁄₁₆ in. (h. 45.4 cm, diam. 22.7 cm)

Gift of Mrs. M. L. Storer, 1903.394

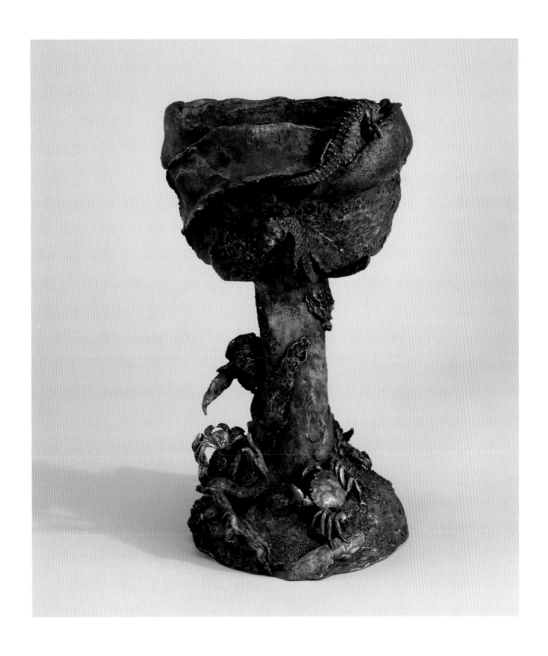

Plate 130

Maria Longworth Nichols Storer (1849–1932)

Chalice, 1898

Silver electroplated on tin and semiprecious stones

H. 12 in., diam. 7 in. (h. 30.5 cm, diam. 17.8 cm)

Gift of Mrs. M. L. Storer, 1903.387

189

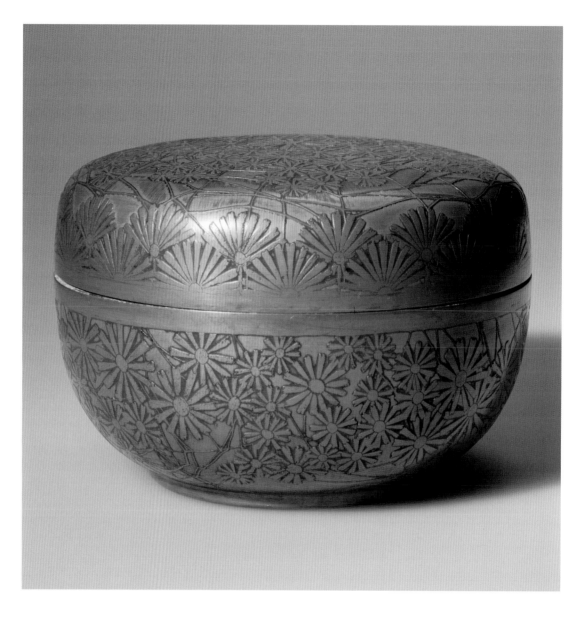

Plate 131
Mary Louise McLaughlin (1847–1939)
Covered Bowl, 1884
Copper
H. 5¼ in., diam. 7¾ in. (h. 13.3 cm, diam. 19.6 cm)
Gift of Mary Louise McLaughlin, 1937.13

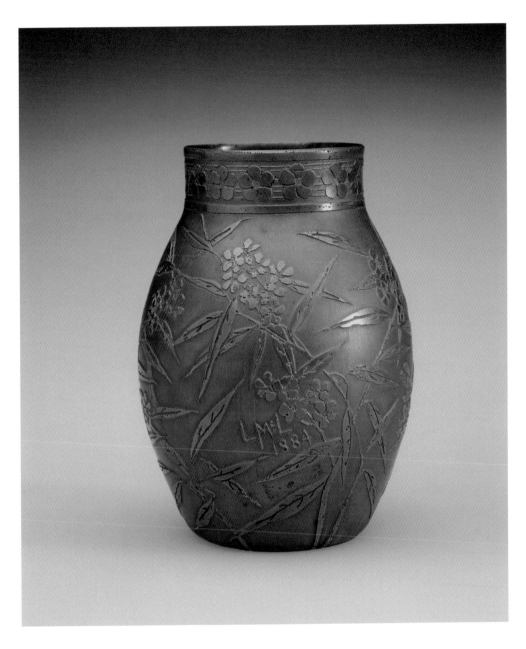

Plate 132

Mary Louise McLaughlin (1847–1939)

Vase, 1884

Copper

H. 5 in., diam. 3 ¾ in. (h. 12.7 cm, diam. 9.5 cm)

Museum Purchase: Dwight J. Thomson Endowment, 1999.165

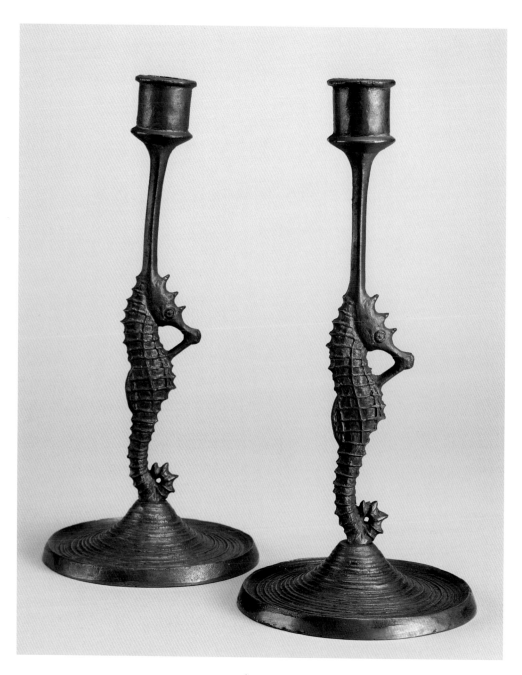

Plate 133

Edward Timothy Hurley (1869–1950)

Candlesticks, 1916

Bronze

H. 11 in., diam. 5 ⅛ in. (h. 27.9 cm, diam. 13 cm)

Gift of Theodore A. Langstroth, 1970.624 a,b

192

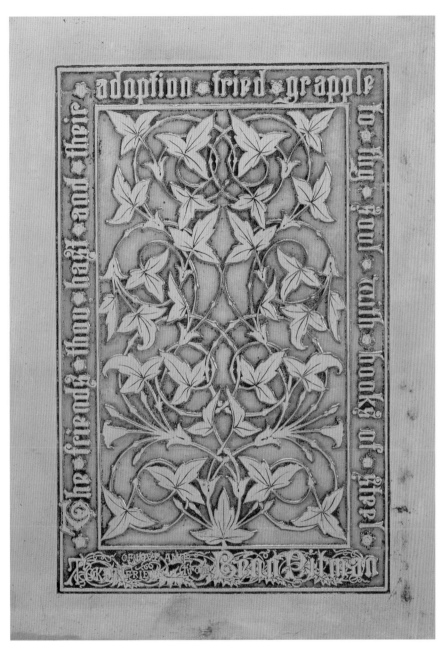

Plate 134

Benn Pitman (1822–1910)

Plaque, ca. 1880s

Brass

H. 6½ in., diam. 8¾ in. (h. 16.5 cm, diam. 22.5 cm)

Museum Purchase: Dwight J. Thomson Endowment, 1999.166

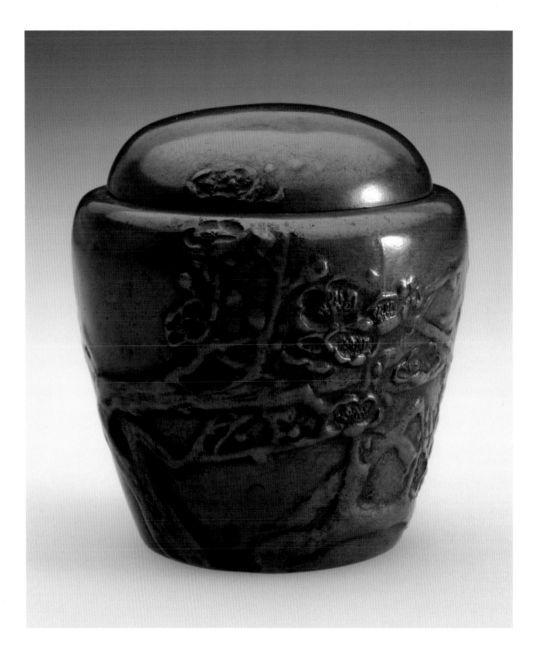

Plate 135
Edna Boies Hopkins (1873–1937)
Ginger Jar, ca. 1900
Bronze
H. 3 ¼ in., diam. 3 in. (h. 8.2 cm, diam. 7.6 cm)
Museum Purchase: Dwight J. Thomson Endowment, 1999.164

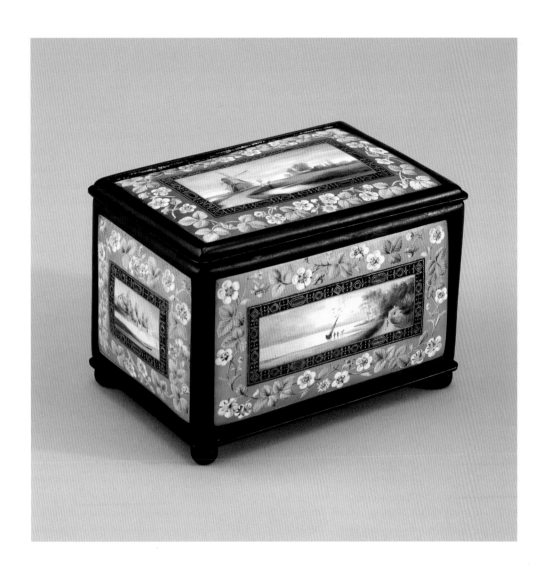

Plate 136

Anna Riis (1865–1945)

Box, 1910

Copper and enamel

3 x 4⅜ x 3⅜ in. (7.62 x 11.1 x 8.6 cm)

Gift of the Porcelain League of Cincinnati, 1911.602

<div style="text-align: center;">

9

</div>

The Twentieth Century

To appreciate present day art, one must change one's way of
seeing, must recognize new forms and a few years hence change
again. It is change that keeps life vital and living.

—John E. Weis

When I joined the staff [of the Art Academy of Cincinnati], the
teachers were still in the Munich School of Duveneck, and I was
the lone wolf. I was the lone voice with the largest class.

—Paul Chidlaw

The history of painting, sculpture, and decorative arts in Cincinnati in the twentieth century has not yet been written. As we gain historical perspective on the century just past, the collections of the Cincinnati Art Museum will grow and deepen. Nearly all works of art illustrated in this section date from the turn of the twentieth century to World War II. During that era, a collegial group of resident artists and educators made paintings that although generally conservative in style—often marked by Impressionist and Post-Impressionist influence—are united by an appealing *joie de vivre* that was surely comforting in one of America's more turbulent periods. By 1939, however, the enthusiasm for abstract painting was growing among some of Cincinnati's cultural leaders and began to splinter the art world of the city. The resulting diversity, though not always comfortable, was certainly exciting. Recent decades have been marked by the devaluation of the art of painting, by the rise of the studio crafts movement, and by the proliferation of new media. Future publications and exhibitions will study the importance of these events to the ever-transforming art life of the city.

By the turn of the twentieth century, Cincinnati's industrial development was far outpaced by newer cities of the Midwest such as Cleveland, Chicago, and Detroit. A decrease in the immigration that had fueled the city's dynamic nineteenth-century culture created a more stable environment favoring tradition over innovation. Yet the city's artists and art institutions prospered and the quality of creative work did not diminish.

The twentieth century's first decades saw a perpetuation of late-nineteenth-century artistic traditions. Frank Duveneck dominated the teaching of painting until his death in 1919. His passing, and the deaths of Henry Farny in 1916 and Lewis Henry Meakin in 1917, marked the close of a generation; nevertheless, their legacies prevailed through the teaching afforded by their students and younger colleagues. James Roy Hopkins, a former Duveneck pupil known for images of lovely women in artistic poses (pl. 137), briefly replaced his master as director of the Art Academy. Carolyn Lord (pl. 54), a student of Thomas Noble, taught drawing and painting at her alma mater from 1885

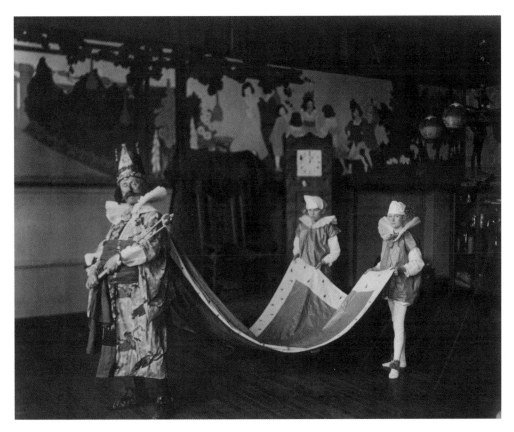

Fig. 17. Clement J. Barnhorn as Old King Cole at the Mother Goose Ball, Art Academy of Cincinnati, 1915. *Cincinnati Art Museum Archives*

until 1927, serving as a role model for countless young women. Clement J. Barnhorn, Duveneck's close friend, schooled several generations of sculptors over a period of thirty-five years (1900–1935). His accomplishments and those of his many disciples are seen in sculptural embellishment of the city's parks, squares, and public buildings. The Cincinnati Art Club, founded in 1890 for men only (the club has admitted women since 1979), and the Women's Art Club, established two years later, provided life drawing sessions, outdoor sketching expeditions, and exhibition venues for the art community. Still thriving today, these organizations celebrate both the continuity of Cincinnati as an art center and the realist traditions of the period of their founding.

The city's artistic character in the first half of the century was shaped by home-grown talents. Many of the painters grew up in the city, studied at the Art Academy—

primarily with Duveneck—and called the city home in their adult years. Duveneck protégés Herman Wessel and his wife Bessie Hoover Wessel (pl. 148) contributed to the art life of Cincinnati for many decades. Herman taught painting at the Art Academy from 1909 to 1947, his long tenure overlapping that of John E. Weis, who taught from 1918 to 1955. Many of the artists who resided in the city turned to Cincinnati's picturesque river views, gracious parks, and street scenes for their subjects (pls. 143, 144). In contrast, Paul Ashbrook and Dixie Selden (pl. 142) made Cincinnati home base for careers devoted to creating vibrant paintings in far-off locales from Mexico to Venice. The city enthusiastically provided them with exhibitions and patronage.

The appreciation of art by the community was nowhere better demonstrated than in a remarkable program initiated by the Cincinnati Public Schools. A collection of paintings (mostly by Cincinnati artists) was amassed with contributions from schoolchildren. Because these paintings adorned their classrooms, generations of students took pride in ownership of the works. Ornate school buildings were appointed with ceramic fountains and tile by The Rookwood Pottery Company, and with murals such as *The Harvesters* (pl. 147), painted by Louis Endres in 1927 for Oakley Elementary School. The Cincinnati schools offered children of all socioeconomic backgrounds their first exposure to art and thereby promoted the flowering of culture in the city.

The furniture and ceramic industries continued to flourish in Cincinnati until the Great Depression. For quality of design and fine craftsmanship, the furniture produced by the Shop of the Crafters (pl. 139) made an important contribution to the American Arts and Crafts Movement. Opened in 1904, the firm was owned and managed by German American Oskar Onken, who employed skilled artisans and the noted Hungarian professor and designer Paul Horti. In the company's 1906 catalogue, Onken touted his philosophy, which opposed Victorian excess and mass production: "The Crafter movement seeks to obliterate over-decoration, purposeless, meaningless designs and to install instead, a purity of style, which will express at once, beauty, durability and usefulness."[1] The simple lines and planar surfaces of the handcrafted furniture are embellished only with subtle, inlaid ornament that harmonizes with the form. By about 1919 the Shop of the Crafters may have ceased operation. During the 1920s, The Rookwood Pottery Company produced highly accomplished ceramics in the new Art Deco style. With the

Fig. 18. Herbert Barnett and a student at the Art Academy of Cincinnati, ca. 1950. *Cincinnati Art Museum Archives*

onset of the Depression, however, although the company remained in business, it lost preeminence.

Beginning in the late 1930s, significant changes began to transform the Cincinnati art world. A new era was heralded by the founding in 1939 of the Modern Art Society, an organization that presented important exhibitions (often held at the Cincinnati Art

Museum) and lecture series on modern and contemporary art. Renamed the Contemporary Arts Center in 1956, it remains a vital force for the new in Cincinnati today. After World War II, the city's colleges and universities, including the Art Academy of Cincinnati, steadfastly continued to nurture artistic talent. Although they were only in the city in the late 1940s, abstract painters Ralston Crawford and Joseph Albers made a major impact by opening new worlds to students weary of traditional fare. As in the past, many artists left Cincinnati to seek prominence in New York City, which had re-emerged after the war as the nation's art capital. Some of Cincinnati's finest resident artists remained, including painters Herbert Barnett (pl. 149) and Paul Chidlaw (pl. 150), who carried on the city's tradition of art education with tremendous dedication. Among their students are such internationally recognized artists as Jim Dine and Tom Wesselmann. In the Cincinnati Wing, the Cincinnati Art Museum celebrates the beautifully crafted, exquisitely designed, and multifaceted work produced by the painters, sculptors, and decorative artists who have helped to define the culture of the Queen City. Today, Cincinnati is once again repositioning itself, seeking new ways to define its role in the national and international culture of the twenty-first century.

JA

Plate 137
James Roy Hopkins (1877–1969)
Frivolity, ca. 1905
Oil on canvas
46 x 35 ½ in. (116.8 x 90.2 cm)
Annual Membership Fund, 1913.254

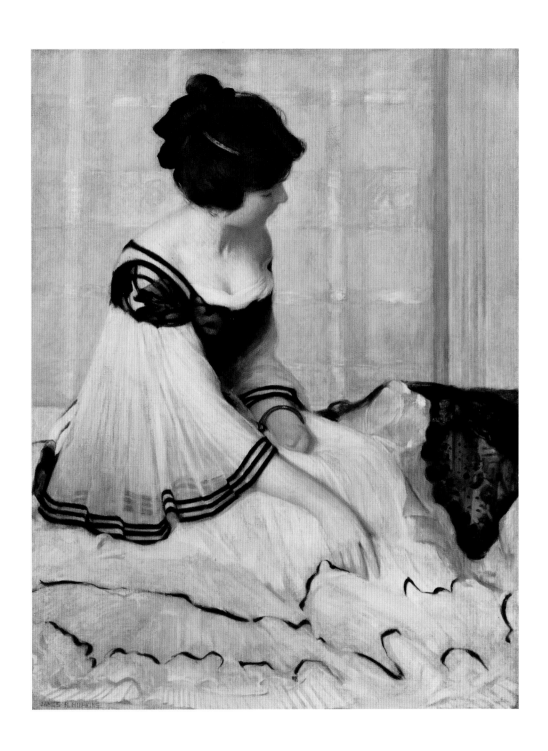

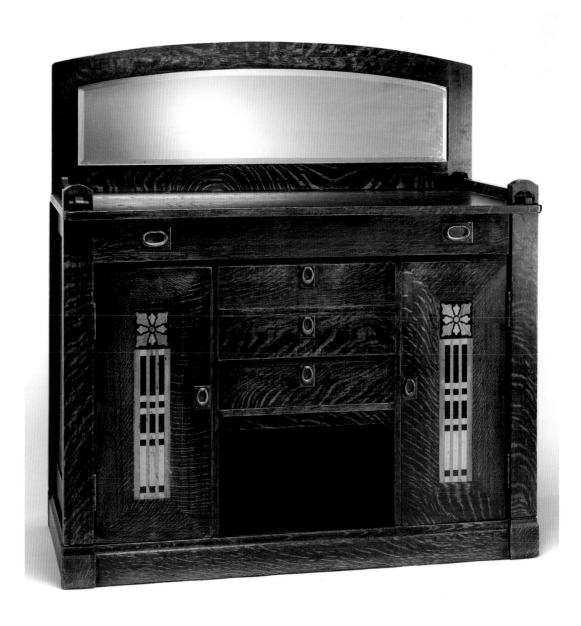

Plate 139

Shop of the Crafters (1904–1920)

Sideboard, ca. 1910

Oak, inlay of various woods, coppered metal

56 ¾ x 53 ½ x 23 ¾ in. (144.1 x 135.9 x 60.3 cm)

Gloria W. Thomson Fund for Decorative Arts, 1989.107

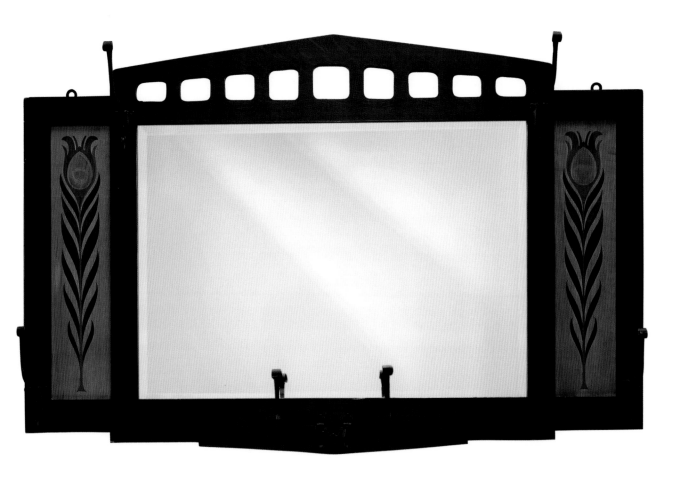

Plate 140

Shop of the Crafters (1904–1920)

Hat Rack, ca. 1910

Oak, inlay of various woods, glass, wrought iron

26½ x 40½ x 6⅛ in. (67.3 x 102.9 x 15.6 cm)

Gift of Cincinnati Art Galleries, 1986.908

Plate 141
Charles Kaelin (1858–1929)
Winter in Harbor, ca. 1915–16
Oil on canvas
28 x 31 1/16 in. (71.2 x 81.1 cm)
Source Unknown, 1920.426

Plate 142

Dixie Selden (1868–1935)

79th and Riverside Drive, 1915

Oil on canvas

24 x 18 in. (61 x 45.7 cm)

Gift of Bethel M. Caster in memory of her brother and sister-in-law,
Kenneth and Annelise Caster, for their contributions to the arts,
civic, and university life of Cincinnati, 1999.172

Plate 143

Frances Farrand Dodge (1878–1969)

Pavilion Street, Mount Adams, ca. 1920

Oil on artist board mounted on masonite

26⅛ x 19 in. (66.4 x 48.3 cm)

Museum Purchase: Bequest of Mr. and Mrs. Walter J. Wichgar, 2001.138

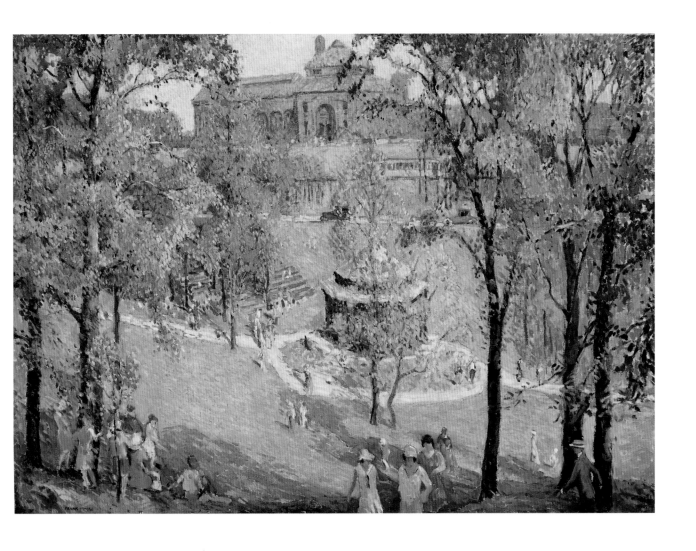

Plate 144

Frank Myers (1899–1956)

View of the Cincinnati Art Museum and Eden Park, ca. 1925

Oil on canvas

35 ¾ x 49 ½ in. (90.8 x 125.7 cm)

Gift of Alice Palo Hook, 1972.249

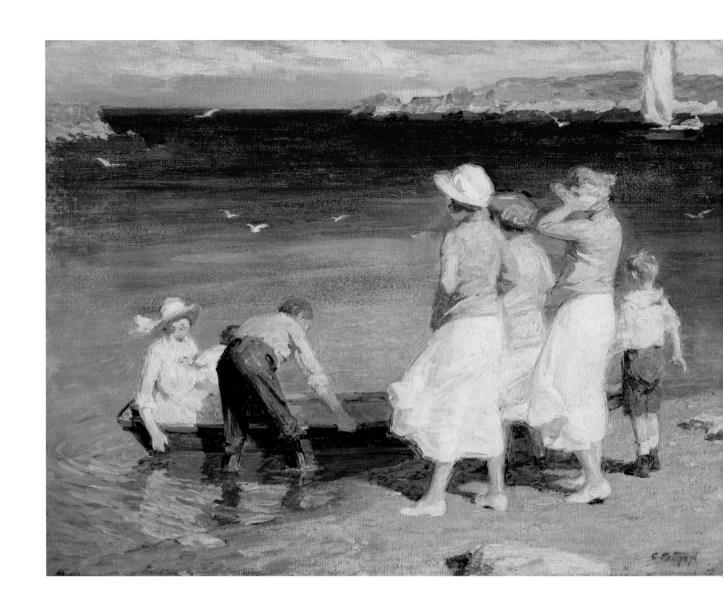

Plate 145
Edward Potthast (1857–1927)
A Sailing Party (Going for a Sail), ca. 1924
Oil on canvas
30¼ x 40¼ in. (27.7 x 102.2 cm)
Gift of Henry M. Goodyear, M.D., 1984.218

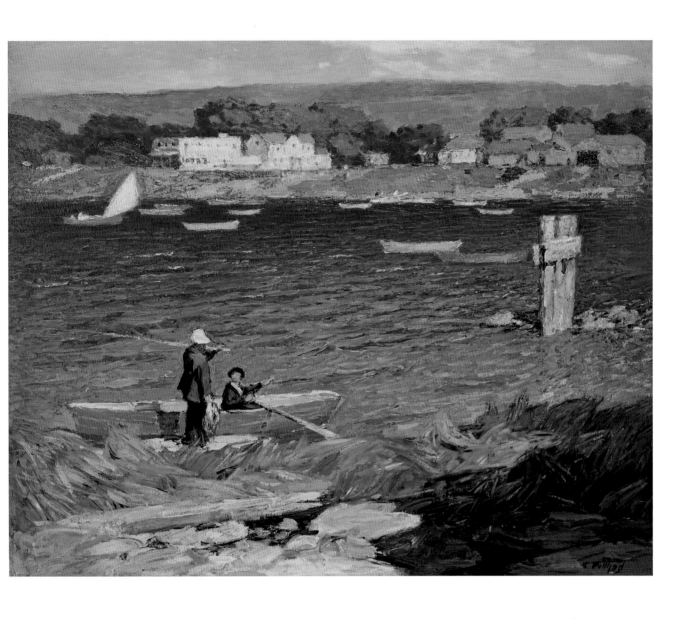

Plate 146
Edward Potthast (1857–1927)
A Day's Fishing, 1925–26
Oil on canvas
24⅛ x 30¼ in. (61.3 x 76.8 cm)
Bequest of Mrs. Doris Dieterle Kelly Van Fossen
in memory of George Franz Dieterle, 2001.139

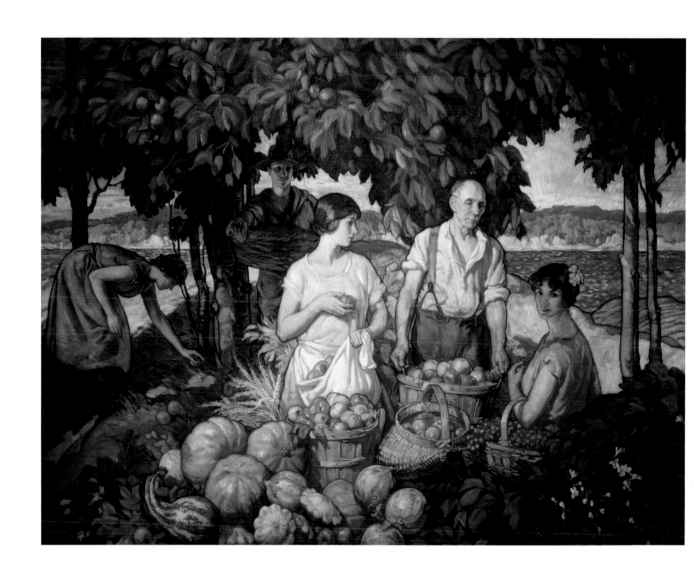

Plate 147

Louis Endres (1896–1989)

The Harvesters, 1927

Oil on canvas

108 x 132 in. (274.3 x 335.3 cm)

Gift of Cincinnati Art Galleries, 2000.4

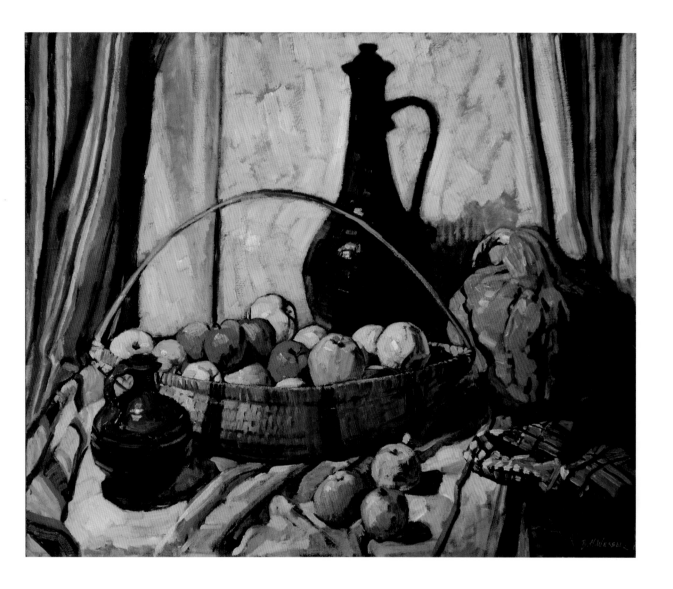

Plate 148

Bessie Hoover Wessel (1888–1973)

Still Life, 1945

Oil on canvas

30 x 36 in. (76.2 x 91.4 cm)

Gift of Mr. and Mrs. Robert H. Wessel in memory of the artist, 1988.261
© *Dr. Helen M. Wessel, CEO, The Wessel Foundation*

Plate 149
Herbert Barnett (1910–1972)
Gray Ruin and Stone House, 1948
Oil on board
24 x 36 in. (61 x 91.4 cm)
Gift of Mrs. Benjamin Tate, 1954.243
© *Courtesy of Peter Barnett*

Plate 150

Paul Chidlaw (1900–1989)

Boogie Woogie, 1980

Oil on canvas

40 x 30 in. (101.6 x 76.2 cm)

Museum Purchase with funds provided by
William Motto and Barbara Gould, 1993.233

Notes

Chapter 2: Frank Duveneck

1. Henry James, art note in *The Nation* (3 June 1875), 376; and Henry James, "On Some Pictures Lately Exhibited," *The Galaxy* 20 (July 1875), 95.

2. Oliver Dennett Grover, "Duveneck and His School," unpublished paper delivered before the Woodlawn Woman's Club, 18 January 1915, Cincinnati Art Museum Archives.

Chapter 3: Aesthetic Movement Furniture

1. Henry L. Fry, "Wood Carving: Origin of the Art in Cincinnati," *Cincinnati Daily Gazette*, 26 July 1876, 6.

2. "Famous Cincinnati Wood Carver of Bygone Years, H. L. Fry, Posthumously Tells of Art Fostered Here," *Cincinnati Times-Star*, 25 April 1940, 16.

3. Ibid.

Chapter 4: The Academic Tradition

1. "At the Art School," *Cincinnati Tribune*, 1 June 1895, 6.

2. Quoted in *The Golden Age: Cincinnati Painters of the Nineteenth Century* (Cincinnati: Cincinnati Art Museum, 1979), 25.

Chapter 6: American Impressionism and the Queen City

1. "O. M. I.: Elections of Officers Last Night; Nineteenth Exhibition of the School of Design," *Cincinnati Enquirer*, 10 March 1875, p. 8, col. 3.

2. "Cincinnati Art: Exhibition of Paintings at Closson's—'Whar's Dat Squirrel Gone?'" *Cincinnati Enquirer*, 6 February 1883, p. 8, col. 3.

Chapter 7: Cincinnati Looks West

1. *Cincinnati Daily Gazette*, 8 November 1881, 8; quoted in Denny Carter, *Henry Farny* (New York: Watson-Guptill Publications in Association with the Cincinnati Art Museum, 1978), 21.

2. Quoted from an unidentified source in Forrest Fenn, *The Beat of the Drum and the Whoop of the Dance: A Study of the Life and Work of Joseph Henry Sharp* (Santa Fe: Fenn Publishing Co., 1983), 281.

3. Joseph H. Sharp to Commissioner Jones, Department of the Interior, Office of Indian Affairs, 18 January 1902. Copy in Cincinnati Art Museum Archives; location of original unknown.

4. Quoted in "Farny Views Gathering of Own Indians," *Cincinnati Post*, 15 May 1915, 311.

Chapter 9: The Twentieth Century

1. Reprinted in Stephen Gray, ed., *Arts and Crafts Furniture: Shop of the Crafters at Cincinnati* (New York: Turn of the Century Editions, 1983), 4.

Photo Credits

Index